D1175614

For the Love of BAGS

TEXTS BY JULIA WERNER & DENNIS BRAATZ
PHOTOGRAPHS BY SANDRA SEMBURG

teNeues

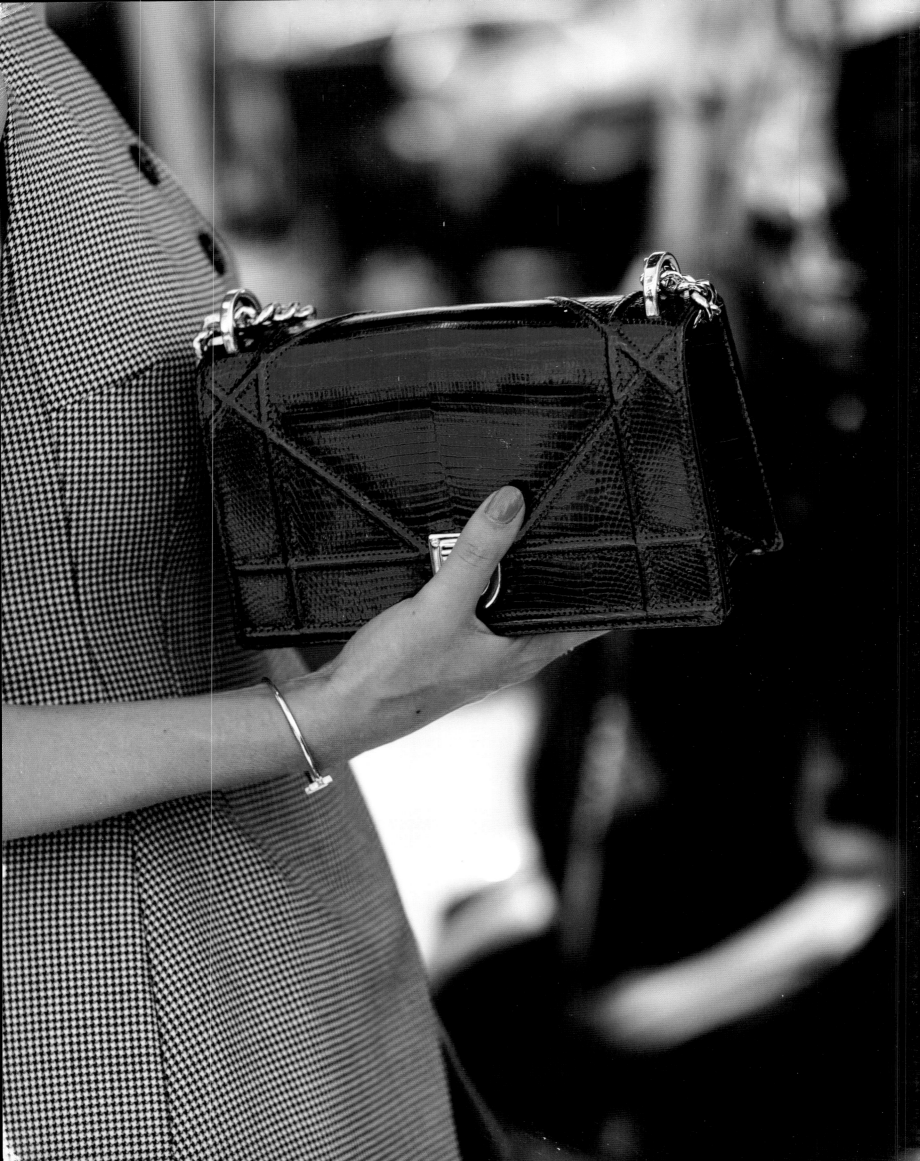

CONTENTS

04 Introduction

12 The Icons

44 It Bags

88 Atelier Bags

122 Insta Bags

192 Evening Jewels

204 Conversation Pieces

216 Index

218 Biographies

220 Credits & Imprint

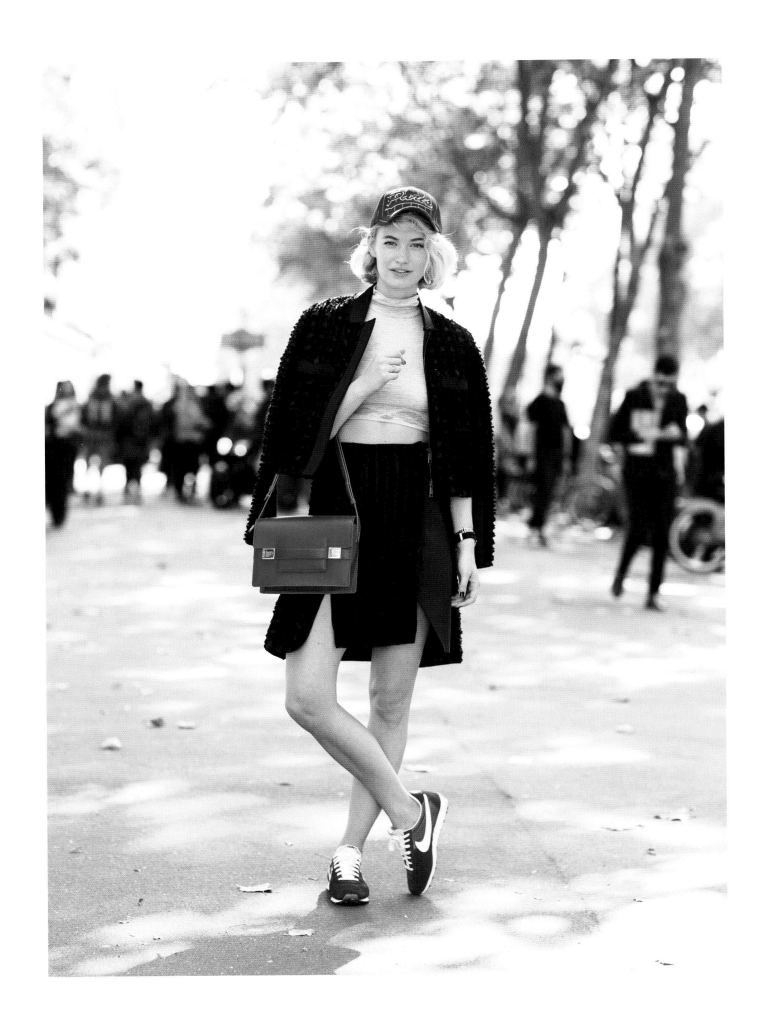

FOREWORD

VORWORT | PRÉFACE

—

The bag as the ultimate object of desire is not a surprise. When a woman buys a bag, she must have no fear that it will not suit her, no matter how big or small, thick or thin she is. The bag completes her look or creates it from the start, regardless of its own characteristics. So it is the most addictive of fashion drugs. But of course, that alone is not enough to explain why women sometimes set whole worlds in motion to get their hands on a particular model. They call stores around the world, go on mile-long waiting lists, and, if they are not rich, happily live on nothing for a month rather than go without the bag with which they fell in love. How can bags time and again provoke this exclusively feminine feeling where without it, life cannot be complete?

The bag is actually a male invention. The coins that jangle in trouser pockets in modern times were kept in leather or fabric bags worn by men during the Medieval Ages. However, this was, just because the purse had not yet been invented. The women of the Rococo movement imitated it for practical reasons: they stowed smelling salts, handkerchiefs, and powders in small bags, but hidden beneath a large skirt. That changed in the 18th century when the reticule became fashionable: a sewn silk bag with two cords, which could be coiled elegantly around the wrist. This development was, however, eclipsed by fashion: ever tighter and ever more transparent clothes no longer lent themselves to allowing the transport of essentials on the petticoat. And so the handbag was still far from its present-day cult status.

Its highpoint came only when women began to travel: in the mid-19th century, the first railway lines for passengers began to appear, and it quickly became clear that for such demanding trips, silk bags were useless. Only at this point did rigid designs made of leather with metal frames and snap fastenings come to the fore. It wasn't until the roaring twenties that ladies were given a first glimpse of what status bags would eventually have. Minaudières, a kind of evening bag, belonged to the cocktail-look like a pearl necklace and a fringe at the hem. These small works of art made of plastic, silk, and gold were real gems—which is why you could find them exclusively at jewelers like Cartier. It was only in the late 1970s that designers like Yves Saint Laurent began to offer bags suitable for the spirit of their collection alongside the ready-to-wear fashion. The Fendi Baguette, a small, richly decorated bag which just fit under the arm and, when worn, reminded one of the famous French bread, led in the 1990s the era of the It Bag. "It" status was very hard to get. And you didn't get "It" without a waiting list.

The most important feature of an It Bag is exclusivity, and the least important, functionality. The Paddington bag by Chloé, with its pristine decorative lock, felt as heavy as a bunch of books hanging on the arm—when empty. Nevertheless, it sold 8,000 units in the year of its launch before ever reaching the stores. It seems that for many women the right bag is more important than a healthy back.

In the mid-1990s, with the first cult bags also came the great paradigm shift in the fashion industry. Large luxury companies with international sales channels bought small, family-run luxury labels and turned them into brands as well known as Coca-Cola: Gucci, Louis Vuitton, Chloé. Suddenly these temples of good style were no longer only entered by a few. Suddenly the entire world wanted to be in. So accessories, shoes, and above all bags became the new object of desire for the mainstream—and the main source of income for the great fashion houses.

A dress with a four-figure price? Probably not for the average wage earner. By contrast, a bag? More likely. After all, the soft leather gives a feeling of having made a safe investment. Fashion designers became creative directors who no longer cared only about the perfect drape of a dress, but a whole cosmos. The way this cosmos looks can be expressed most succinctly with a bag. The people who buy them, thus become part of this world.

In the last two decades there have been many It Bags which have triggered hype: from the Bowling Bag from Prada to the Trapèze by Céline, whose form is imitated to this day by numerous competitors without ever perfecting it. The feeling of not owning a particular model, or at least not simply being able to carry one out of the shop, always multiplies the success of a bag many times over. Scarcity is a factor of success for a bag as much as a great new design. The Kelly bag by Hermès has only really experienced becoming an icon in the last two decades. The bag of bags, which was designed back in 1935, has experienced its big comeback; the waiting time for delivery is legendary.

Whenever it becomes in vogue in the fashion world to declare the end of the bag as a cult object, a new star bag appears on the stage, and everything starts all over again. Currently, countless women yearn for the Puzzle bag from Loewe. At the same time, ever more creative accessory start-ups are coming into the spotlight: Mansur Gavriel attained fame within one season with a Bucket Bag which costs only a fraction of the big label bags. Similarly, Paula Cademartori's colorful inlaid bags have also become hits. They seem to be designed for the Instagram era: they cry out for attention, but are wearable for every woman. So where does this feeling that the right bag makes life better come from? Probably because it's true. Nothing has been so often and so playfully reinvented as the handbag. It is simply a trait that appeals to women.

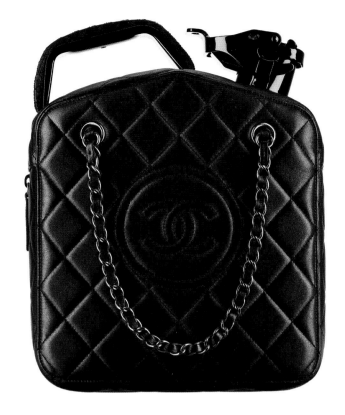

JERRY CAN BAG, CHANEL
PUZZLE BAG, LOEWE

Die Tasche als ultimatives Objekt der Begierde ist keine Überraschung. Wenn eine Frau eine Tasche kauft, muss sie nicht fürchten, dass sie ihr nicht passt, egal wie groß, klein, dick oder dünn sie ist. Die Tasche komplettiert ihren Look oder kreiert ihn erst, ganz unabhängig von ihren eigenen Eigenschaften. Sie ist also die gefahrenfreiste Modedroge. Aber das allein reicht natürlich nicht als Erklärung, warum Frauen manchmal Welten in Bewegung setzen, um an ein bestimmtes Modell zu kommen. Sie rufen dann in Läden auf der ganzen Welt an, lassen sich auf kilometerlange Wartelisten setzen – und leben, wenn sie nicht reich sind, lieber einen Monat lang von nichts, als auf das Modell zu verzichten, in das sie sich verliebt haben. Wie lösen Taschen bloß immer wieder aufs Neue dieses exklusiv weibliche Gefühl aus, dass das Leben ohne sie nicht perfekt sein kann?

Die Tasche ist eigentlich eine männliche Erfindung. Das, was heute in den Hosentaschen klimpert, also Münzen, trugen die Herren im Mittelalter in Taschen aus Leder oder Stoff mit sich herum. Allerdings nur, weil das Portemonnaie noch nicht erfunden war. Die Damen des Rokoko imitierten dies aus praktischen Gründen: Riechsalz, Taschentuch und Puder verstauten sie in kleinen Beuteln, allerdings versteckt unter dem weiten Rock. Das änderte sich erst im 18. Jahrhundert, als das Ridikül in Mode kam, ein aus Seide genähter Beutel mit zwei Schnüren, die sich elegant ums Handgelenk winden ließen. Diese Entwicklung war allerdings der Mode geschuldet: immer engere, immer durchsichtigere Kleider ließen es nicht mehr zu, das Transportmittel für das Nötigste am Unterrock zu befestigen. Noch war die Handtasche also sehr weit entfernt von ihrem heutigen Kultstatus.

Ihre Reise zum Zenith begann erst, als auch die Frauen sich auf die Reise machten: als Mitte des 19. Jahrhunderts die ersten Eisenbahnlinien für Passagiere geöffnet wurden, war schnell klar, dass Seidenbeutel für strapaziöse Trips nicht zu gebrauchen sind. Erst zu diesem Zeitpunkt wurden rigide Modelle aus Leder mit Metallrahmen und Schnappverschluss gefertigt. Eine erste Vorahnung dessen, was Taschen einmal sein würden, bekamen Damen dann aber erst in den Golden Twenties. Minaudières, also Abendtaschen, gehörten zum Cocktail-Look wie die Perlenkette und Fransen am Rocksaum. Diese kleinen Kunstwerke aus Kunststoff, Seide und Gold waren echte Schmuckstücke. Weshalb sie auch nur bei Juwelieren wie Cartier zu finden waren. Erst in den späten 1970er-Jahren begannen Designer wie Yves Saint Laurent, in ihren Läden neben Ready-to-wear auch Taschen passend zum Spirit der Kollektion anzubieten. Die Fendi Baguette,

eine kleine, reich dekorierte Tasche, die gerade so unter den Arm passte und beim Tragen an das französische Brot erinnerte, leitete dann in den 1990er-Jahren die Ära der It-Bags ein. „It", das war vor allem: kaum zu bekommen. Ohne Warteliste kein It-Bag-Status.

Die wichtigste Eigenschaft einer It-Bag ist: Exklusivität, und die unwichtigste: Funktionalität. Die Paddington Bag von Chloé mit ihrem dekorativen Schloss fühlte sich damals – ungefüllt – am Arm eher so schwer an wie ein Bündel Bücher. Trotzdem verkaufte sie sich im Jahr ihrer Lancierung 8 000 Mal, bevor sie überhaupt in die Läden kam. Die richtige Tasche ist vielen Frauen also wichtiger als ein gesunder Rücken.

Mit den ersten Kult-Taschen kam Mitte der 1990er-Jahre auch der entscheidende Paradigmenwechsel in der Modeindustrie. Große Luxuskonzerne mit internationalen Vertriebskanälen kauften kleine, familiengeführte Luxuslabels und machten aus ihnen Marken, so bekannt wie Coca-Cola: Gucci, Louis Vuitton, Chloé. Plötzlich waren diese Tempel des guten Stils nicht mehr nur das Zuhause von einigen wenigen. Plötzlich wollte die ganze Welt hinein. So wurden Accessoires, Schuhe und vor allem Taschen zum neuen Sehnsuchtsobjekt der Masse – und die Haupteinnahmequelle großer Modehäuser. Ein Kleid mit einem Preis im vierstelligen Bereich? Eher nicht für den Normalverdiener. Hingegen eine Tasche? Schon eher, schließlich gibt einem softes Leder das Gefühl, ein sicheres Investment getätigt zu haben. Aus Modedesignern wurden so Kreativdirektoren, die sich nicht mehr nur um den perfekten Fall eines Kleids kümmern, sondern um einen ganzen Kosmos. Wie dieser Kosmos aussieht, lässt sich am prägnantesten mit einer Tasche ausdrücken. Wer sie kauft, wird Teil dieser Welt.

Es hat in den letzten zwei Jahrzehnten viele It-Bags gegeben, die Hypes ausgelöst haben: Von der Bowling Bag von Prada bis zur Trapèze von Céline, deren Form bis heute von ziemlich vielen Konkurrenten nachgeahmt wird, deren Status aber nie erreicht wurde. Immer hat das Gefühl, genau dieses Modell nicht besitzen, oder es zumindest nicht einfach aus einem Laden tragen zu können, den Erfolg einer Tasche um ein Vielfaches multipliziert. Seltenheit ist für eine Tasche ebenso ein Erfolgsfaktor wie großartiges, neues Design. So erlebte die Kelly Bag von Hermès eigentlich erst in den letzten zwei Jahrzehnten ihre Ikonisierung – die Tasche aller Taschen, bereits 1935 entworfen, hatte ihr großes Comeback, ihre Wartezeit auf eine Bestellung ist legendär.

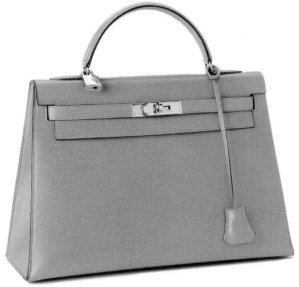

Immer wenn es in der Mode gerade wieder sehr en vogue ist, das Ende der Tasche als Kultobjekt zu besingen, betritt ein neuer Taschenstar die Modebühne – und alles geht von vorne los. Im Moment sehnen sich unzählige Frauen nach der Puzzle Bag von Loewe. Gleichzeitig rücken immer kreativere Accessoire-Start-ups ins Rampenlicht: Mansur Gavriel wurden innerhalb einer Saison mit einer Bucket Bag berühmt, die nur einen Bruchteil der bekannten Label Bags kostet. Genauso große Stars sind Paula Cademartoris bunte Intarsien-Taschen. Sie scheinen für die Instagram-Ära entworfen zu sein: sie schreien nach Aufmerksamkeit, sind dabei aber für jede Frau tragbar. Woher also kommt dieses Gefühl, dass die richtige Tasche das Leben besser macht? Wahrscheinlich weil es stimmt. Nichts wurde so oft und so spielerisch neu erfunden wie die Handtasche. Das ist ganz einfach eine Besonderheit, die Frauen sehr sympathisch ist.

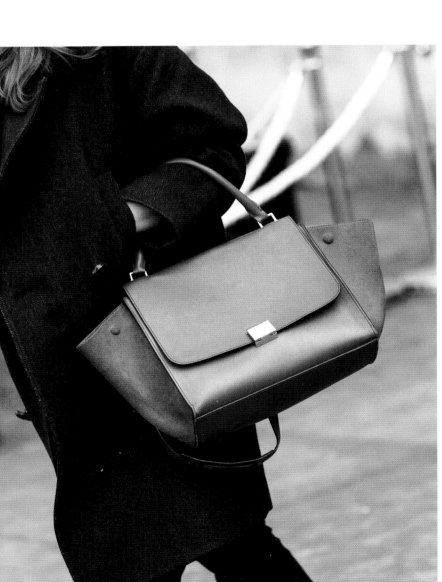

KELLY BAG, HERMÈS
TRAPÈZE BAG, CÉLINE

Le sac en tant qu'ultime objet du désir, voilà qui n'est pas surprenant ! Lorsqu'une femme fait l'acquisition d'un sac, elle ne doit pas craindre qu'il ne lui aille pas, qu'elle soit grande ou petite, grosse ou mince, quelle importance ! Le sac peaufine son look ou bien le crée, sans tenir compte de ses particularités. De toutes les addictions à la mode, il est celle la moins dangereuse. Mais il reste à comprendre pourquoi les femmes sont prêtes à déployer autant d'efforts pour acquérir le modèle visé. Elles appellent au téléphone dans les boutiques du monde entier, elles se font mettre sur des listes d'attente sans fin. Et si elles ne sont pas riches, elles préfèrent vivre de rien pendant un mois plutôt que de renoncer au modèle dont elles sont tombées amoureuses. Comment les sacs parviennent-ils à susciter sans cesse ce sentiment exclusivement féminin que la vie ne peut pas être parfaite sans eux ?

Le sac est en fait une invention masculine. Les hommes, au Moyen Âge, ont recouru aux sacs en cuir ou en tissu afin d'éviter de mettre dans leur poche des pièces de monnaie sonnantes, mais aussi tout simplement, parce que le porte-monnaie n'avait pas encore été imaginé. Les dames de l'époque rococo les imitaient pour des raisons pratiques : elles entassaient leurs sels, leur mouchoir et leur poudre dans de petits sacs, dissimulés sous leur vaste jupe. Cela changea seulement au XVIIIᵉ siècle lorsque le réticule, un petit sac cousu, en soie et doté de deux cordelettes, qui s'entouraient élégamment autour du poignet, connut le succès. On devait toutefois cette évolution à la mode : des robes toujours plus étroites, toujours plus transparentes, n'autorisaient plus de fixer le moyen de transport du nécessaire au jupon. Le sac était alors encore très éloigné de son statut culte d'aujourd'hui.

Son ascension débuta seulement lorsque les femmes se mirent à voyager. Au milieu du XIXᵉ siècle, alors que les voix ferroviaires s'ouvraient aux passagers, il apparut clairement que les sacs en soie étaient mal adaptés aux voyages exténuants. Ce n'est qu'à cette époque que furent réalisés des modèles rigides en cuir, avec des cadres métalliques et des fermetures à déclic. Mais c'est au cours de l'Âge d'Or des années 1920 que les femmes eurent alors l'intuition de la place éminente que le sac était appelé à tenir dans le futur. Les minaudières, à savoir des sacs de soirée, faisaient partie intégrante du look de cocktail à l'image des colliers de perles et des franges sur le bas des jupes. Ces petites œuvres d'art en matière plastique, soie et or étaient de véritables bijoux. C'est la raison pour laquelle on les trouvait uniquement chez des joailliers comme Cartier. C'est seulement dans les années 1970 que des designers comme Yves Saint Laurent commencèrent

à proposer des sacs, aux côtés du prêt-à-porter, épousant l'esprit de la collection. La Baguette Fendi, un petit sac richement décoré, qui tenait juste sous le bras et qui n'était pas sans rappeler, de par son port, le pain français, introduisit l'ère des it-bags dans les années 1990. « It » signifiait avant tout : quasi impossible à obtenir. Pas de statut de it-bag sans liste d'attente !

La qualité la plus importante d'un it-bag est l'exclusivité, la moins importante la fonctionnalité. Le sac Paddington de Chloé avec son cadenas décoratif semblait peser, vide, l'équivalent d'un paquet de livres. Pourtant, il se vendit à l'époque, l'année de son lancement, à 8 000 exemplaires avant même qu'il ne soit mis en vente en boutique. Le sac idéal est, aux yeux des femmes, plus important qu'un dos droit.

L'apparition des premiers sacs cultes s'accompagna d'un changement des paradigmes dans l'industrie de la mode. De grands groupes de luxe usant de canaux de distribution internationaux achetèrent des petits labels de luxe à gestion familiale et en firent des marques aussi connues que Coca-Cola : Gucci, Louis Vuitton, Chloé. Soudain, ces temples de bon style n'étaient plus seulement la demeure de quelques heureux élus. Tout d'un coup, le monde entier voulait y pénétrer. C'est ainsi que les accessoires, les chaussures et surtout les sacs devinrent des objets que le commun des mortels se mit à vouloir ardemment posséder mais aussi la principale source de revenus des grandes maisons de couture. Une robe affichée à un prix s'étalant sur quatre chiffres : le consommateur ne se pose pas la question de son achat. En revanche, un sac en cuir soft donne davantage le sentiment d'avoir accompli un véritable investissement. Les designers devinrent alors des directeurs artistiques qui ne s'occupaient plus seulement du cas d'une robe parfaite mais de tout un univers. Et c'est par le biais d'un sac que cet univers s'exprime le mieux. Celui qui l'acquiert fait désormais partie de cet univers.

De nombreux it-bags ont suscité dans les deux dernières décennies un engouement frénétique : du sac Bowling de Prada au Trapèze de Céline dont la forme a été imitée par de nombreux concurrents mais jamais égalée. Le sentiment de ne pas pouvoir posséder exactement ce modèle ou dumoins de ne pas pouvoir l'emporter d'une boutique a considérablement multiplié le succès d'un sac. La rareté se révèle pour un sac un facteur de réussite tout autant qu'un design grandiose et novateur. C'est ainsi que le sac Kelly d'Hermès obtint réellement son statut d'icône dans les deux dernières décennies. Le sac parmi tous les sacs, créé en 1935, fit son grand come-back. Le temps d'attente pour une commande est légendaire.

Chaque fois que l'on se complaît à annoncer la fin de l'hégémonie du sac en tant qu'objet de culte, un nouveau sac fait son apparition sur le devant de la scène de la mode et tout recommence depuis le début. En ce moment, d'innombrables femmes convoitent le sac Puzzle de Loewe. Parallèlement, des startups d'accessoires des plus créatives font leur entrée sous les feux de la rampe. Le label Mansur Gavriel devint célèbre en une saison avec un sac seau qui coûte seulement une fraction du prix d'un sac de marques connues. Les sacs colorés à ornements de Paula Cademartori sont également de grandes stars parmi les sacs. Ils semblent être conçus pour Instagram : ils réclament de l'attention mais sont en même temps portables par chaque femme. Mais d'où vient ce sentiment que le sac idéal rend la vie meilleure ? Vraisemblablement parce que c'est vrai. Seul le sac a su se réinventer si souvent et de manière si ludique. C'est tout simplement cette spécificité qui le rend si sympathique aux yeux des femmes.

DOLCE & GABBANA BAG

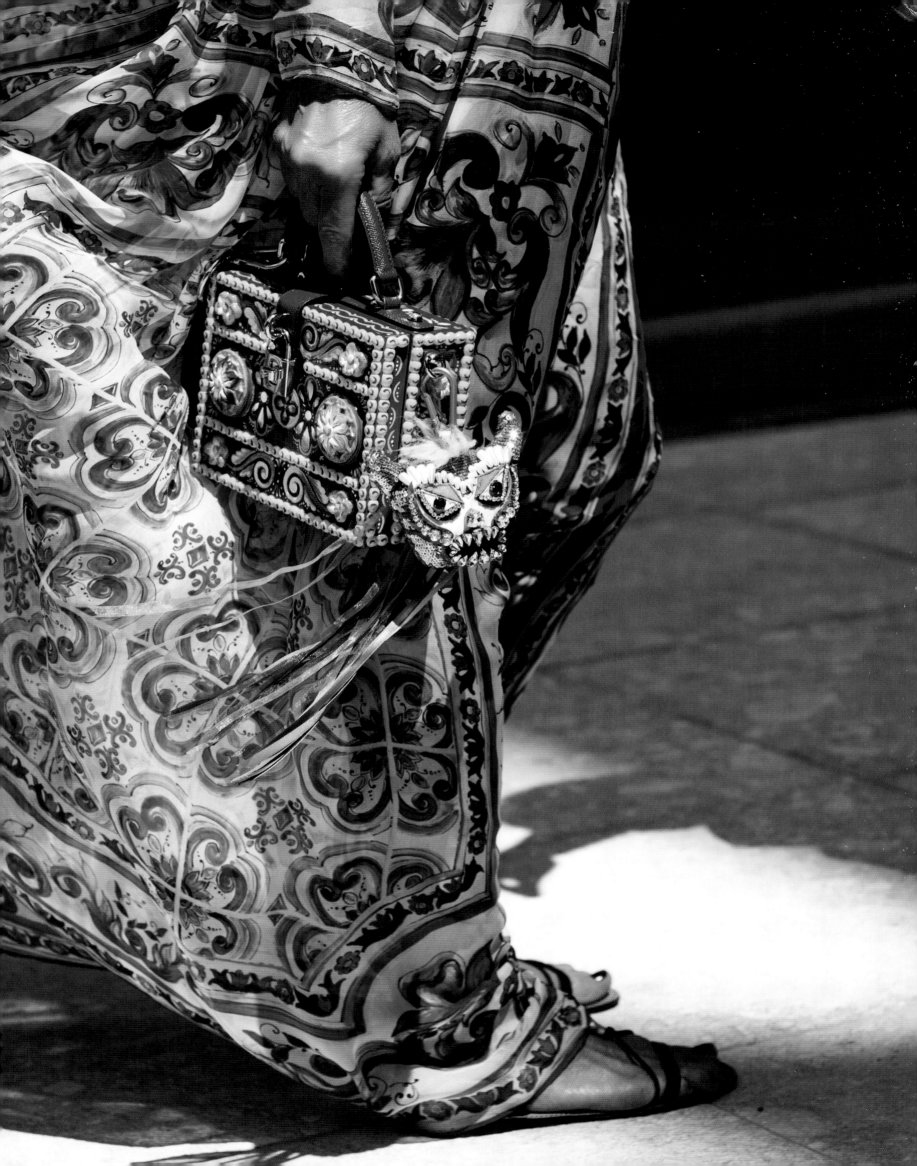

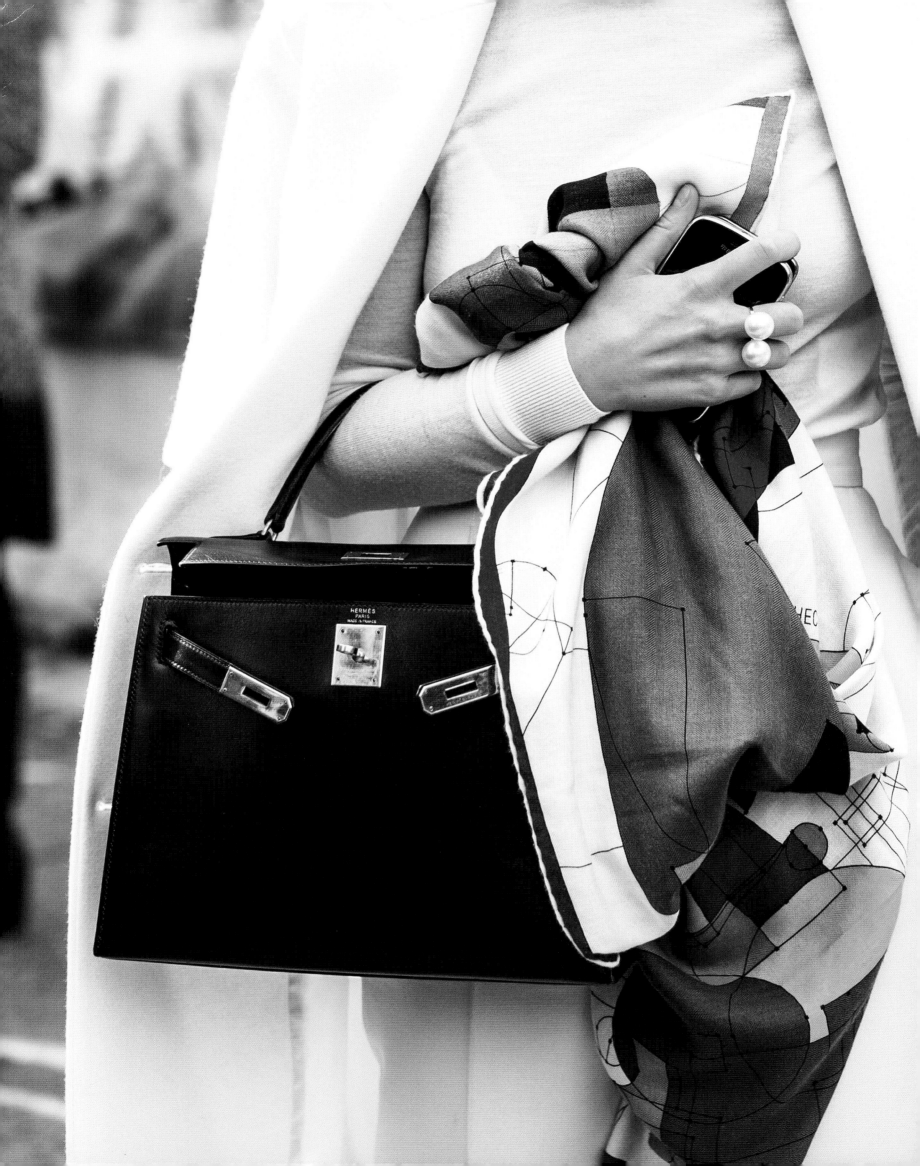

THE ICONS

—

Over and over again, people's boundless passion for various bags has caused hysterical waves of hype and resulted in endless waiting lists at the manufacturers'. But iconic bags are something special: the love for them never fades and has endured for decades. The story of these timeless bags always begins with a fateful connection to a living style icon. Would the Kelly bag be as famous without Grace Kelly? Perhaps we would have long since tired of looking at the Chanel 2.55, were it not for its creator Coco, who literally invented fashion for independent women. Iconic bags stand above the fray of changing fashion trends and are automatically heirloom pieces. The same principle that applies to successful men is true of these bags as well: they reach their maximum potential with a strong woman at their side.

Die bedingungslose Leidenschaft für verschiedenste Taschen hat immer wieder hysterische Hypes verursacht und zu endlosen Wartelisten bei ihren Herstellern geführt. Doch ikonische Taschen stechen heraus: Denn die Liebe zu ihnen hört nie auf und dauert mitunter seit Jahrzehnten an. Immer beginnt die Geschichte einer solchen Tasche mit der schicksalhaften Verbindung zu einer lebendigen Stilikone. Wer weiß, ob die Kelly Bag ohne Grace Kelly heute so berühmt wäre. Oder ob wir uns an der 2.55 von Chanel nicht längst sattgesehen hätten, wäre da nicht ihre Erfinderin Coco gewesen, die den Stil passend zur unabhängigen Frau erfunden hat. Iconic Bags sind über jeden Modetrend erhaben. Sie werden automatisch zu Erbstücken. Für sie gilt ein ähnliches Prinzip wie für erfolgreiche Männer. Mit einer starken Frau an ihrer Seite entfalten sie ihre maximale Wirkung.

La passion inconditionnelle éprouvée à l'égard de sacs totalement différents les uns des autres a toujours suscité des réactions hystériques et conduit à la création de listes d'attente sans fin de la part des fabricants. Toutefois, les sacs iconiques occupent une place bien à part car l'amour qu'on leur voue ne cesse jamais et dure parfois des décennies. La naissance d'un tel sac est toujours liée à sa rencontre fortuite avec une icône de style, quant à elle bien vivante. Qui sait si le sac Kelly eût connu un tel succès si Grace Kelly ne l'avait pas adopté ? Ou peut-être bien que le 2.55 aurait fini par nous lasser, si sa créatrice, Coco, n'avait pas su inventer un style adapté à la femme indépendante. Les sacs iconiques survivent, indifférents aux modes qui se succèdent. Ils deviennent automatiquement des objets intemporels. Les hommes, pour asseoir leur réussite et en décupler ses effets au maximum se montrent, une femme prestigieuse à leur bras. Les sacs iconiques se nourrissent des mêmes principes que les hommes pour assurer leur triomphe.

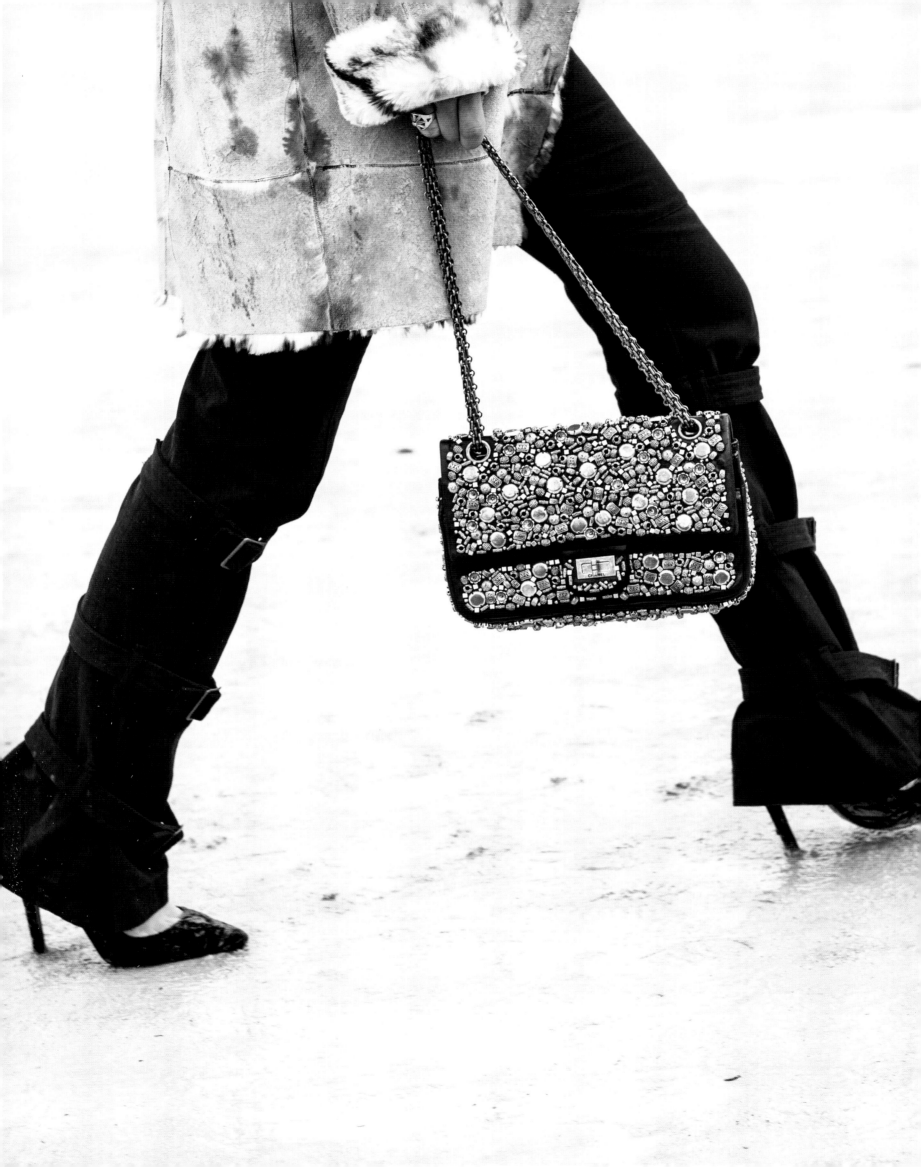

CHANEL'S 2.55

It sounds so simple, and yet few people know the secret: the 2.55 is called 2.55 because it was created in February 1955. At the time, Coco Chanel was sick and tired of never having her hands free while carrying her purse. She took her inspiration from the bags used by the French military, which were secured with a shoulder strap to guarantee the wearer's freedom of movement, just like Mademoiselle Chanel's binoculars, which she always wore to watch horse races. Saddles and saddle blankets provided the model for the bag's high-quality, extremely durable workmanship. So it's not really surprising that women all over the world immediately bought one. Even today, the 2.55 is still one of the best-selling bags out there. The production process has never changed: 180 individual steps are needed to make the bag, and production team members must have five years of experience at Chanel before they can make the 2.55.

Es klingt so einfach, dabei wissen es die Wenigsten: Die 2.55 heißt 2.55, weil sie im Februar des Jahres 1955 erfunden wurde. Coco Chanel hatte damals keine Lust mehr, durch das Tragen ihrer Handtasche nie die Hände frei zu haben. Die Taschen des französischen Militärs kamen ihr als Inspiration deshalb gerade recht. Sie waren an einem Schulterriemen befestigt, um uneingeschränkte Bewegungsfreiheit zu garantieren. Ebenso, wie Mademoiselle Chanels Fernglas, das sie sich immer zum Pferderennen umhängte. Den Impuls für die hochwertige, strapazierfähige Art der Verarbeitung gaben dann auch Sättel und Satteldecken. Wirklich überraschend ist es also nicht, dass Frauen auf der ganzen Welt sofort zugriffen. Die 2.55 verkauft sich noch heute so gut wie kaum eine andere Tasche. An der Fertigung hat sich nie etwas geändert: 180 einzelne Schritte sind notwendig und fünf Jahre Arbeitserfahrung bei Chanel Voraussetzung, um an der Produktion beteiligt sein zu dürfen.

Cela semble si simple, pourtant peu de personnes le savent : le 2.55 s'appelle ainsi parce qu'il a été créé en février 1955. À l'époque, Coco Chanel en eut assez de n'avoir jamais les mains libres à cause du port de son sac à main. Les sacs du corps militaire lui servirent à point nommé d'inspiration. Ils étaient fixés à une bandoulière, assurant une liberté de mouvement illimitée. À l'image des jumelles de Mademoiselle Chanel, qu'elle portait en bandoulière lors des courses de chevaux. Les selles et les tapis de selles donnèrent l'impulsion pour la grande qualité et la résistance du procédé de fabrication. Il n'est vraiment pas surprenant que des femmes du monde entier aient jeté immédiatement leur dévolu sur le 2.55. Encore de nos jours, il est peu probable qu'un autre sac se vende mieux que le 2.55. Rien n'a jamais été modifié à sa fabrication : 180 étapes individuelles sont nécessaires et il faut cinq ans d'expérience professionnelle chez Chanel pour bénéficier du droit de participer à sa production.

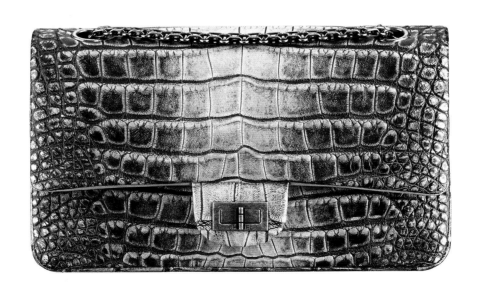

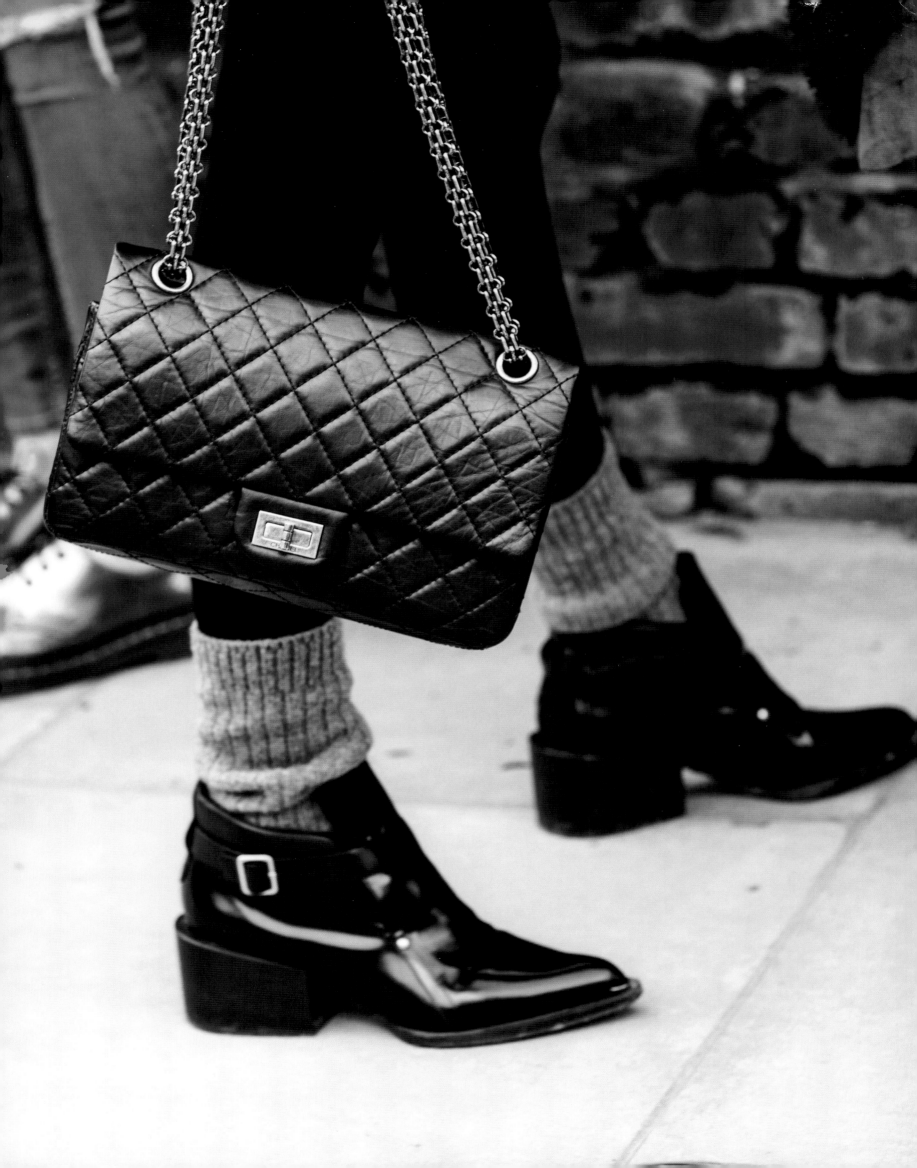

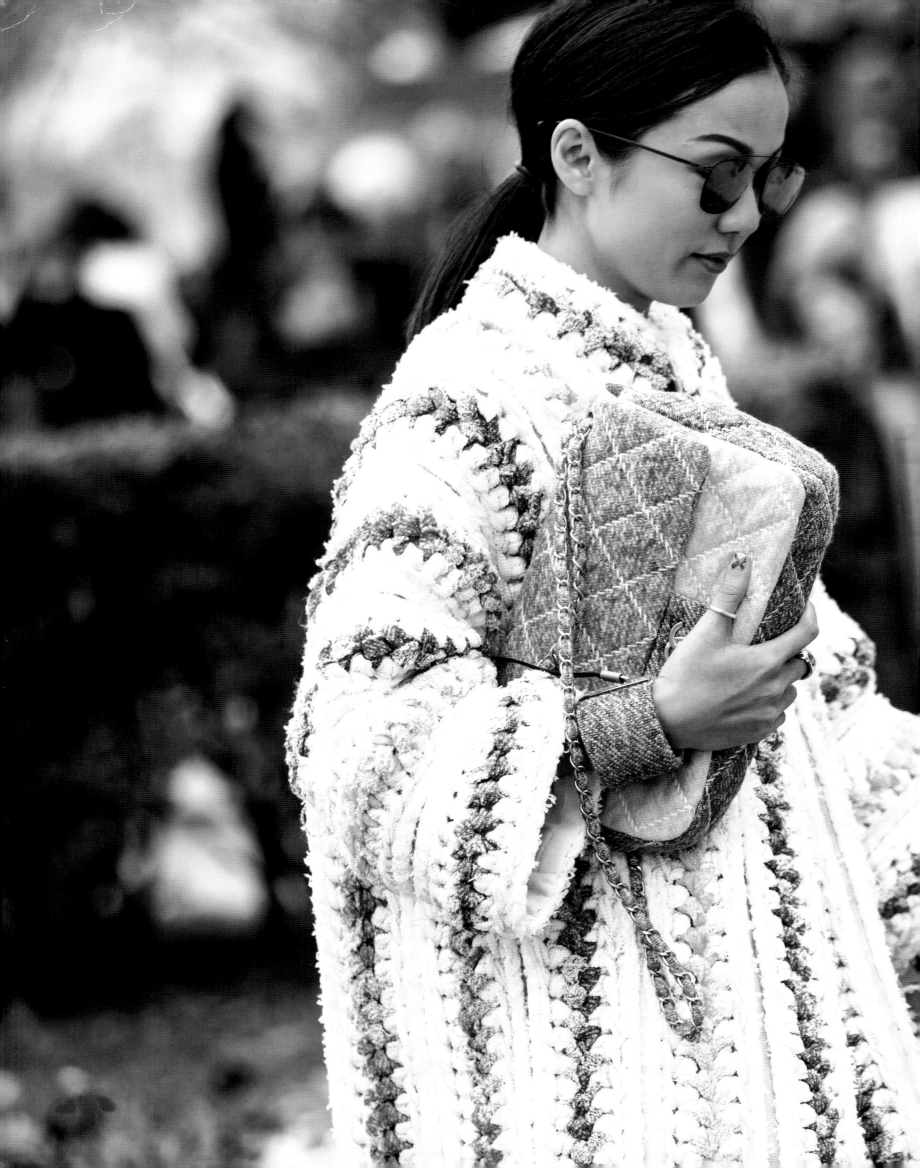

NAME: 2.55
CREATED IN: 1955
NAMED FOR:
THE MONTH AND YEAR IT WAS DESIGNED

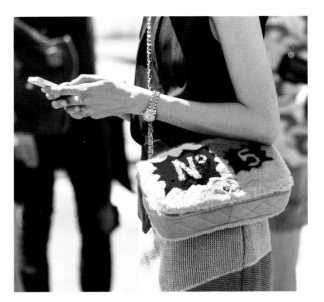

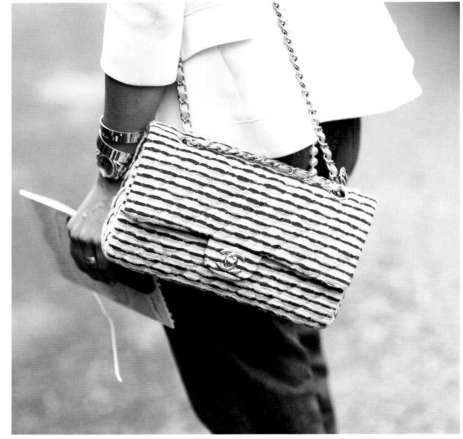

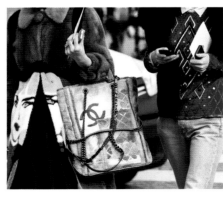

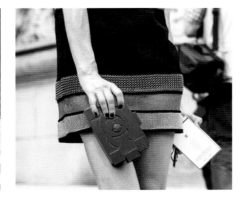

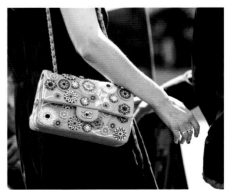

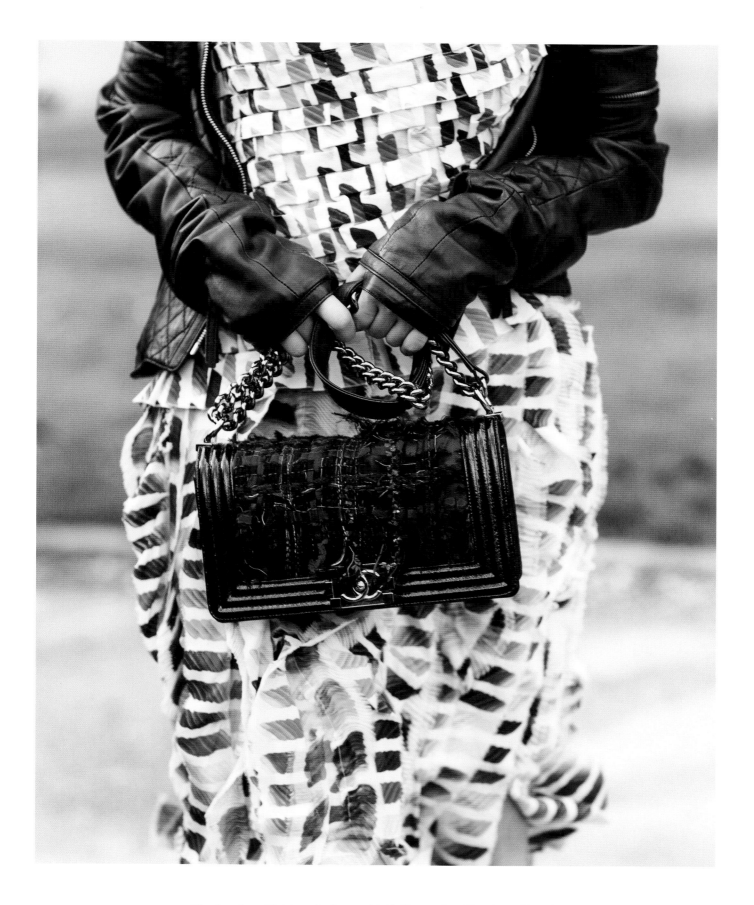

Timeless, Lego Clutch, and other models (left), as well as Chanel Boy (above).

Timeless, Lego Clutch und andere Modelle (links), sowie Chanel Boy (oben).

Le sacs Timeless, Lego Clutch et d'autres modèles (à gauche), aussi Chanel Boy (en haut).

GUCCI'S JACKIE BAG

—

Barbra Streisand, Salma Hayek, Kate Moss: none of them would have worn this bag without fashion icon Jackie O., who was never seen in public in the '50s and '60s without her hobo-style bag. Even when she became First Lady at the side of John F. Kennedy in 1961, she held fast to her beloved bag. By this time, she had dozens of these in all colors to match her outfits. Her White House advisers said she should get rid of them, and that they were an image problem because they were made in Italy, not the United States. Guccio Gucci debuted the bag in Italy in 1947, presenting it as the Constance with leather tassels and a vertical closure. When Gucci found out how much Jackie loved the Constance and how she brushed aside the criticism from her advisers, he soon renamed the bag the Jackie Bag—a star was born.

Barbra Streisand, Salma Hayek, Kate Moss. Sie alle hätten diese Tasche wohl nie ohne die Modeikone Jackie O. getragen. In den 1950er-und 1960er-Jahren wurde sie ausschließlich mit ihrer in der Mitte leicht durchhängenden Hobo gesehen. Sie legte sie nicht einmal ab, als sie 1961 an der Seite von John F. Kennedy zur amerikanischen First Lady avancierte. Das Modell besaß sie mittlerweile in unzähligen Versionen, die farblich auf ihre Kostüme abgestimmt waren. Die Berater im Weißen Haus rieten von dem Gebrauch aus Imagegründen ab, da sie nicht in den USA, sondern in Italien gefertigt wurde. 1947 hatte Guccio Gucci sie dort erstmals der Öffentlichkeit präsentiert – unter dem Namen Constance – mit Ledertroddeln und vertikaler Schließe. Als Gucci jedoch erfuhr, wie sehr Jackie an der Constance hing und sich zudem unbeeindruckt von der hauseigenen Kritik zeigte, folgte kurzerhand die Umbenennung in Jackie Bag – und die Geburt einer Legende.

Barbra Streisand, Salma Hayek, Kate Moss. Toutes n'auraient jamais porté ce sac sans l'icône de style Jackie O. Dans les années 1950 et 1960, on ne la voyait jamais sans son Hobo, légèrement affaissé au centre. Elle ne s'en défit même pas en 1961 lorsqu'elle endossa le rôle de First Lady américaine aux côtés de John F. Kennedy. Elle possédait ce modèle dans d'innombrables versions, qui étaient en accord avec la couleur de ses tailleurs. Les conseillers de la Maison Blanche lui en déconseillèrent l'usage pour des raisons d'image car ce sac n'était pas fabriqué aux USA, mais en Italie. En 1947, Guccio Gucci l'avait présenté pour la première fois au public, sous le nom de Constance, avec des pompons en cuir et une fermeture verticale. Mais lorsque Gucci apprit à quel point Jackie était attachée au modèle Constance et qu'elle se montrait imperméable aux critiques de son entourage, il fut en un tour de mains rebaptisé le sac Jackie. C'est ainsi que naquit une légende.

NAME: JACKIE BAG | CREATED IN: 1947 | NAMED FOR: JACKIE O.

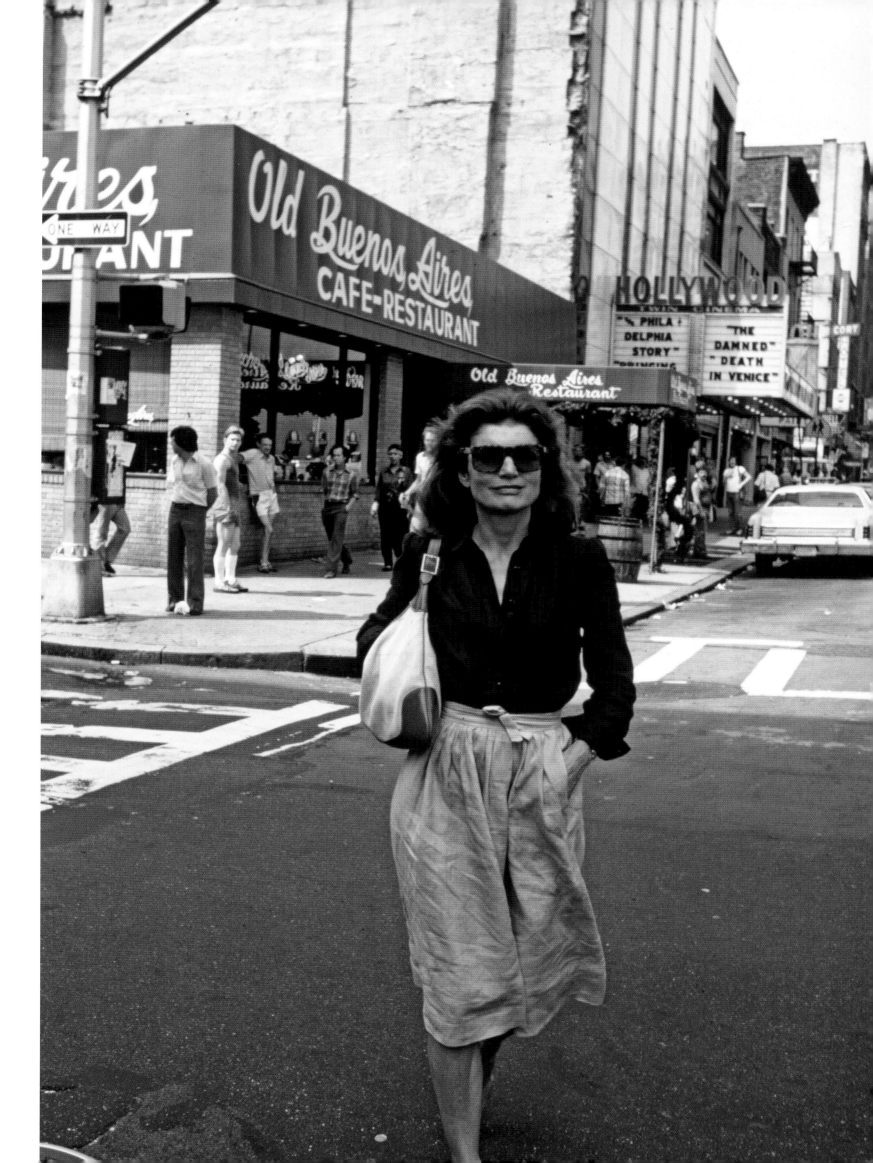

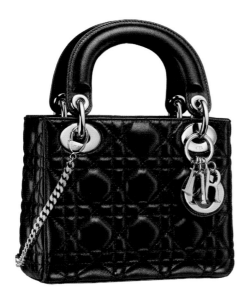

THE STORY OF THE LADY DIOR

In our minds, the Lady Dior is the bag that true ladies carry—as the name says. This bag is actually the youngest of our iconic bags: Christian Dior was long dead when Dior launched the bag in 1994, nicknaming it *chouchou* (little pet). Then there was a momentous meeting when Bernadette Chirac, wife of French president Jacques Chirac, gave this bag to a famous Englishwoman. Lady Diana fell in love with the Dior bag, ordered it in many different colors, and was rarely seen in public without one. In November 1995, the fashion house renamed the Chouchou the Lady Dior in Diana's honor. It is said that the surface design of the original bag, which resembles woven rattan, is an homage to Christian Dior himself, who had his guests sit on Napoleon III-style rattan chairs at his very first fashion show in 1947.

Die Lady Dior ist in unseren Köpfen die Tasche der Ladys – wie auch schon ihr Name sagt. Dabei ist sie die jüngste unter den Ikonen: Christian Dior lebte schon lange nicht mehr, als das Modehaus den Klassiker 1994 lancierte und ihm den Spitznamen *Chouchou* gab. Dann kam es zu einer folgenreichen Begegnung, zu deren Anlass die französische Präsidentengattin Bernadette Chirac das Modell einer berühmten Engländerin schenkte. Lady Diana verliebte sich in die Dior-Tasche, orderte sie daraufhin in unzähligen Farben und zeigte sich fortan fast nur noch mit ihr. Das Modehaus benannte Chouchou, das Schätzchen, zu Ehren Dianas im November 1995 in Lady Dior um. Man sagt übrigens, die Oberflächengestaltung des Originalentwurfs, die an geflochtenes Rattan erinnert, sei eine Hommage an Christian Dior selbst, der die Zuschauer seiner allerersten Modenschau 1947 auf Rattanstühlen im Stile Napoleon III. Platz nehmen ließ.

À l'instar de son nom, le sac Lady Dior est, dans nos esprits, le sac des ladies. Il est le premier du genre parmi les icônes : Christian Dior n'était plus en vie depuis longtemps lorsque la maison de couture lança le classique en 1994 et lui donna le surnom de *Chouchou*. Il s'en suivit une rencontre aux conséquences imprévisiblement fécondes, au cours de laquelle Bernadette Chirac offrit ce modèle à une Anglaise célèbre, Lady Diana, qui en tomba amoureuse et qui le commanda par la suite dans d'innombrables coloris pour ne se montrer pratiquement qu'avec lui. La maison de couture rebaptisa en novembre 1995 Chouchou, le petit trésor, en Lady Dior, en hommage à Diana. Du reste, on dit que la conception de la surface du modèle original, qui n'était pas sans rappeler du rotin tressé, était un hommage à Christian Dior lui-même, qui fit asseoir les spectateurs lors de son tout premier défilé en 1947 sur des chaises en rotin de style Napoléon III.

Morning, afternoon, evening: after Princess Diana had been given the Dior model,
she could no longer be parted from it. She soon had the bag in countless colors and variants—the fashion house
renamed the design then known as Chouchou in her honor, thus bringing about the Lady Dior.

Morgens, mittags, abends: Nachdem Prinzessin Diana das Dior-Modell geschenkt bekommen hatte,
konnte sie sich nicht mehr davon trennen. Sie besaß die Tasche schon bald in unzähligen Farben
und Varianten – das Modehaus benannte den Entwurf Chouchou ihr zu Ehren deshalb schnell in Lady Dior um.

Matin, midi et soir : Lady Diana, après qu'elle eut reçu en cadeau le modèle Dior, ne se séparera plus de lui.
Elle possédait déjà peu de temps après ce sac dans divers coloris et différentes variations. C'est la raison pour laquelle la
maison de couture rebaptisa rapidement la création Chouchou en Lady Dior, en son honneur.

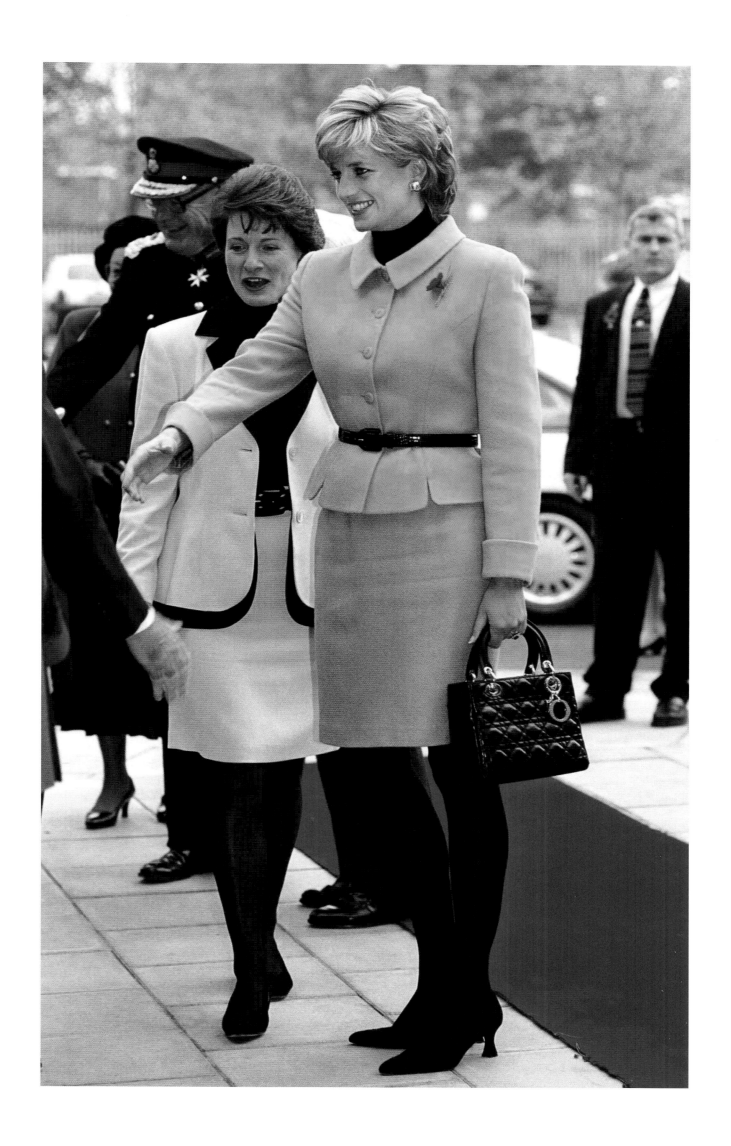

NAME: LADY DIOR
CREATED IN: 1994
NAMED FOR: LADY DIANA

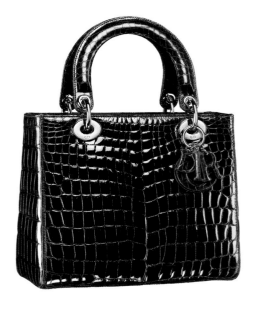 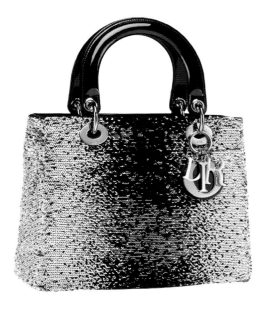

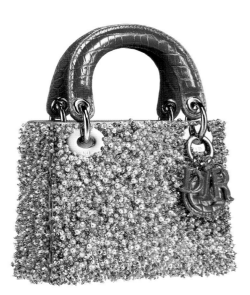 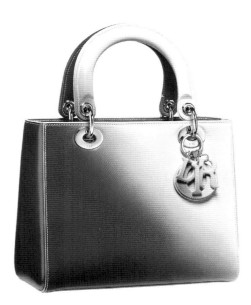

Embroidered, braided, in the ombré look: under Dior's new chief designer Raf Simons, Lady Dior shows its
modern face. And suddenly it is seen on the street (almost) as often as during its heyday when Lady Diana carried it.

Bestickt, geflochten, im Ombré-Look: Unter dem neuen Dior-Chefdesigner Raf Simons zeigt die Lady Dior ihr modernes Gesicht.
Und plötzlich wird sie auf der Straße wieder (fast) genauso oft abgelichtet wie zu ihren Hochzeiten – als Lady Diana sie trug.

Brodé, tressé, au look ombré. Sous le fétiche du nouveau chef designer de Dior, Raf Simons,
le Lady Dior montre son nouveau visage moderne. Et soudain, il apparaît dans la rue avec une fréquence quasiment
comparable à celle de son apogée, lorsque Lady Diana le portait.

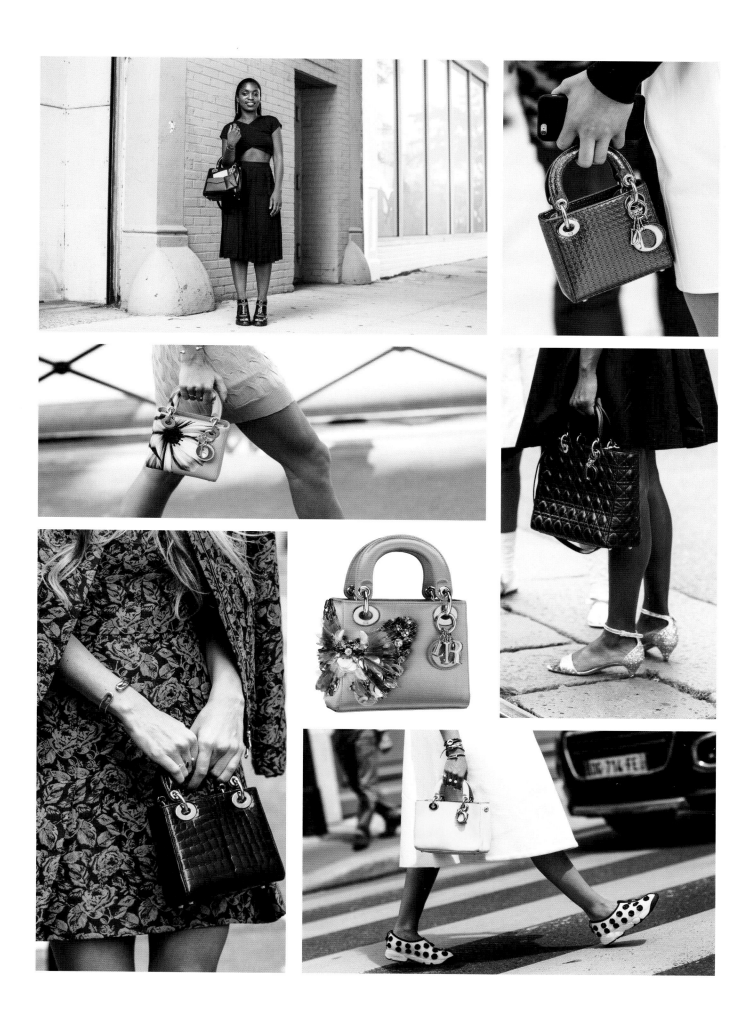

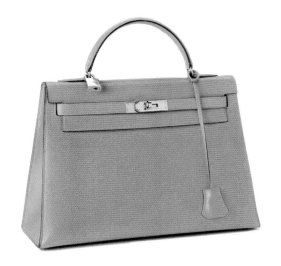

THE STORY OF
THE KELLY

What started as *petit sac pour dame* (small bag for ladies) later became the famous Kelly bag. Hermès had already developed this elegant model in the '30s, but it wasn't until a photograph of Grace Kelly carrying the *petit sac* soon after her marriage to Prince Rainer III of Monaco appeared in *Life* magazine that it became known worldwide. It is said that the princess was using the bag to hide the beginnings of a baby bump from the press. The fact is that it was the famous actress' favorite bag and she rarely carried any other. To this day, the bag is adored around the world, and Hermès receives so many requests for it that current production hardly meets demand. With the permission of the princess, the official renaming of the bag did not occur until many years after the *Life* magazine photo appeared.

Aus dem *petit sac pour dame* (z.dt. kleine Tasche für die Dame), wurde erst viel später die heute berühmte Kelly Bag. Bereits in den 1930er-Jahren hatte Hermès das elegante Modell vorgestellt. Aber erst als Grace Kelly 1956 kurz nach ihrer Hochzeit mit Fürst Rainier III. von Monaco im *Life* Magazin mit dem *petit sac* abgebildet wurde, erlangte sie weltweite Berühmtheit. Es heißt, die Fürstin habe damals mithilfe der Tasche erste Anzeichen ihrer Schwangerschaft kaschieren wollen. Fakt ist, dass sie zur Lieblingstasche der Schauspielerin wurde, die von da an nur noch selten eine andere trug. Noch heute ist die Tasche so beliebt und die Nachfrage so hoch, dass die Produktion den großen Bedarf kaum decken kann. Die offizielle Umbenennung der Tasche erfolgte übrigens erst viele Jahre nach Erscheinen des *Life* Magazins mit der Genehmigung der Fürstin.

Le *petit sac pour dame* fut baptisé sac Kelly bien après sa création. Déjà dans les années 1930, Hermès avait présenté cet élégant modèle. Mais ce n'est qu'à la suite d'une apparition de Grace Kelly peu de temps après son mariage avec le Prince Rainier III de Monaco dans le magazine *Life* en compagnie du *petit sac*, que le Kelly accéda à sa notoriété internationale. Il est relaté que la princesse cherchait à dissimuler les prémisses de sa grossesse au moyen de ce sac. C'est un fait avéré qu'à partir de ce moment-là, l'actrice célèbre en fit son sac de prédilection et ne porta que très rarement d'autres sacs. Encore aujourd'hui, le sac Kelly est adoré dans le monde entier et Hermès reçoit tellement de demandes que la production actuelle ne peut presque pas les accomplir. Le nouveau nom fut officialisé de très nombreuses années après la parution du magazine *Life*, avec l'approbation de la princesse.

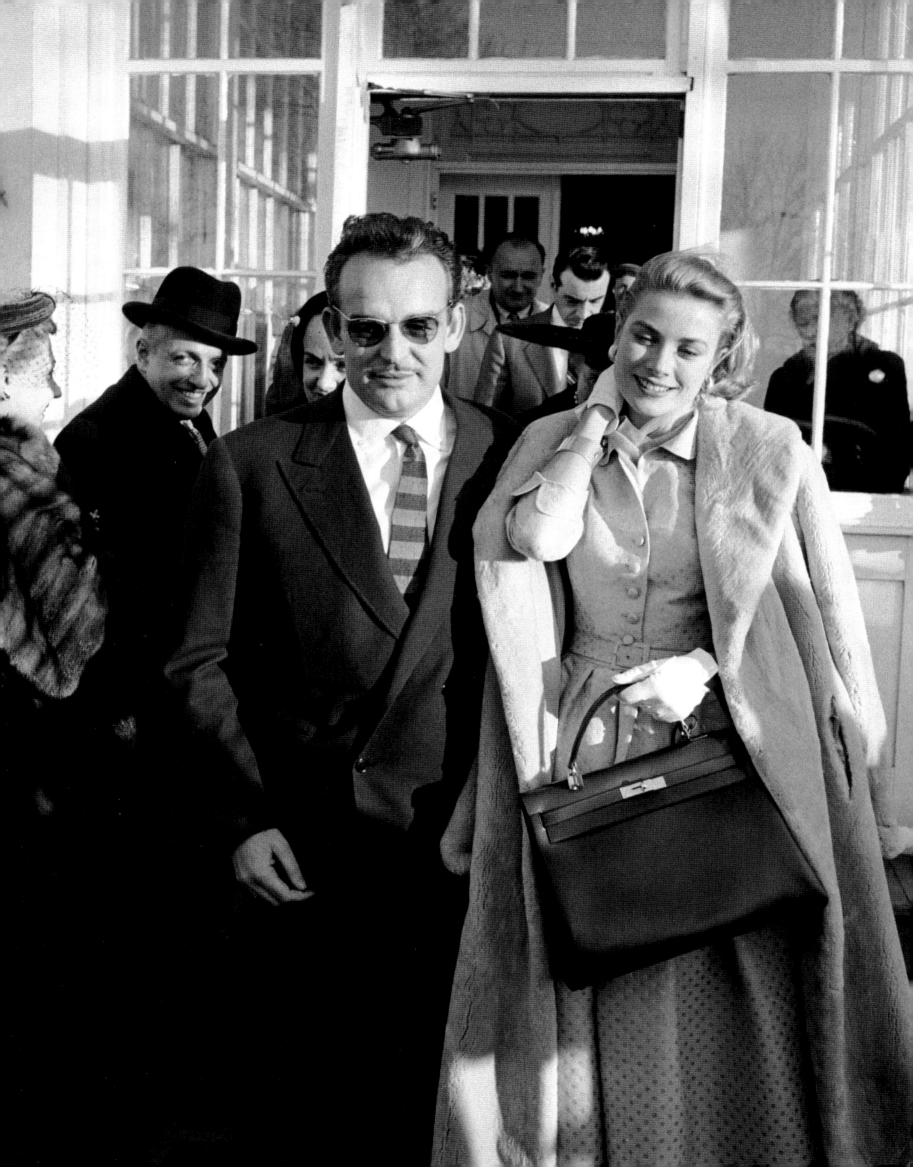

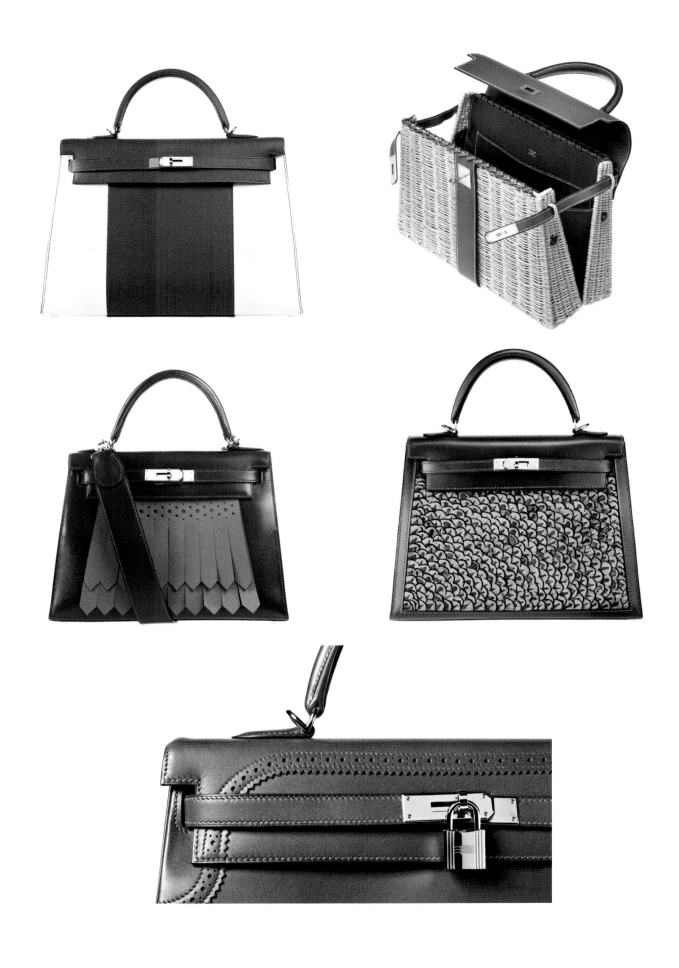

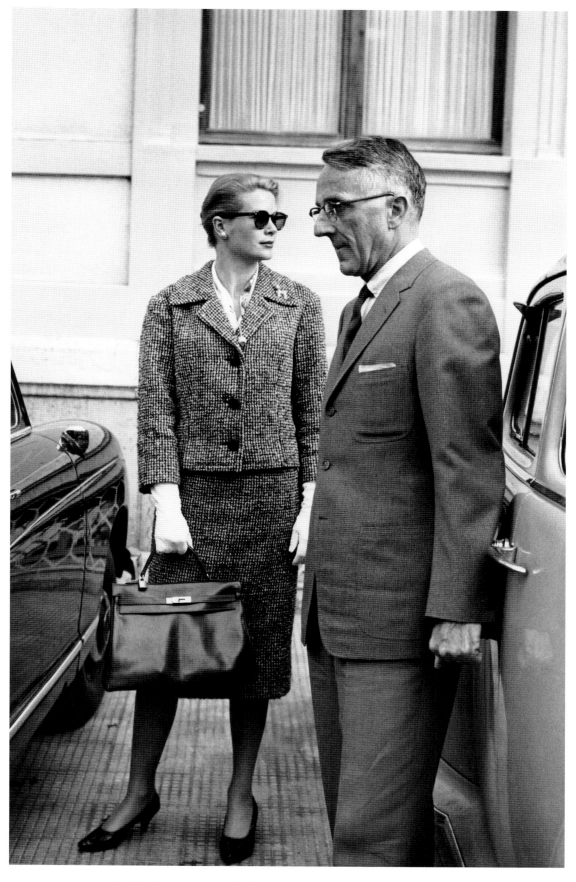

NAME: KELLY BAG | CREATED IN: 1935 | NAMED FOR: GRACE KELLY

YOU CAN NEVER HAVE TOO MANY KELLY BAGS

INTERVIEW
WITH MIROSLAVA DUMA

Miroslava Duma is one of the most influential fashion bloggers around, with over half a million followers on Instagram. Her online magazine *Buro 24/7* is one of the top web addresses in terms of fashion, lifestyle, and culture—not only in her native Russia, but also in international fashion circles.

The businesswoman is also a fashion consultant and Digital Media Director for the Russian luxury store TsUM, a freelance fashion journalist, and a street-style icon. Quite often in her hand: a Hermès Kelly bag. It's high time to ask Miroslava about her collection.

Miroslava Duma gehört zu den einflussreichsten Mode-Bloggerinnen. Bei Instagram hat sie über eine halbe Million Follower. Ihr Online-Magazin *Buro 24/7* ist eine der ersten Webadressen in Sachen Mode, Lifestyle und Kultur – nicht nur in ihrer Heimat Russland, sondern auch in internationalen Modekreisen.

Die Businessfrau ist außerdem Fashion Consultant und Digital Media Director für den russischen Luxus-Store TsUM, arbeitet als freie Modejournalistin – und ist Streetstyle-Ikone. Ziemlich oft dabei: eine Hermès Kelly Bag. Höchste Zeit, Miroslava nach ihrer Sammlung zu fragen.

Miroslava Duma compte parmi les blogueuses les plus influentes. Elle est suivie sur Instagram par plus d'un demi-million de followers. Son magazine online *Buro 24/7* est l'une des premières adresses du web en matière de mode, style de vie et culture, pas seulement dans sa patrie, la Russie, mais également dans les cercles de mode internationaux.

La femme d'affaires est, de plus, consultante en mode et directrice de la communication digitale de TsUM, le grand magasin de luxe russe. Elle travaille en tant que journaliste de mode freelance et comme icône de style de rue. Assez souvent avec elle: un sac Kelly d'Hermès. Il est grand temps d'interroger Miroslava au sujet de sa collection.

Dear Miroslava Duma, can you remember your very first Kelly bag? (Did you buy it on your own or was it a gift? Which size was it and which color? Do you still wear it?)

It was a gift from my mother, a vintage mini Kelly bag. Most special is the first one I received from my mother, a mini black Kelly I was looking at when my mom was wearing it and dreaming for it to become mine one day. It's very special because it came from my mother, who is the most important person in my life.

What do you love about Kelly bags? What makes them so special for you?

The Kelly bag is made by one individual craftsman in about 18 hours of work. It is a very big and laborious job that deserves special attention and respect.

From all bag icons, the Kelly bag is one of the most all-time and everyday wearable bags. Would you agree?

Absolutely!

Do you sometimes think you have enough of Kelly Bags?

You can never have too many of them.

Liebe Miroslava Duma, können Sie sich noch an Ihre erste Kelly Bag erinnern? (Haben Sie sie selbst gekauft oder war sie ein Geschenk? Welche Größe und Farbe hatte sie? Tragen Sie sie noch immer?)

Sie war ein Geschenk meiner Mutter, eine schwarze Mini Kelly Bag. Sie ist mir ausgesprochen wichtig, da ich sie von meiner Mutter bekommen habe. Immer wenn meine Mutter sie trug, habe ich sie bewundert und ich träumte davon, dass sie eines Tages mir gehören würde. Meine Mutter ist die wichtigste Person in meinem Leben, das macht dieses Geschenk umso besonderer.

Was lieben Sie an der Kelly Bag? Was ist für Sie herausragend an dem Modell?

Die Kelly Bag wird von einem einzigen Täschner in etwa 18 Arbeitsstunden gefertigt. Es ist ein schwerer und arbeitsaufwendiger Job, der besondere Aufmerksamkeit und Respekt verdient.

Von allen ikonischen Taschen ist die Kelly Bag eine der tragbarsten Taschen für jeden Tag. Würden Sie zustimmen?

Absolut!

Denken Sie manchmal Sie haben genug Kelly Bags?

Man kann niemals genug haben.

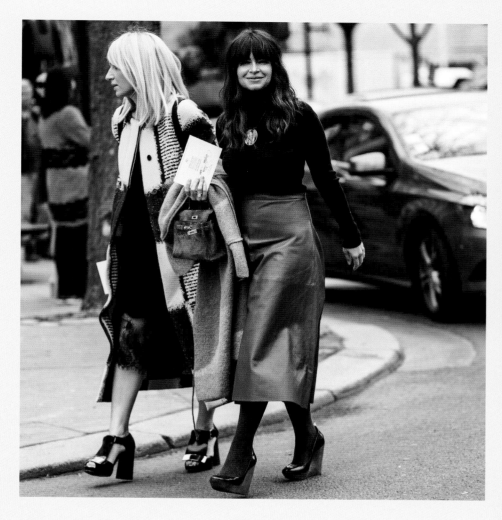

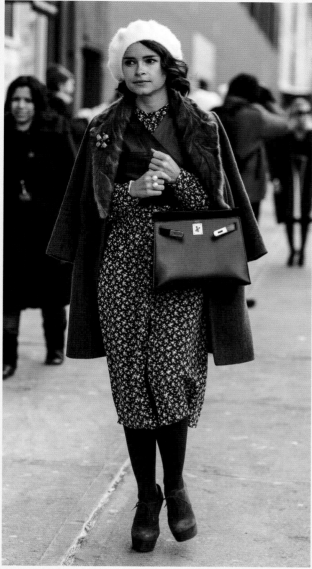

Chère Miroslava Duma, pouvez-vous vous souvenir de votre tout premier sac Kelly ? (L'avez vous acheté vous-même ou vous a-t-il été offert ? Quelle taille et quelle couleur avait-il ? Continuez-vous de le porter ?)

C'était un cadeau de la part de ma mère, un mini sac Kelly vintage. Le plus spécial m'a été offert par ma mère : il s'agit du mini Kelly noir, que je voyais ma mère porter et dont je rêvais qu'un jour il m'appartiendrait. Et il est vraiment spécial car il me vient de ma mère qui est la personne la plus importante dans ma vie.

Qu'aimez-vous chez les sacs Kelly ? Qu'est-ce qui les rend si spéciaux à vos yeux ?

Le sac Kelly est réalisé par un seul et unique artisan et nécessite 18 heures de travail. C'est un très long travail qui requiert beaucoup d'application, une attention spéciale et beaucoup de respect.

Parmi tous les sacs icônes, le sac Kelly est-il celui qui se porte le plus facilement à n'importe quelle occasion et tous les jours ?

Absolument !

Vous arrive-t-il de penser que vous possédez trop de Kelly ?

On n'en a jamais assez.

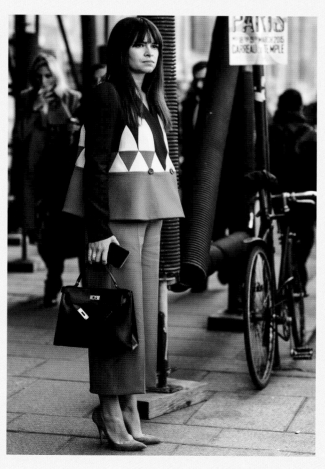

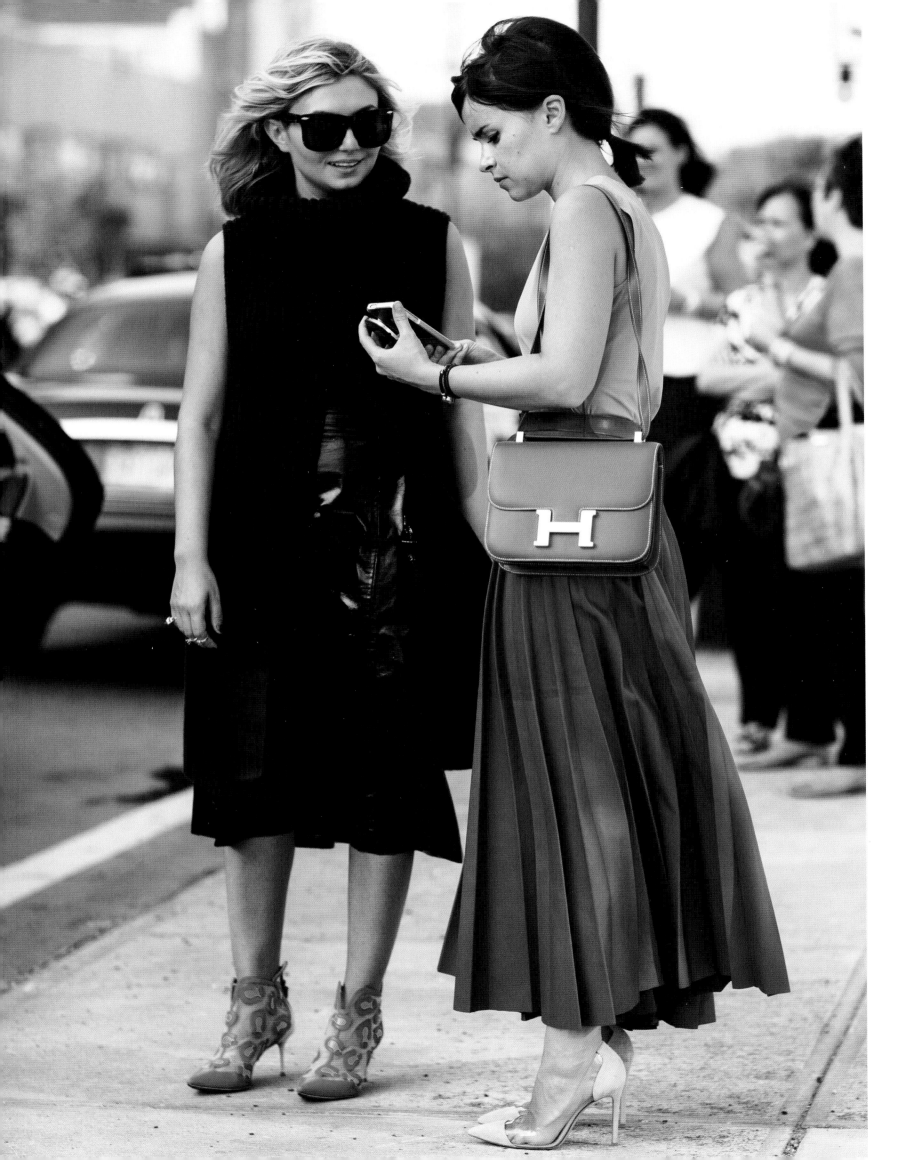

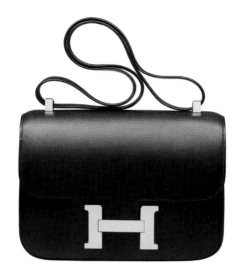

THE STORY OF THE CONSTANCE

The Constance is an equally fashionable and elegant Hermès bag. Again, it was named after a particular lady who scored this coup by virtue of the date of her birth, never suspecting that it would create an inextricable link between her and this legendary bag. Designer Catherine Chaillet named her design in the '60s after her daughter, who was born that same year. Today, Constance Chaillet is a renowned journalist and writer. The Constance bag is a small work of art. It takes 14 hours of work by a single craftsman to create the rigid bag with the prominent H closure. Why such fascination? It may be the Constance's simple, sleek lines or its chameleon-like adjustable carry strap, which made it ideal worn over the shoulder in the '70s and allowed it to morph into an under-the-arm bag in the '90s. But perfect bags cannot be explained rationally.

Die Constance ist eine ebenso modische wie elegante Hermès Tasche. Auch sie wurde nach einer bestimmten Frau benannt, der dieser Coup mit dem Tag ihrer Geburt gelang; ohne ahnen zu können, dass auf diese Weise eine legendäre Tasche untrennbar mit ihr verbunden sein würde. Die Designerin Catherine Chaillet gab ihrem Entwurf in den 1960er-Jahren den Namen ihrer Tochter, die im selben Jahr geboren wurde. Constance Chaillet ist heute renommierte Journalistin und Schriftstellerin. Die Constance ist ein kleines Kunstwerk: 14 Stunden Arbeit eines einzigen Ledermachers stecken in der rigide geformten Tasche mit dem prominenten H-Verschluss. Wahrscheinlich liegt die Faszination in der Schlichtheit ihrer Form. Und in ihrem einzigartigen Chamäleon-Talent – der Trageriemen lässt sich auf verschiedene Längen einstellen und passte an der Schulter getragen so perfekt in die 1970er-Jahre wie unter den Arm in den 1990er-Jahren. Aber perfekte Taschen lassen sich nicht erklären.

Le Constance est un sac de la maison Hermès également à la mode et élégant. Lui aussi doit son nom à une femme particulière, qui réussit ce coup magistral le jour de sa naissance, sans pouvoir supposer qu'un sac légendaire serait de cette manière inséparablement lié à sa personne. Dans les années 1960, la créatrice Catherine Chaillet attribua à sa création le nom de sa propre fille. Constance Chaillet est aujourd'hui une journaliste et écrivain de renom. Le Constance est une petite œuvre d'art : ce sac à la forme rigide et au fermoir en forme du célèbre H est le fruit de 14 heures de travail d'un seul et unique maroquinier. La fascination exercée par ce sac réside certainement dans la sobriété de sa forme. Et dans son talent unique de caméléon – la bandoulière se laisse régler selon différentes longueurs; il présentait autant d'allure lorsqu'il était porté sur l'épaule dans les années 1970 que lorsqu'il était porté sous le bras dans les années 1990. Mais la perfection d'un sac ne s'explique pas.

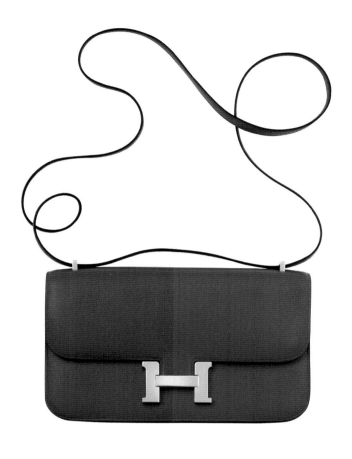

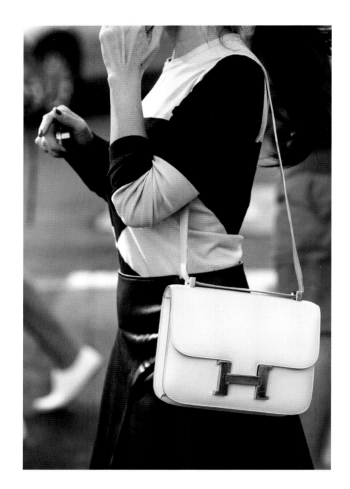

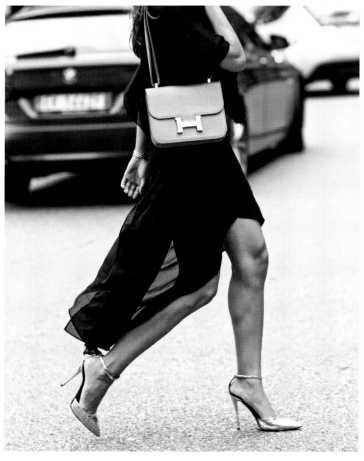

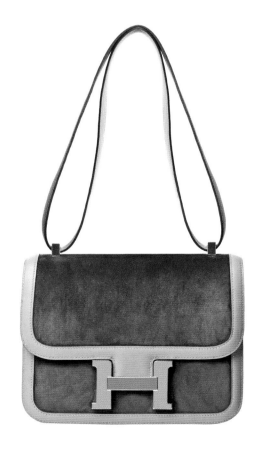

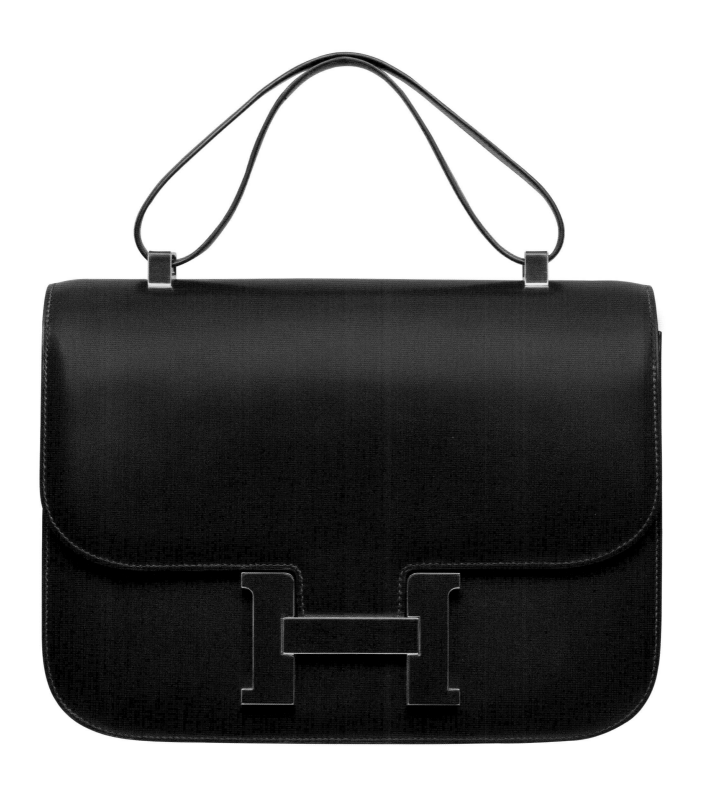

No matter what size, regardless of color: the Constance accompanies with grace and style.

Egal in welcher Größe oder Farbe: die Constance begleitet ihr Trägerin mit Grazie und Stil.

Quelle que soit sa taille ou sa couleur: le Constance accompagne sa porteuse toujours avec grâce et style.

IT BAGS

—

What mink coats were to women in the '50s, the right purse was to women in the '90s and beyond. Every era of fashion has its holy grail. From the very first It Bag, the Fendi Baguette, to the Trapèze by Céline, all It Bags are thrillingly new, and life seems pointless without them (until a new object of desire shows up the following season). Buying a practical purse is like an arranged marriage—snagging an It Bag is a passionate affair. It's even better if you can't get the bag right away. No waiting list? No It Bag. Exclusivity continues to be the most important feature of an It Bag, even when it is now more often than not artificially produced. The rise of the It Bag in the mid-'90s ushered in a new paradigm in the luxury goods industry. Fashion houses suddenly made more money from accessories than they did from clothing, allowing small fashion houses to become giant luxury conglomerates whose names are now as well known as Coca-Cola. And this is what made it possible for millions of women around the globe to enter into the inner circle of the fashion world that had previously been barred to all but a happy few.

Was in den 1950er-Jahren für jede Frau die Nerzjacke war, ist seit den 1990er-Jahren die richtige Tasche. Jede Mode-Ära hat ihren eigenen heiligen Gral. Von der allerersten It-Bag, der Fendi Baguette, bis zur Trapèze von Céline: alle It-Bags sind aufregend neu, und ein Leben ohne sie erscheint sinnlos (bis es in der nächsten Saison ein neues Objekt der Begierde gibt). Der Kauf einer praktischen Tasche ist eine Zweckheirat. Das Ergattern einer It-Bag ein Liebesrausch. Noch besser, wenn man etwas nicht sofort haben kann – keine Warteliste, keine It-Bag. Exklusivität ist bis heute das wichtigste Merkmal einer solchen Tasche, auch wenn sie mittlerweile sehr oft künstlich erzeugt wird. Der Aufstieg der It-Bags läutete Mitte der 1990er-Jahre einen Paradigmenwechsel in der Luxusindustrie ein. Modehäuser verdienten auf einmal mehr mit Accessoires als mit Kleidung. Nur so konnten aus kleinen Modehäusern riesige Luxuskonzerne werden, deren Namen heute so bekannt sind wie Coca-Cola. Und nur so eröffnete sich plötzlich für Millionen Frauen auf der Welt die Möglichkeit, in den bis dahin nur für die Happy Few geöffneten Zirkel der Modewelt einzutreten.

Le sac idéal est depuis les années 1990 ce qu'a été pour chaque femme le manteau de vison dans les années 1950. Chaque ère de mode possède son propre Saint Graal. Depuis le tout premier it-bag, la Baguette Fendi, jusqu'au Trapèze de Céline, tous les it-bags sont passionnément nouveaux et une existence sans eux devient absurde (jusqu'à l'apparition d'un nouvel objet du désir à la prochaine saison). L'achat d'un sac pratique est un mariage de raison, l'achat d'un it-bag une ivresse amoureuse. C'est encore mieux quand on ne peut pas l'avoir immédiatement. Pas de it-bag sans liste d'attente. L'exclusivité est jusqu'à ce jour la caractéristique essentielle d'un tel sac, même si elle est suscitée de manière artificielle. L'ascension du it-bag traduit un changement de paradigme dans l'industrie du luxe. Les maisons de couture gagnent désormais plus d'argent avec les accessoires qu'avec les vêtements. C'est essentiellement pour cette raison que de petites maisons de couture sont devenues de grands groupes du luxe, dont les noms sont aussi connus que Coca-Cola. Et c'est aussi par ce biais-là que s'offrit à des millions de femmes la possibilité de pénétrer dans le cercle du monde de la mode, ouvert jusqu'alors seulement à quelques heureuses élues.

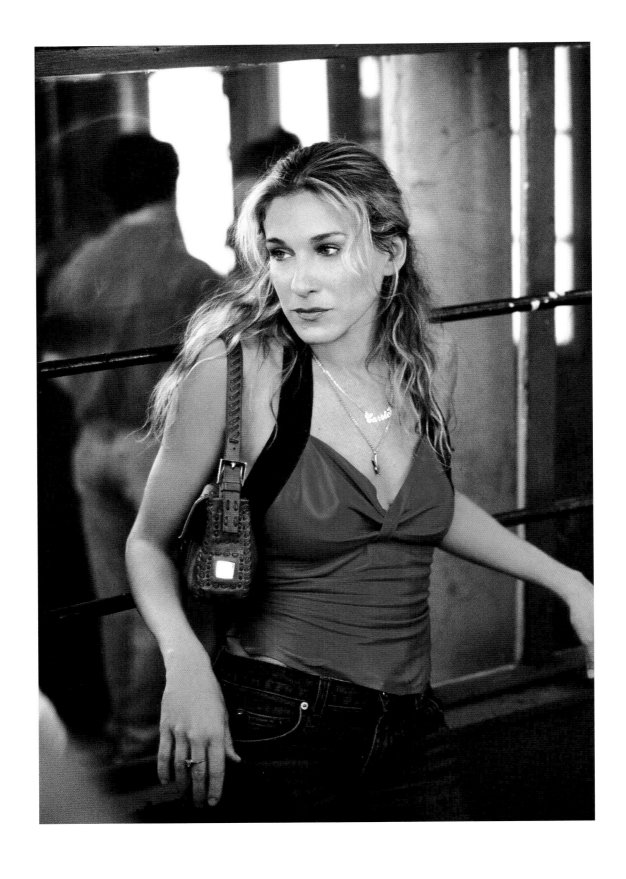

FENDI

Fendi—the luxury fashion house in Rome that had become famous for its beautiful furs—had to reinvent itself in the mid-'90s. And it was not head designer Karl Lagerfeld who pulled it off, but rather Silvia Venturini Fendi, daughter of the company's founder. She in turn was inspired by the work of artist Nathalie Hambro, who was producing handmade bags at the time—one-of-a-kind bags with haute hippie allure. So Venturini Fendi created the Baguette, a small, rectangular bag with a large double-F closure on the front and a strap so short that the bag would just fit under a woman's arm the way a stereotypical French person would carry a baguette. The shape remained the same from the beginning, but there were countless variations: you could get the bag in leather, in python skin, or with accents of crystal or feathers or Indian mirror designs. So it was a bag that everyone could wear without losing their individuality. The Baguette was an immediate success, but did not become a cult object until three years later, when Carrie Bradshaw sported a Baguette for the entire third season of *Sex and the City* for millions of viewers. Years later, Sarah Jessica Parker wrote about how much the Baguette ultimately influenced the series in the *Financial Times*. Initially, show stylist Patricia Field didn't have much money to outfit the series, and Fendi was the first luxury fashion house that agreed to provide clothing and accessories. This affected the entire arc of the series, especially Carrie's penchant for spending more on her wardrobe than on her apartment. What would have become of *Sex and the City* without the Fendi Baguette, which sparked many other brands to send their fashions as well? The ladies would not have looked nearly as fabulous as they did.

Fendi – das große römische Luxus-Modehaus, das mit den schönsten Pelzen berühmt geworden war – musste sich Mitte der 1990er-Jahre neu erfinden. Nicht Chefdesigner Karl Lagerfeld tat das. Sondern Silvia Venturini Fendi, Tochter der Firmengründer. Sie wiederum wurde durch Arbeiten der Künstlerin Nathalie Hambro inspiriert, die damals handgemachte Taschen produzierte – Unikate mit Haute Hippie-Allure. Venturini Fendi erfand: die Baguette. Eine schmale, rechteckige Tasche mit großem Doppel-F-Verschluss auf der Vorderseite und einem Riemen, so kurz, dass die Tasche gerade so unter den Arm einer Frau wie das Baguette unter den eines Klischee-Franzosen passt. Von Anfang an war die Form immer gleich, aber es gab die Baguette in unzähligen Varianten: in Leder, aus Python, mit Applikationen von Kristallen, Federn oder indischen Spiegelelementen. Eine Tasche also, die alle tragen konnten, ohne ihre Individualität zu verlieren. Die Baguette wurde sofort zum Erfolg, zum Kultobjekt allerdings erst drei Jahre später, als Carrie Bradshaw in der gesamten dritten Staffel von *Sex and the City* die Baguette einem Millionenpublikum zur Schau trug. Viele Jahre später hat Sarah Jessica Parker in der *Financial Times* darüber geschrieben, wie die Baguette die ganze Serie beeinflusst hat. Die Stylistin Patricia Field habe anfangs kein großes Budget gehabt, um die Serie auszustatten und Fendi sei das erste Modehaus gewesen, dass sich bereit erklärt habe, Mode zur Verfügung zu stellen. Das habe die ganze Handlung mitbestimmt – besonders Carries Hang dazu, mehr Geld für ihre Kleider auszugeben als für ihr Zuhause. Was wäre aus *Sex and the City* geworden ohne die Fendi Baguette, die unzählige andere Brands dazu animierte, Kleider zu schicken? Nun, die Damen hätten lange nicht so gut ausgesehen.

Fendi, la grande maison d'haute couture romaine, devenue célèbre grâce à ses somptueuses fourrures, dut se réinventer dans les années 1990. Ce ne fut pas Karl Lagerfeld qui le fit mais Silvia Venturini Fendi, la fille des fondateurs de l'entreprise. Cette dernière s'inspira à son tour du travail de l'artiste Nathalie Hambro, qui produisait à l'époque des sacs réalisés à la main, des modèles uniques à l'allure haute hippie. Venturini Fendi inventa la Baguette. Un sac rectangulaire, étroit, doté d'un grand fermoir double F sur le devant et d'une bandoulière si courte que le sac allait juste sous le bras d'une femme, tout comme une baguette de pain sous le bras d'un Français tout droit sorti d'un cliché. La forme des débuts n'a pas été modifiée, mais il existe une multitude de variantes de la Baguette : en cuir, en python, avec des applications de cristal, de plumes ou des éléments miroitants indiens. Donc un sac que tout un chacun pouvait porter, sans perdre son individualité. La Baguette fut immédiatement couronnée de succès mais ce n'est que trois ans après sa création qu'elle accéda au titre d'objet culte, lorsque Carrie Bradshaw l'arbora pendant l'ensemble de la troisième saison de *Sex and the City*. De nombreuses années plus tard, Sarah Jessica Parker avait écrit dans le *Financial Times* à quel point la Baguette avait influencé la série. La styliste Patricia Field n'avait pas disposé au début d'un grand budget pour « habiller » la série et Fendi fut la première maison d'haute couture à se déclarer prête à mettre à disposition des articles de mode. Cela avait exercé une influence sur la trame de la série, en particulier cette propension de Carrie à dépenser plus d'argent pour ses vêtements que pour son appartement. Quel destin aurait connu la série sans la Baguette Fendi qui incita de nombreuses marques à envoyer leurs vêtements ? Eh bien, les dames n'auraient jamais été aussi élégantes.

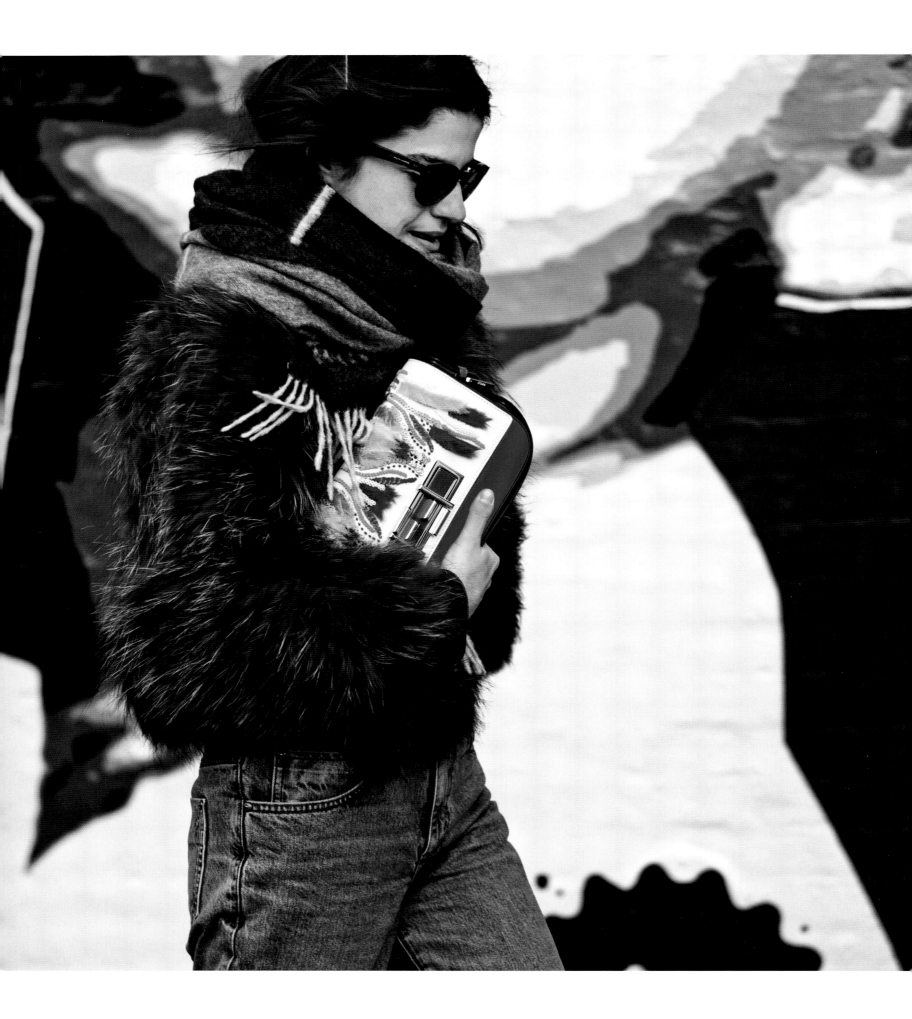

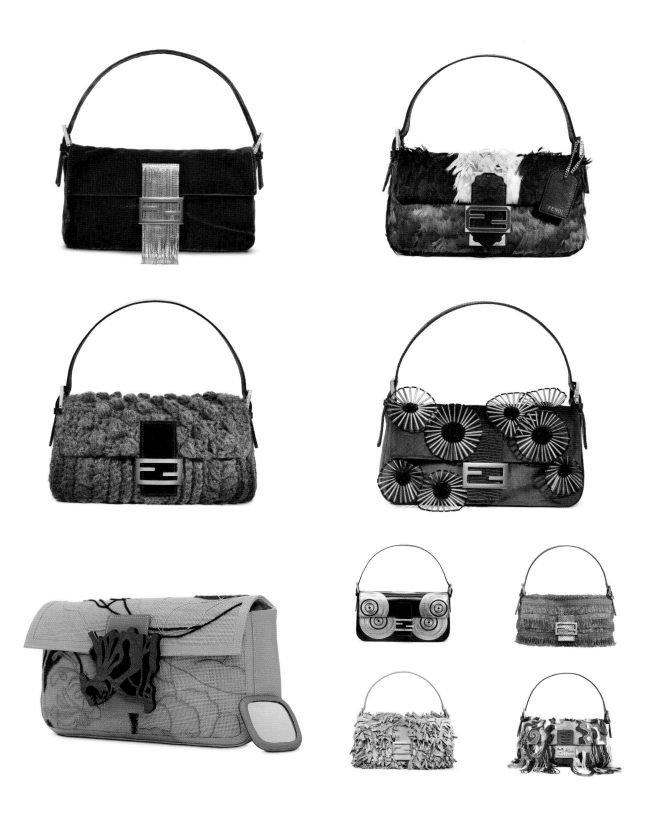

Fendi's double-F logo stands for Fun Fur, because the Roman label became famous with its furs.

Das Doppel-F-Logo von Fendi steht für Fun Fur, denn das römische Label wurde mit Pelzen berühmt.

Le logo en forme de double F de Fendi suggère la griffe Fun Fur, car la marque romaine a été rendue célèbre par ses fourrures.

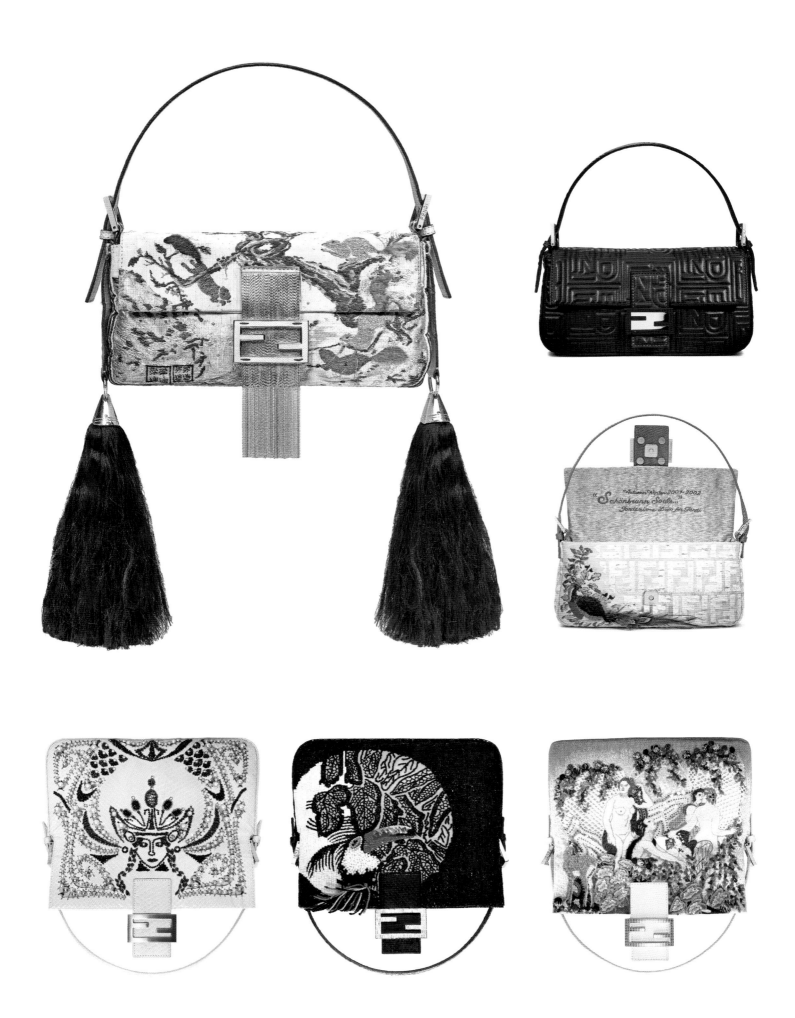

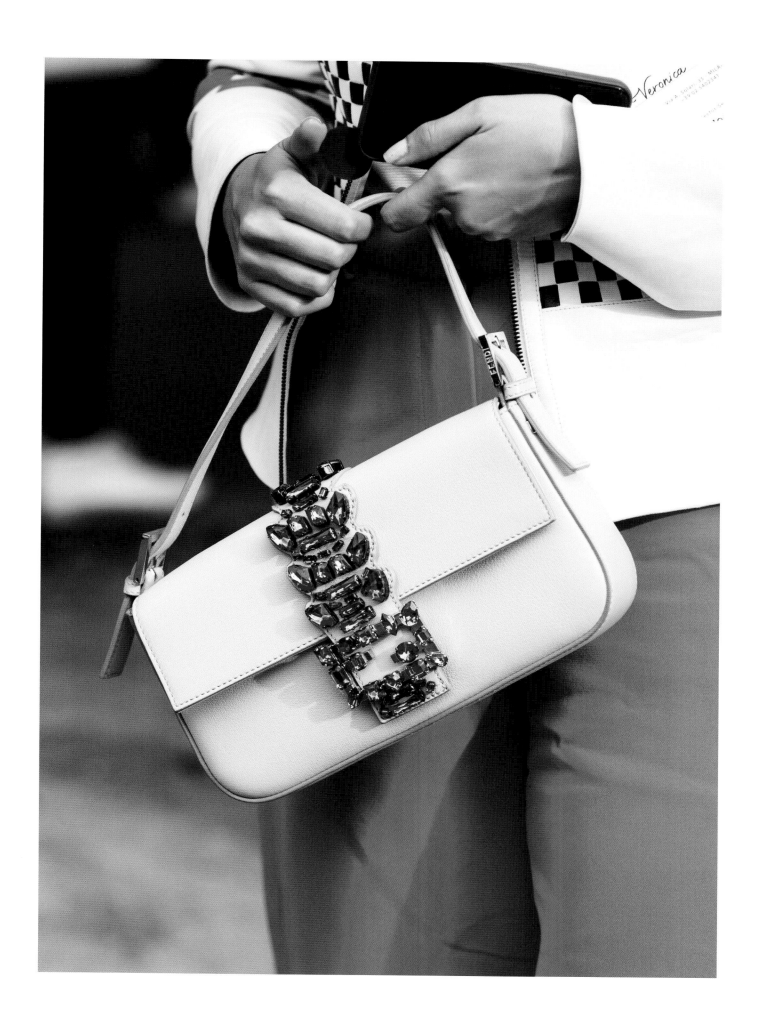

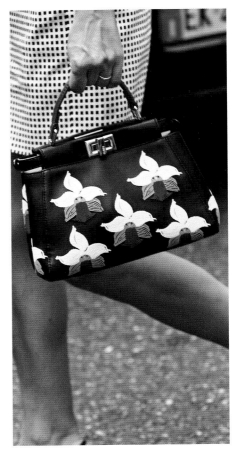

The bag designs by Silvia Venturini Fendi with such cheerful names as By The Way and Peekaboo, however, are just as fun.

Die Taschenentwürfe von Silvia Venturini Fendi mit so lustigen Namen wie
By The Way oder Peekaboo bringen allerdings mindestens genauso viel Fun.

Les créations de sacs de Silvia Venuturini Fendi qui portent des noms si drôles comme
By the Way ou Peekaboo sont, du reste, au moins aussi fun que les noms choisis.

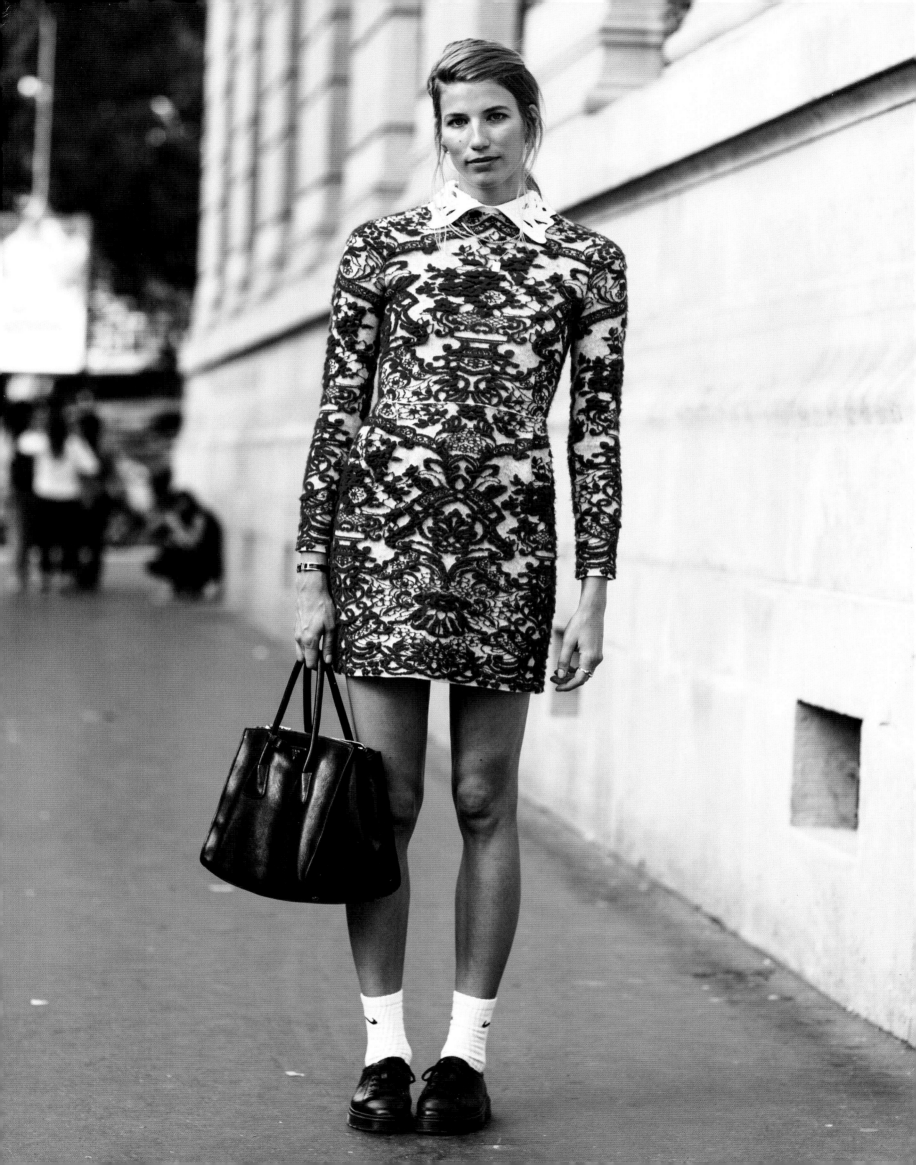

PRADA

You'd be hard pressed to name a label that has sold as many bags as Prada. After all, Miuccia Prada is considered the woman who made purses a must-have accessory in the first place. In the '80s, she started a small revolution in her parents' leather goods company by launching a luggage line of ultralight nylon with Prada's hallmark: an embroidered triangle with the Prada logo. The backpack from this collection became an essential item for the fashion intelligentsia. A ready-to-wear line and a handbag collection followed that made the It-Bag hype possible: women just wanted a Prada bag, any Prada bag. The label itself, rather than a specific model, was "it." But if there is a particular bag that symbolizes women's passion for Prada, it is the Bowling bag. The shape is reminiscent of traditional bowling ball bags seen in movies like *The Big Lebowski*, only with perforated leather instead of mesh netting and quirky color options. Few bags have been copied as often as this one, and no other bag so beautifully summarizes the style that made Prada famous: something a little offbeat is the ultimate in chic.

Wohl kaum ein Label hat so viele Taschen verkauft wie Prada – Miuccia Prada gilt schließlich als die Frau, die die Designertasche als unverzichtbares Accessoire überhaupt erst erfunden hat. In den 1980er-Jahren sorgte sie für eine kleine Revolution im Lederwarenunternehmen ihrer Eltern, lancierte Reisegepäck aus superleichtem Nylon mit dem unverkennbaren Markenzeichen, einem aufgestickten Dreieck inklusive Prada-Logo. Der Rucksack aus dieser Kollektion wurde zum Must-have der Fashion-Intelligentsia. Es folgte Ready-to-wear und eine Handtaschen-Linie, die den It-Bag-Hype überhaupt erst möglich machte: Frauen wollten eine Prada-Tasche, ganz egal welche. Das Label an sich, nicht ein bestimmtes Modell, war: „It". Aber wenn man sich auf eine festlegen will, die die Prada-Leidenschaft symbolisiert, dann ist das die Bowling Bag. Die Form erinnert an eine klassische Transporttasche für Bowlingkugeln, wie man sie zum Beispiel schon in *The Big Lebowski* gesehen hat. Aber natürlich mit perforiertem Leder statt Mesh-Einsätzen und in besonderen Farbstellungen. Kaum eine Tasche ist so oft kopiert worden wie diese, und keine bringt den Stil, der Prada berühmt gemacht hat, so auf den Punkt: Das ein wenig Sonderbare ist der ultimative Chic.

Pratiquement aucune marque n'a vendu autant de sacs que Prada. Après tout, Miuccia Prada est considérée comme la femme qui a absolument fait du sac de designer l'indispensable accessoire. Dans les années 1980, elle fut à l'origine d'une petite révolution au sein de l'entreprise de maroquinerie de ses parents en créant un bagage en nylon ultraléger, doté de son insigne emblématique, reconnaissable entre tous, le triangle brodé, incluant le logo Prada. Le sac à dos de cette collection devint un must de l'intelligentsia de la mode. S'en suivit Ready-to-wear et une ligne de sacs à main, qui rendit vraiment possible l'engouement pour le it-bag : les femmes voulaient un sac Prada, n'importe lequel. La marque était « it » et non un modèle particulier. Mais si l'on souhaite se focaliser sur un modèle qui symbolise la passion Prada, eh bien il faut faire référence alors au sac Bowling. Sa forme évoque un bagage classique destiné au transport des boules de bowling comme on a pu en voir, par exemple, dans le film *The Big Lebowski*. Mais naturellement avec du cuir perforé à la place des empiècements en maille et dans des teintes décalées. Aucun sac ou presque n'a été aussi souvent copié que celui-ci et aucun n'illustre aussi parfaitement le style qui a fait la célébrité de Prada : une touche d'étrangeté au service du chic ultime.

The run on Prada bags began with the legendary Bowling bag (see previous page).
After that, Miuccia Prada has repeatedly put the cat amongst the pigeons, for example with creations in the form of a doctor's bag.

Der Run auf Prada-Taschen begann mit der legendären Bowling Bag (siehe vorige Seite).
Danach sorgte Miuccia Prada immer wieder für Aufregung, zum Beispiel mit Modellen in Form einer Doktortasche.

L'engouement frénétique pour les sacs Prada commença avec le légendaire sac Bowling (voir page précédente).
Par la suite, Miuccia Prada provoqua sans cesse de l'émoi, avec par exemple, des sacs en forme de sacoches de médecin.

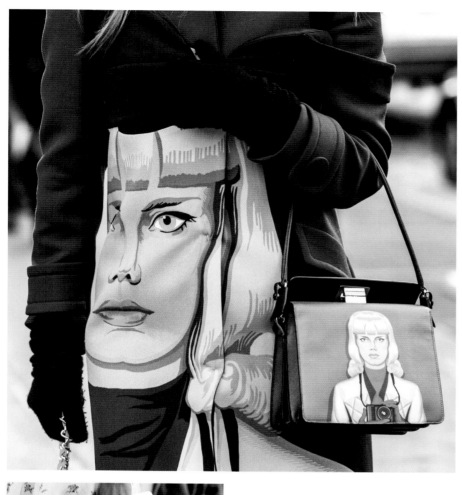

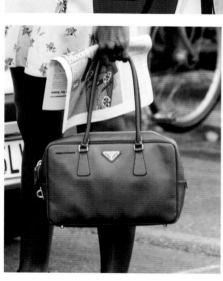

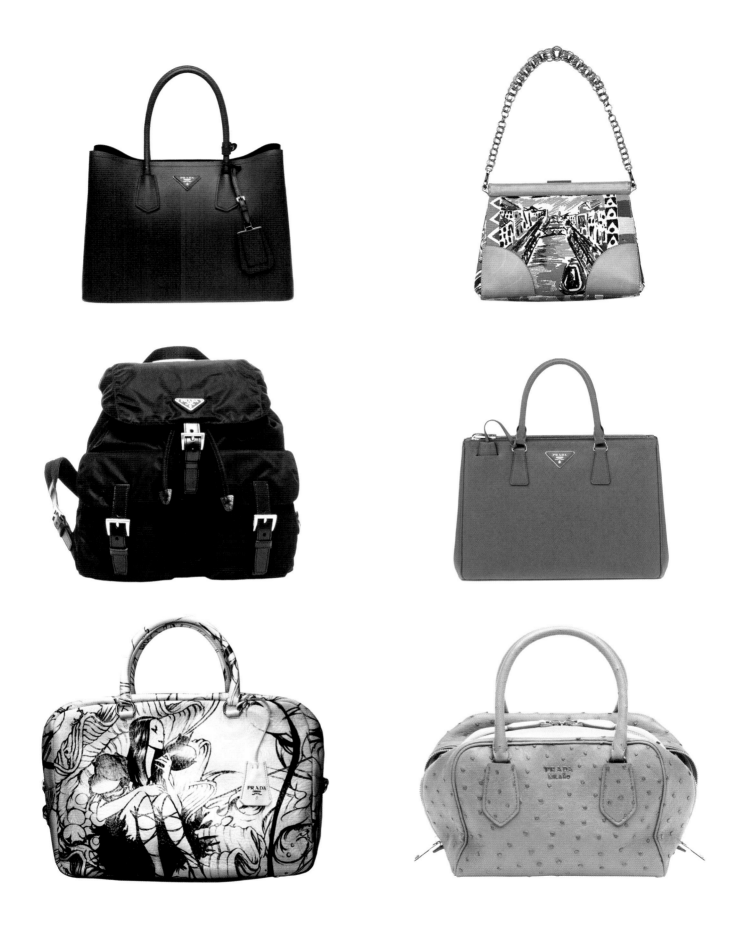

The backpack was Prada's first object of desire. Shopper bags in bright colors are perfect everyday companions as are bags with art prints that have value for collectors.

Der Rucksack war das erste Prada-Objekt der Begierde. Shopper in leuchtenden Farben sind perfekte Everyday-Begleiter.
Und Taschen mit Art-Prints Stücke mit Sammlerwert.

Le sac à dos a été le premier objet du désir de Prada. Les shoppers aux couleurs étincelantes sont les parfaits compagnons du quotidien.
Et les sacs aux impressions artistiques sont des pièces précieuses, à sans doute collectionner.

CHLOÉ

Very few labels can sell out of a product before it even hits the stores, but Chloé managed it with the Paddington bag in 2005. This slightly wider variation of a doctor's bag with relatively long handles comes with a genuine padlock together with key (hence its weight of 3 lbs). At least 8,000 units were sold, which is why for many fashion experts, this bag originated the hype around It Bags at the time. With Marcie, a classic handbag whose design is based on a saddlebag, Chloé was better prepared for the onslaught. When the product was launched, the number of units was already in the five figures—and Marcie is constantly being produced afresh, in new, special colors each season. It nonetheless still sells through online shops faster than almost any other bag.

Nur die wenigsten Labels schaffen den Ausverkauf eines Produkts noch bevor es überhaupt in die Läden kommt. Chloé ist es mit der Paddington Bag 2005 gelungen. Die etwas breitere Variante einer Doktortasche mit verhältnismäßig langen Henkeln ist mit einem echten Vorhängeschloss samt Schlüssel versehen (daher hat sie auch ein Eigengewicht von knapp 1,5 Kilogramm). Die Auflage betrug immerhin 8 000 Stück, weshalb das Modell für viele Mode-Experten den Hype um It-Bags in dieser Zeit begründete. Bei der Marcie, einer klassischen Handtasche, deren Design an eine Satteltasche angelehnt ist, war Chloé bereits besser auf den Ansturm vorbereitet. Von ihr gab es bei Produkteinführung schon eine Stückzahl im fünfstelligen Bereich – und sie wird stetig nachproduziert, jede Saison in neuen, besonderen Farben. Sie verkaufen sich in den Onlineshops trotzdem so schnell aus, wie kaum eine andere Tasche.

Peu de marques réussissent cet exploit de vendre tous les stocks disponibles d'un produit avant même que ce produit soit mis en vente en boutique. Chloé y est parvenue en 2005 avec le sac Paddington, la version quelque peu étirée en longueur de la sacoche de médecin, avec des anses relativement longues et un véritable cadenas avec ses clés (ce qui explique son poids brut de 1,5 kilogrammes). Le nombre de sacs mis sur le marché s'élevait du reste à 8 000. C'est pourquoi ce modèle atteste aux yeux de nombreux experts de l'engouement pour le it-bag. En ce qui concerne le Marcie, un sac à main classique dont le design est basé sur une sacoche de selle, Chloé était mieux préparée à son accueil tapageur. Lors de son lancement, il a été produit à un nombre à 5 chiffres et il est depuis constamment réédité, chaque saison dans de nouveaux coloris particuliers. Il n'y a toutefois guère d'autres sacs qui, à l'instar des sacs Chloé, se vendent toujours aussi rapidement dans les boutiques en ligne.

Lily Donaldson with Paddington, backstage at Chloés Spring/Summer Show 2005.
Marcie, Drew, and Faye: the Chloé street style stars have names as beautiful as those of their owners (right).

Lily Donaldson mit Paddington, backstage bei der Frühjahr/Sommer-Schau von Chloé 2005.
Marcie, Drew und Faye: die Chloé-Streetstyle-Stars haben so schöne Namen wie ihre Besitzerinnen (rechts).

Lily Donaldson avec son sac Paddington, backstage lors du défilé Chloé printemps-été 2005.
Marcie, Drew et Faye : les stars du street style de Chloé ont des noms tout aussi jolis que celles qui les portent (à droite).

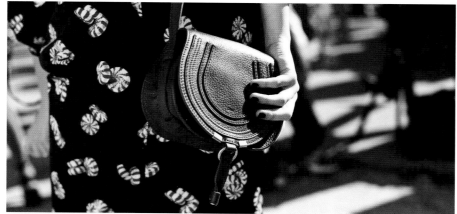
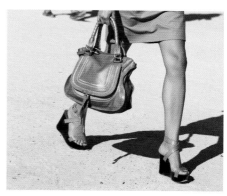
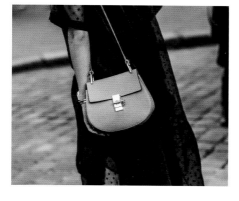
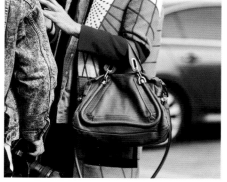

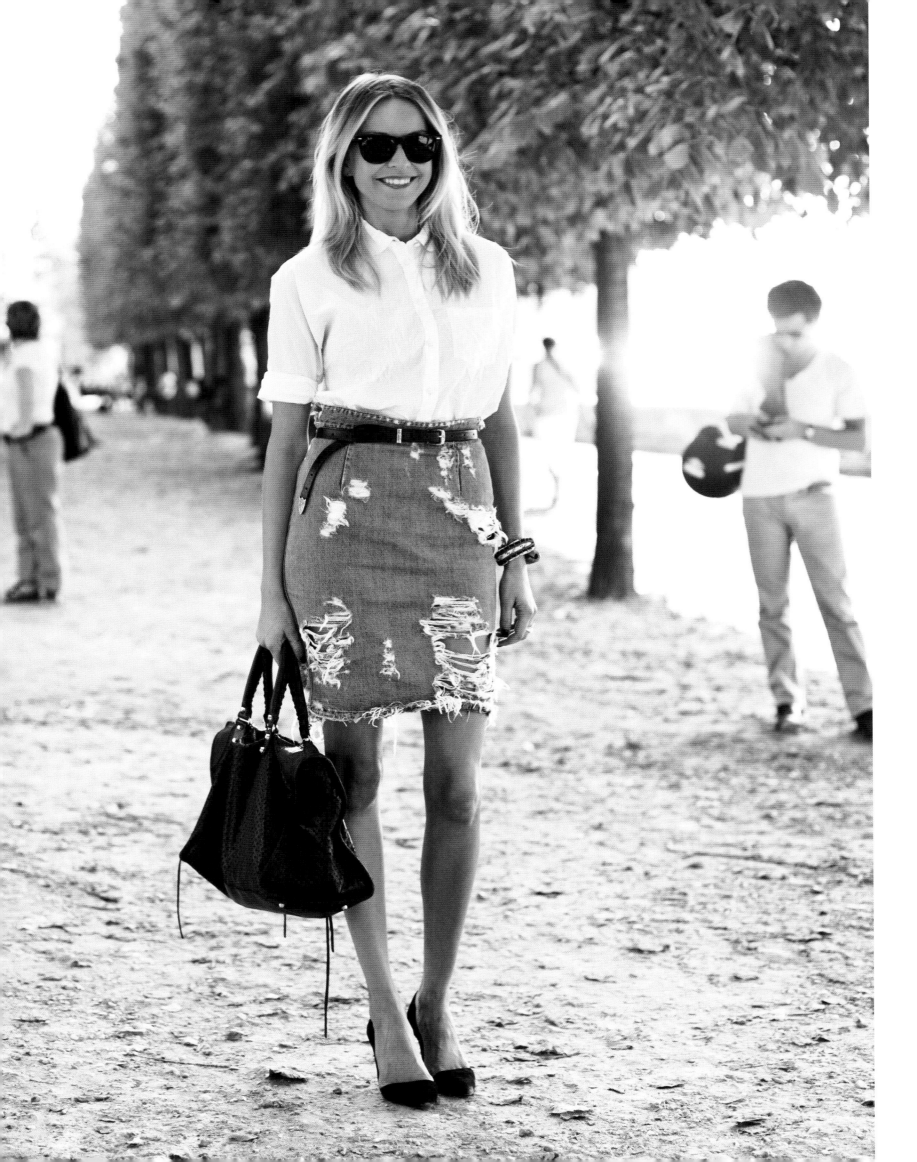

BALENCIAGA

In June 2000, the former Balenciaga designer Nicolas Ghesquière created a bag called the City. Just 18 months later, the *New York Times* declared it to be the most copied model of the year. Women like Kate Moss, Sienna Miller, and Sarah Jessica Parker snapped up the beautifully soft original for the "used look," taken with the rivets like thimbles and narrow leather strips on the zipper. "Although it was new, the City looked like an old companion," the designer said later by way of explaining its success. In 2001, incidentally, he created a slightly narrower version for cocktail and dinner events, called the Lariat. His bosses originally did not want to sell it, because they thought it was too similar to its predecessor. Ghesquière is today no longer at Balenciaga, but the Lariat is still the label's best seller.

Im Juni 2000 stellte der damalige Balenciaga-Designer Nicolas Ghesquière eine Tasche namens City vor. Bereits 18 Monate später kürte die *New York Times* sie zum meist kopierten Modell des Jahres. Frauen wie Kate Moss, Sienna Miller und Sarah Jessica Parker rissen sich damals um das butterweiche Original im Used-Look, besetzt mit Nieten wie Fingerhüte und schmalem Lederstreifen am Reißverschluss. „Obwohl sie neu war, sah die City gleichzeitig wie ein alter Wegbegleiter aus", begründete der Designer später selbst seinen Erfolg. 2001 kreierte er übrigens die leicht schmalere Version für Cocktail- und Dinner-Anlässe, mit dem Titel Lariat. Seine Bosse wollten sie erst nicht in den Verkauf geben, weil sie ihnen zu ähnlich zum Vorgänger erschien. Ghesquière ist heute längst nicht mehr bei Balenciaga, die Lariat aber der Bestseller des Hauses.

En juin 2000, le designer de l'époque, Nicolas Ghesquière présenta un sac du nom de City. Seulement 18 mois après cette présentation, le New York Times l'élut comme le sac le plus copié de l'année. Des femmes comme Kate Moss, Sienna Miller et Sarah Jessica Parker s'arrachèrent l'original, en cuir mou, au look volontairement usé, doté de clous tels des dés à coudre et de lanières en cuir situées sur la fermetureéclair. « Bien qu'il fût nouveau, il ressemblait à un vieux compagnon. » C'est ainsi que le designer lui-même expliquait plus tard son succès. En 2001, il créa du reste la version légèrement plus étroite pour des occasions comme les cocktails et les dîners, qu'il baptisa Lariat. Ses patrons, dans un premier temps, ne voulurent pas le mettre en vente, le jugeant trop ressemblant à son prédécesseur. Si Ghesquière n'est plus depuis longtemps chez Balenciaga, le Lariat, en revanche, est le bestseller de la maison.

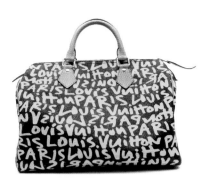

LOUIS VUITTON

The union between art and commerce is probably the best way to describe what Marc Jacobs managed as creative director of Louis Vuitton in the early 2000s with his collaborations. Because he felt the house's traditional monogram design had gotten a little dusty, he commissioned artists to transform it. For example, there was Stephen Sprouse, who distributed the brand name in graffiti-style writing indiscriminately across diverse models (the favorite style of Paris Hilton). Takashi Murakami gave the monogram color and set it on a white background (the favorite style of Naomi Campbell), and a few years later he created a line with cherry motifs (the favorite motif of Nicky Hilton). This all helped Louis Vuitton bags to appear on the fashion radar again. Since then, classic models like Speedy, Lockit, and Alma have left their impression on the streets—they are the ultimate status symbol known by every woman in the world.

Die Verbindung von Kunst und Kommerz, so lässt sich wohl am besten beschreiben, was Marc Jacobs als Kreativdirektor von Louis Vuitton zu Beginn der Nullerjahre mit seinen Kooperationen schaffte. Weil ihm das traditionelle Monogramm-Muster des Hauses zu eingestaubt war, beauftragte er Künstler mit seiner Umgestaltung. Zum Beispiel Stephen Sprouse, der den Markennamen in Graffiti-Schrift wahllos über diverse Modelle verteilte (das Lieblingsmodell von Paris Hilton). Oder Takashi Murakami, der das Monogramm bunt einfärbte und auf weißen Hintergrund setzte (das Lieblingsdesign von Naomi Campbell) und ein paar Jahre später noch einmal eine Linie mit Kirsch-Motiven kreierte (das Lieblingsmotiv von Nicky Hilton). Taschen von Louis Vuitton rückten so erstmals wieder auf das Fashion-Radar. Seitdem prägen klassische Modelle wie Speedy, Lockit und Alma das Straßenbild – sie sind das ultimative Statussymbol, das jede Frau auf der Welt kennt.

La relation entre l'art et le commerce, c'est ainsi que l'on peut le mieux décrire ce qu'a créé Marc Jacobs avec ses coopérations en tant que directeur artistique dans les années 2000. Parce que le motif du monogramme de la Maison lui semblait suranné, il confia à différents artistes la mission de le faire évoluer. Par exemple, Stephen Sprouse qui inscrivit sur le monogramme de manière aléatoire le nom de la marque sous forme de graffitis (le modèle préféré de Paris Hilton). Ou bien Takashi Murakami qui dota le monogramme de couleurs vives et le disposa sur un fond blanc (le modèle préféré de Naomi Campbell). Quelques années plus tard, ce dernier créa encore une nouvelle ligne, cette fois aux motifs de cerises (la marque préférée de Nicky Hilton). Les sacs de Louis Vuitton sont de nouveau dans les phares de la mode. Depuis, des modèles classiques comme le Speedy, le Lockit ou le Alma influencent indiscutablement l'image de la rue et sont le symbole absolu de la réussite que chaque femme connaît.

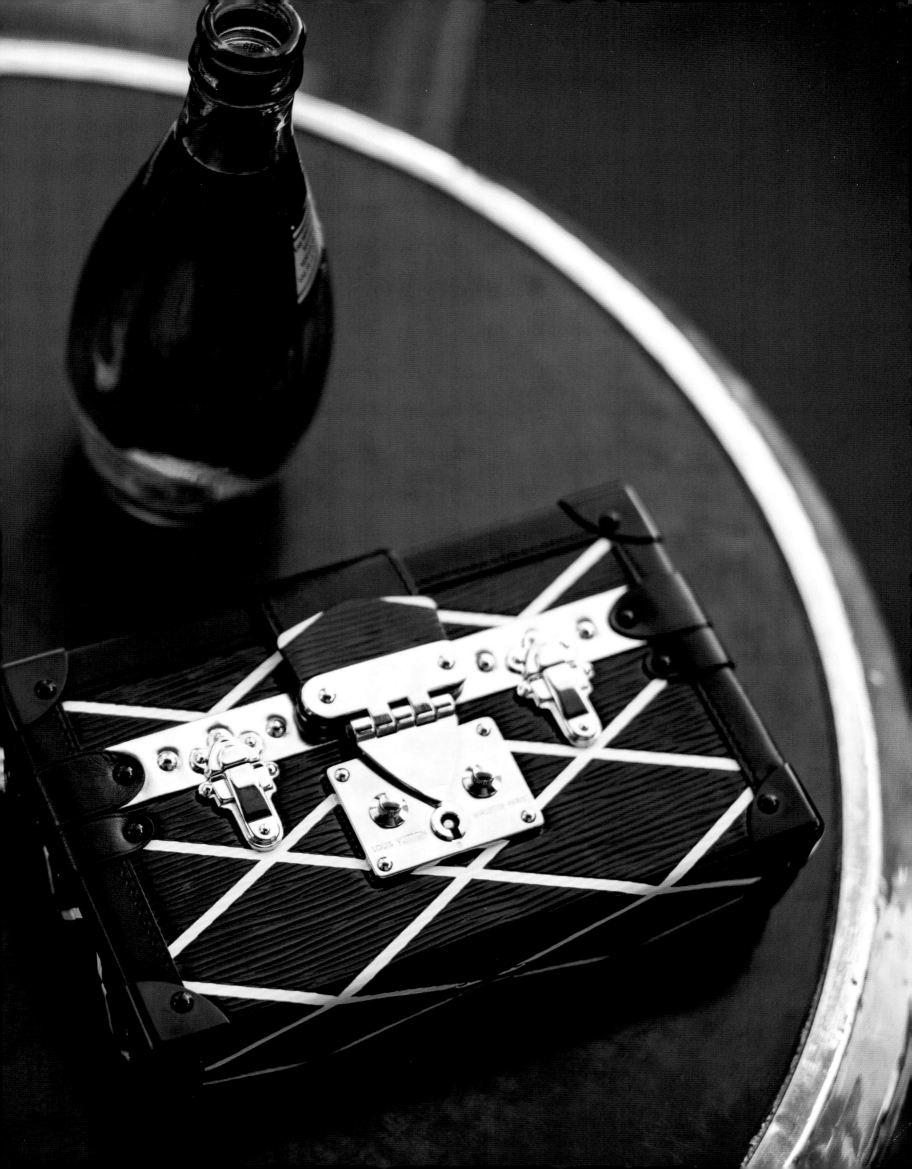

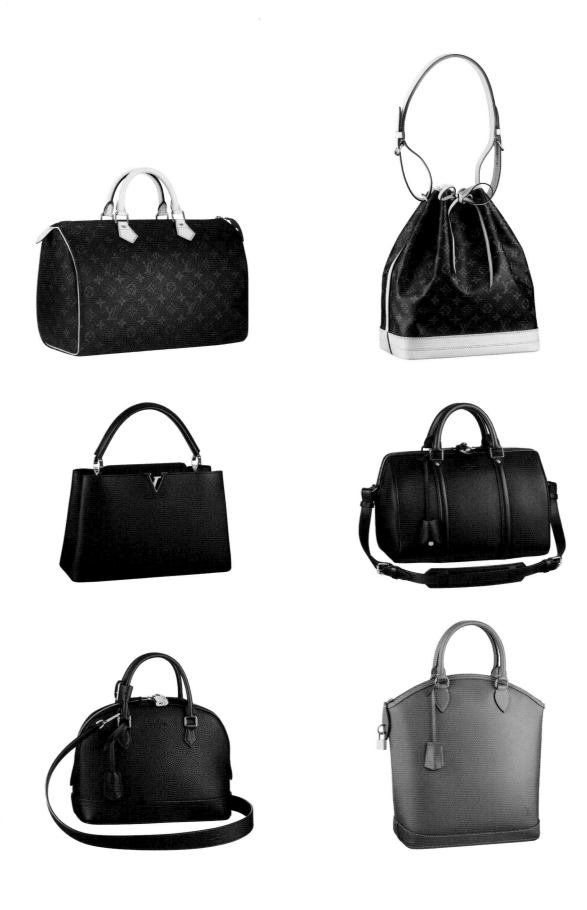

Speedy, Lockit, and Alma are international bestsellers—and are being reinvented again and again.

Speedy, Lockit und Alma sind internationale Bestseller – und werden immer wieder neu erfunden.

Speedy, Lockit et Alma sont des bestsellers internationaux et sont constamment réinventés.

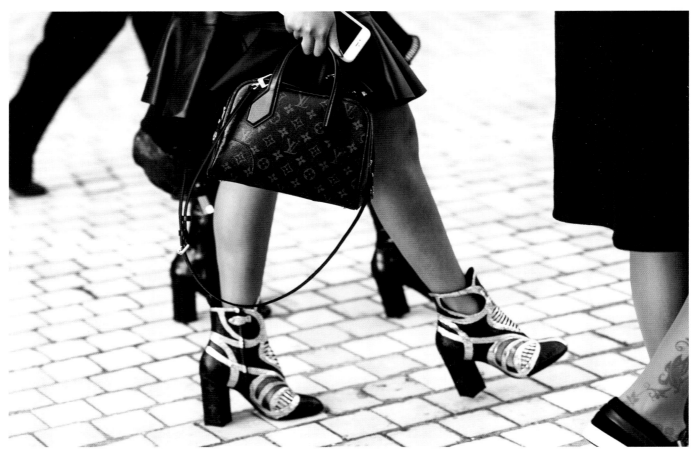

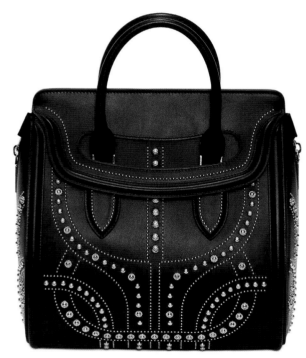

ALEXANDER MCQUEEN

2005 was a good year for bags: the Paddington bag by Chloé became a hit, alongside the Novak by Alexander McQueen. When designing his first bag, McQueen looked to Hitchcock icon Kim Novak for inspiration. And the bag he named after her sold out immediately, because it was not soft and detailed like all other It Bags of the time, but rather rigid and defined in its form. The rest of the McQueen bag mania is history: the Londoner reinvented the elegant evening clutch, in which he passed up on the brass knuckles. After his death, his successor Sarah Burton provided two additional much-loved bags: the Heroine and the De Manta, which in its organic form was reminiscent of the similarly-named sea creature.

2005 war ein gutes Taschenjahr: die Paddington Bag von Chloé wurde ein Hit. Und die Novak von Alexander McQueen auch. Beim Entwerfen seiner ersten Tasche dachte Designer McQueen an die Hitchcock-Ikone Kim Novak. Und die gleichnamige Tasche war sofort ausverkauft. Denn sie war nicht soft und detailverliebt wie all die anderen It-Bags ihrer Zeit. Sie war rigide und klar in der Form. Der Rest der McQueen-Bag-Mania ist Geschichte: der Londoner erfand die elegante Abend-Clutch neu, indem er ihr einen Schlagring verpasste. Nach seinem Tod sorgte seine Nachfolgerin Sarah Burton für zwei weitere große Taschenlieben: die Heroine und die De Manta Bag, die in ihrer organischen Form an die gleichnamige Kreatur aus dem Wasser erinnert.

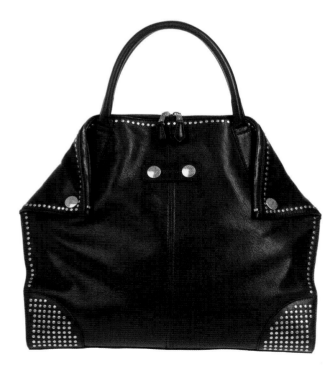

2005 fut une bonne année pour les sacs. Le Paddington de Chloé fut un véritable succès. Et le Novak de McQueen également. Lors de la création de ce modèle, le créateur pensa tout de suite à l'héroïne d'Hitchcock, Kim Novak. Et le sac du même nom fut tout de suite épuisé. Car il n'était ni en cuir doux ni enclin aux détails comme les autres it-bags de l'époque. Sa forme était au contraire rigide et épurée. La suite de la bagmania McQueen appartient à l'histoire : Le Londonien réinventa l'élégante pochette de soirée en la dotant d'un poing américain. Sarah Burton qui lui succéda après sa mort, créa deux autres somptueux sacs : l'Héroïne et le De Manta qui évoque, de par sa forme organique, la créature de l'eau du même nom.

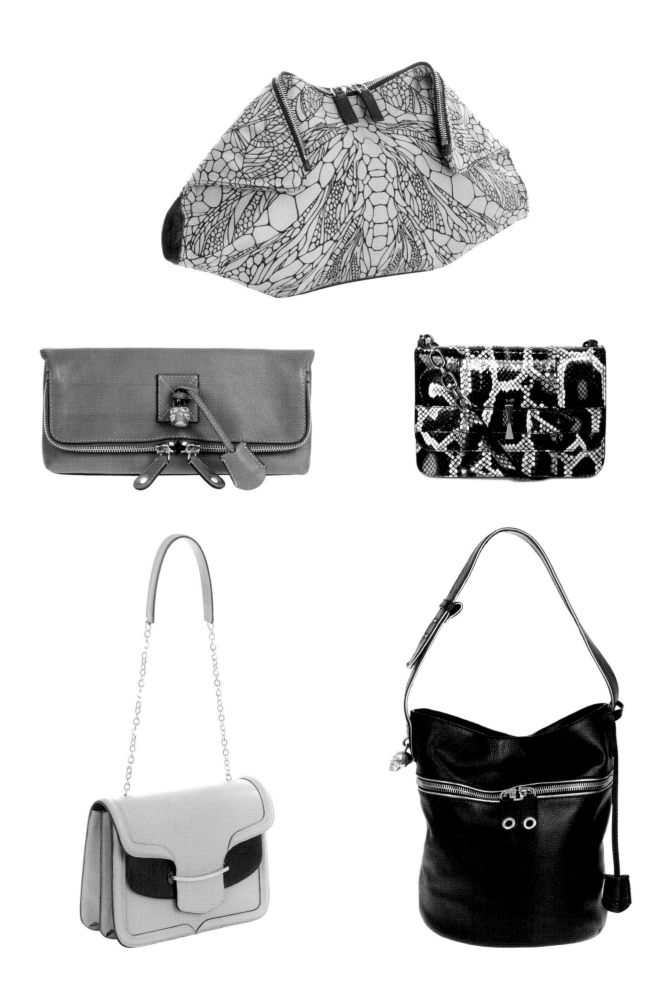

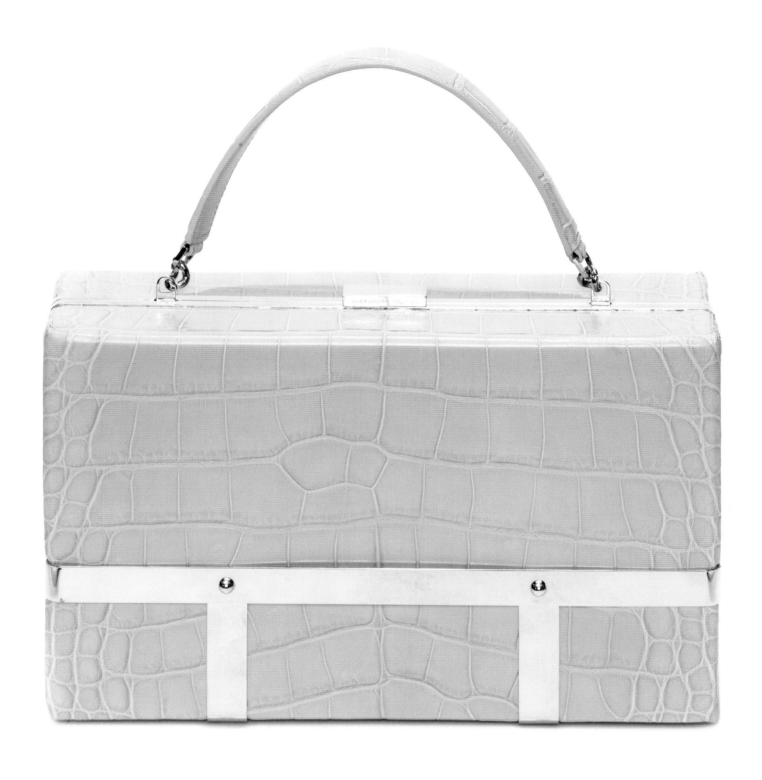

The bright Cage Case made from embossed calf leather with crocodile effect comes from the Fall/Winter Collection 2015.

Die helle Cage Case aus geprägtem Kalbsleder mit Krokodilleder-Effekt stammt aus der Herbst/Winter-Kollektion 2015.

Le sac façon cage, de couleur claire, en cuir de veau, simulant la peau de crocodile est issu de la collection automne-hiver 2015.

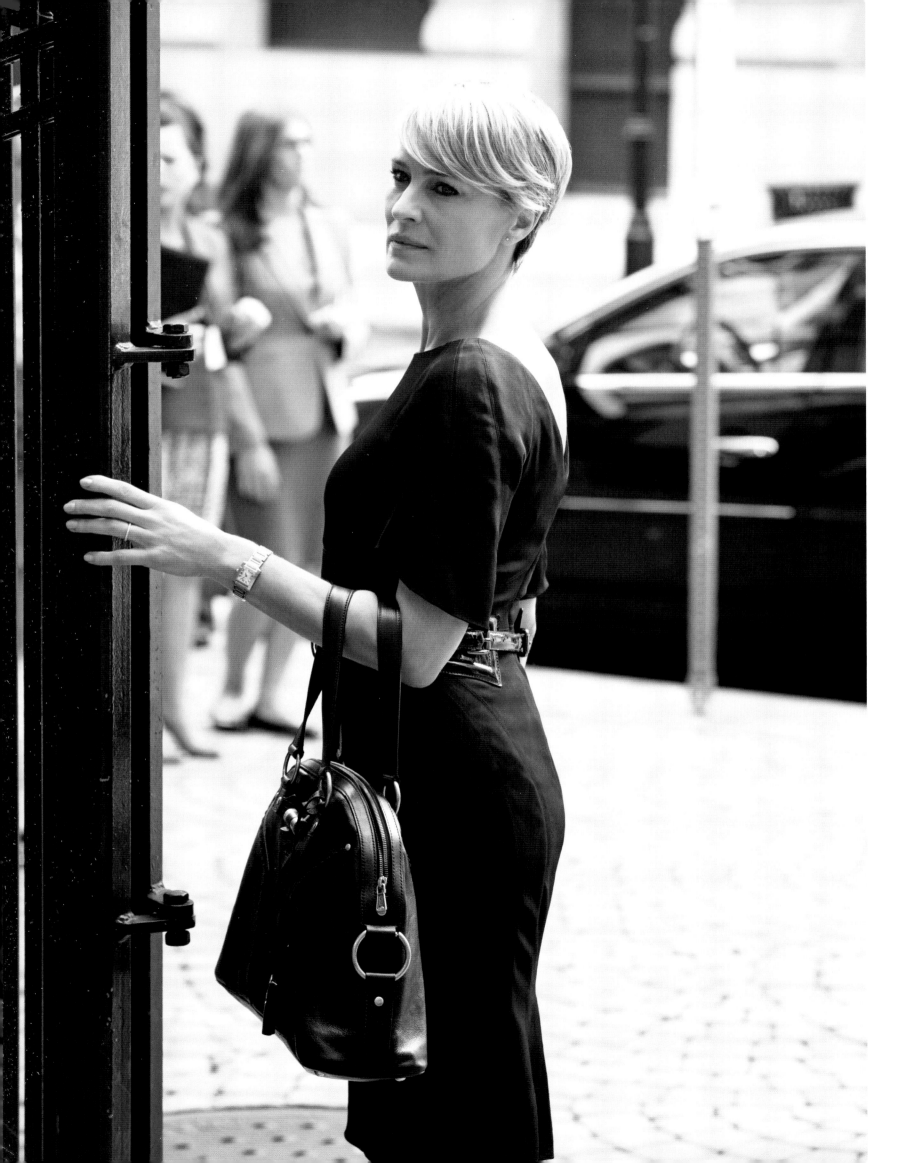

THE MUSE
YVES
SAINT LAURENT

—

No designer has had more creative muses than the great Yves Saint Laurent. This may be precisely why one of his successors, Italian designer Stefano Pilati, gave this name to a bag in 2005. Nonetheless, Pilati later admitted in an interview that he would have preferred not to name the bag at all, since purses are not people. Why did he name it anyway? Probably so it would be simpler for customers to request the object of their passion: the Muse, please! In today's world, there is no place for a nameless bag—how would you search online for a bag without a name? But back to the Muse: the rounded bag with prominent stitching and a heavy closure in the middle was an instant hit and became a best seller. Three years later, the Muse Two appeared, a rectangular bag that many dubbed the "modern Birkin bag." When Hedi Slimane took over creative direction of the label, the Muse was sadly discontinued, a fact that did not stop Robin Wright from carrying one as Claire Underwood in the cult hit series *House of Cards*. The Muse doesn't seem passé, quite the opposite: it seems more modern than ever in the hands of the most ambitious woman in TV history.

Kein Designer hat wohl mehr schöpferische Musen gehabt als der große Yves Saint Laurent. Einer seiner Nachfolger, der Italiener Stefano Pilati, gab vermutlich genau deshalb 2005 einer Tasche diesen Namen. Dennoch bekannte er später in einem Interview, dass er es vorgezogen hätte, auf einen Namen zu verzichten, Taschen seien ja schließlich keine Personen. Warum er sie trotzdem benannte, liegt wohl eher daran, dass es für Kundinnen so eben einfacher war, ihren Wunsch nach dem Objekt der Begierde zu formulieren: die Muse, bitte! Heute gibt es eigentlich kein Taschenmodell mehr ohne Namen – wie sonst sollte man online nach ihnen suchen? Zurück zur Muse: das abgerundete Modell mit prominenter Steppung und schwerem Schloss in der Mitte löste sofort Begeisterung aus und wurde zum Bestseller. Drei Jahre später erschien die Muse Two, ein rechteckiges Modell, dass viele als die „moderne Birkin Bag" betitelten. Muse ist seit Übernahme der Kreativdirektion des Labels durch Hedi Slimane leider aus dem Sortiment des Modehauses verschwunden, was Robin Wright allerdings nicht davon abhielt, sie als Claire Underwood in der Kultserie *House of Cards* zu tragen. Muse wirkt nicht angestaubt, im Gegenteil: in den Händen der ehrgeizigsten Frau der TV-Geschichte scheint sie moderner denn je.

Aucun designer n'a eu autant de muses inspiratrices que le grand Yves Saint Laurent. C'est probablement pour cette raison que l'un de ses successeurs, l'Italien Stefano Pilati, donna précisément ce nom à un sac en 2005. Toutefois, il confessa plus tard dans une interview, qu'il aurait préféré renoncer à un nom, les sacs n'étant pas après tout des personnes. La raison pour laquelle il donna malgré tout un nom à ce sac, réside dans le fait qu'il est plus simple pour les clientes d'exprimer leur souhait pour cet objet du désir : le Muse, s'il vous plaît! De nos jours, il n'existe plus aucun modèle de sac sans nom. Comment pourrait-on sinon les chercher sur Internet ? Revenons au modèle Muse : le modèle aux angles supérieurs arrondis avec la célèbre piqûre et le lourd cadenas au milieu suscita immédiatement l'enthousiasme et devint un bestseller. Trois ans plus tard, le Muse Two fit son apparition, un modèle rectangulaire, auquel nombre de personnes conférèrent le titre de « Birkin Bag moderne ». Malheureusement, depuis la prise de la direction artistique par Hedi Slimane, le Muse a disparu de la gamme de sacs de la maison de couture, ce qui, toutefois, n'empêcha pas Robin Wright de le porter dans son rôle de Claire Underwood dans la série culte *Houses of Cards*. Le Muse n'est pas du tout suranné, mais au contraire, entre les mains de la femme la plus ambitieuse de l'histoire de la télévision, plus moderne que jamais.

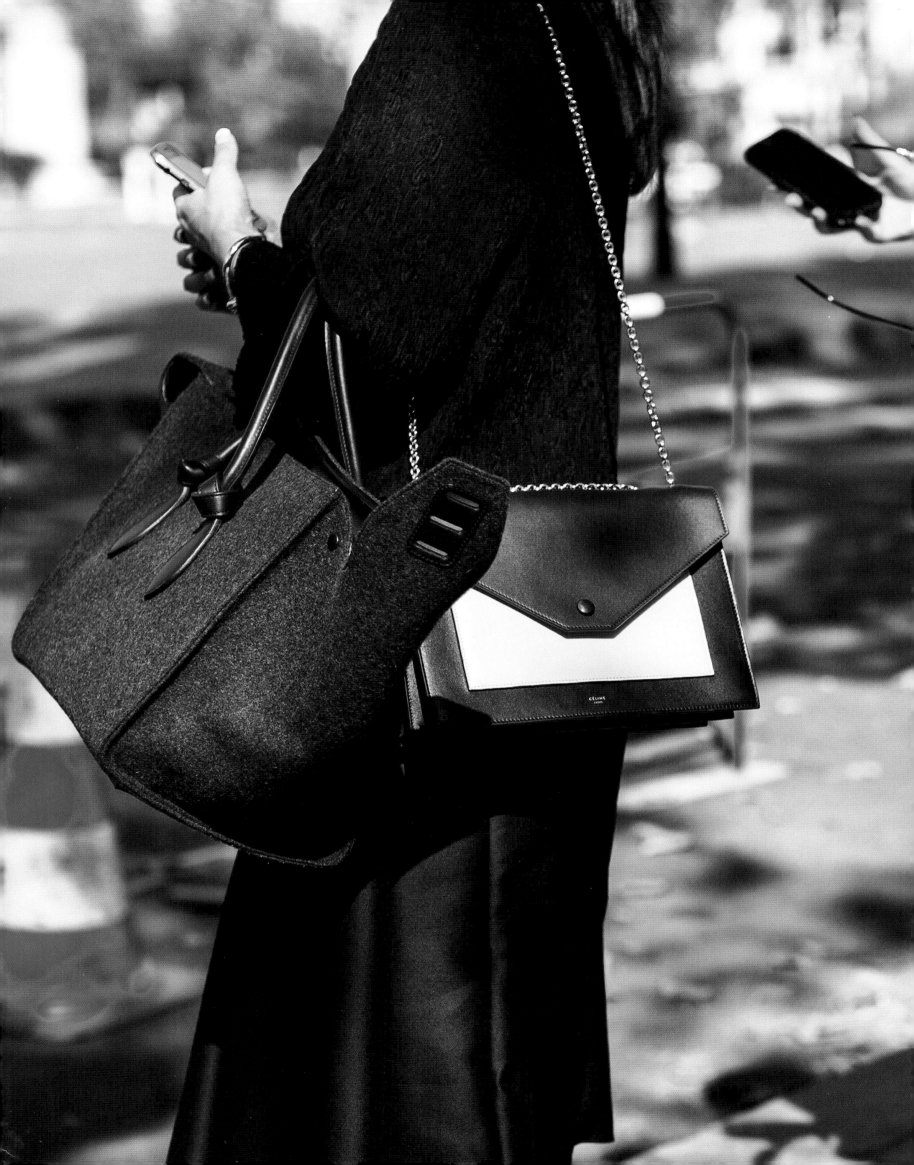

CÉLINE

Everything Phoebe Philo touches becomes an It Bag. The designer of the Paddington bag for Chloé became the creative director at Céline in 2008, transformed the brand into a minimalist fashion mecca for adult women, and threw in a couple of bags along the way. Take, for example, the Box, a Céline classic: she lengthened the straps, removed all of the non-essential elements, and offered it in lemon yellow and electric blue. The Luggage Tote, a large purse reminiscent of luggage (as the name says), became the label's first smash hit in 2010, followed by the almost equally successful Phantom. However, no other bag has had the same lasting influence on the entire fashion world equal to the Trapèze, a handbag with wing-like corners that is still frequently sold out, even years after its rollout. Phoebe simply offers the hit bag in a few new colors each season before leaning back and watching the competition flail around trying to duplicate her success. Any self-respecting fashion label today now includes a bag with wings in its lineup, but Philo knows: true fashionistas only want the original.

Was Phoebe Philo anfasst, wird zur It-Bag. Die Erfinderin der Paddington Bag von Chloé wurde 2008 Kreativchefin von Céline, verwandelte die Marke in ein minimalistisches Modemekka für erwachsene Frauen – und gab ihnen noch ein paar Taschen mit auf den Weg: zum Beispiel die Box, einen Céline-Klassiker: sie verlängerte den Trageriemen, entfernte alles Überflüssige und tauchte ihn in zitronengelb oder electric blue. Die Luggage Tote, eine große Handtasche, die irgendwie an Gepäck erinnert, wurde 2010 der erste große Erfolg, kaum geringer war der der Phantome. Keine Tasche hat allerdings die gesamte Modewelt so nachhaltig beeinflusst wie die Trapèze: eine Henkeltasche mit flügelartigen Ecken, die auch nach Jahren meistens ausverkauft ist. Phoebe verpasst dem Erfolgsmodell einfach jede Saison ein paar neue Farbstellungen. Und kann sich ganz in Ruhe die Bemühungen der Konkurrenz anschauen, einen ähnlichen Hit zu liefern. Es gibt kaum ein Label, das etwas auf sich hält und nicht mittlerweile eine Tasche mit Flügeln im Programm hätte! Philo weiß: Fashion Girls wollen immer nur das Original.

Tout ce que touche Phoebe Philo se transforme en it-bag. La créatrice du sac Paddington de Chloé devint la directrice créative de Céline ; elle transforma la marque en une Mecque de la mode minimaliste pour femmes adultes et leur offrit en plus quelques sacs dont, par exemple le Box, un classique de chez Céline : elle rallongea la bandoulière, éradiqua tout le superflu et le plongea dans le jaune citron ou le bleu électrique. Le Luggage Tote, un grand sac à main, qui ressemble en quelque sorte à un bagage, fut le premier grand succès en 2010. Celui du Phantome fut à peine moindre. Cependant, aucun sac n'a aussi durablement révolutionné le monde de la mode que le Trapèze : un sac à anses avec des angles en forme d'ailes qui se trouve souvent en rupture de stock, cela même après des années depuis sa création. Chaque saison, Phoebe pare son modèle à succès de nouveaux coloris. Et elle peut en toute quiétude observer les efforts de la concurrence à créer un tel hit. Il n'existe pratiquement aucune marque qui ne se respecte sans un sac ailé dans son programme. Philo le sait bien : les filles à la mode veulent toujours l'original.

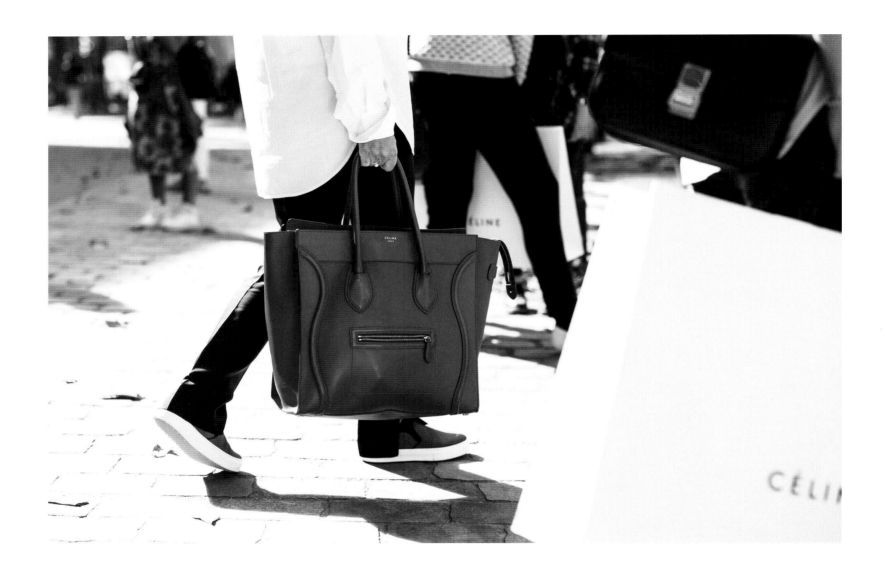

Good investments: Phantom, Classic, Trapèze—Celine bags are no short-lived fashion mayflies. Each season, they are recreated in new colors.

Gute Investition: Phantom, Classic, Trapèze – Céline-Taschen sind keine modischen Eintagsfliegen. In jeder Saison werden sie in neuen Farben aufgelegt.

De bons investissements : le Phantome, le Classic, le Trapèze. Les sacs de Céline ne sont pas éphémères. À chaque saison, ils sont déclinés dans de nouveaux coloris.

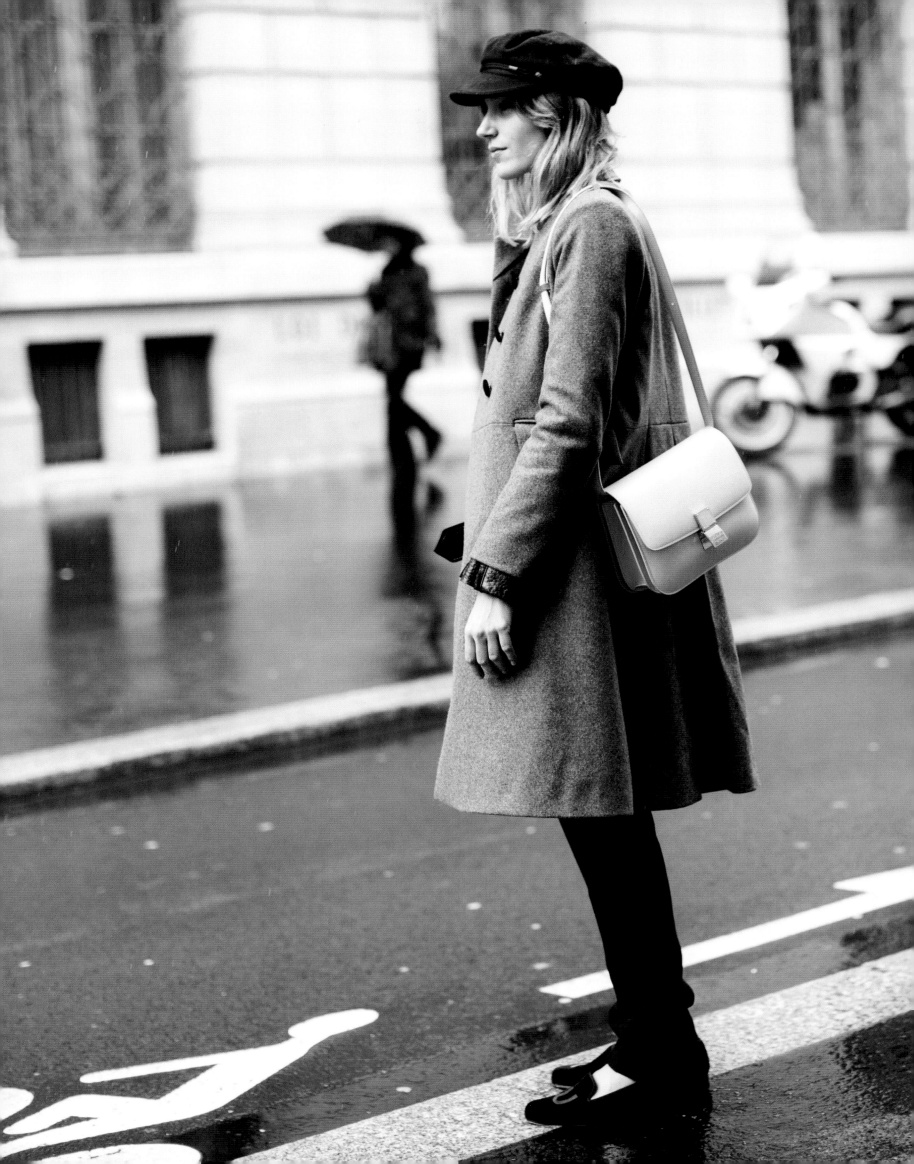

ATELIER BAGS

—

There are bags that you love for a year or two, or sometimes three, and there are bags that you love forever. These latter bags are above the fashion fray, not subject to changing trends. Their design reflects a timeless beauty that endures for decades. And their extraordinary craftsmanship enables women to get decades of use out of them. Such rare and wonderful bags are made by people who put great love and care into every detail. Nothing will deter them from giving their very best, and they keep working on each masterpiece until it is absolutely perfect. What does it take to be one of these craftspeople? An unswerving dedication to tradition, centuries of expertise, and the knowledge that luxury isn't just visual, it's something you can touch.

Es gibt Taschen, die liebt man ein oder zwei, oder manchmal auch drei Jahre. Und es gibt Taschen, die liebt man für immer. Letztere stehen über der Mode. Sie sind keinen Trends unterworfen. Ihr Design ist so zeitlos schön, dass es Jahrzehnte überdauert. Und ihre Qualität ist so hoch, dass sie diese Jahrzehnte auch aushalten. Solche Kostbarkeiten werden von Menschen gemacht, die all ihre Liebe in ein einziges Detail stecken. Sie lassen sich durch nichts aus der Ruhe bringen und arbeiten solange an ihrem Meisterwerk, bis es perfekt ist. Was man dazu braucht? Unbeirrten Willen zur Tradition, jahrhundertealtes Know-how und das Wissen, dass Luxus nicht nur visuell, sondern vor allem haptisch ist.

Il y a des sacs qu'on aime un, deux ou parfois même trois ans. Et il y a des sacs qu'on aime pour toujours. Ces derniers dépassent la mode. Ils ne sont pas soumis aux tendances. Leur design est beau de manière si intemporelle qu'il perdure des décennies. Et leur qualité si élevée que celle-ci défie également les décennies. Ces valeurs précieuses sont faites par des êtres humains qui mettent tout leur amour dans un seul et unique détail. Ils ne se laissent en rien émouvoir et travaillent à leur chef d'œuvre jusqu'à ce que celui-ci soit parfait. Ce dont on a besoin pour cela ? D'une volonté implacable de suivre la tradition, d'un savoir-faire séculaire et de la conviction que le luxe n'est pas seulement visuel mais aussi tactile.

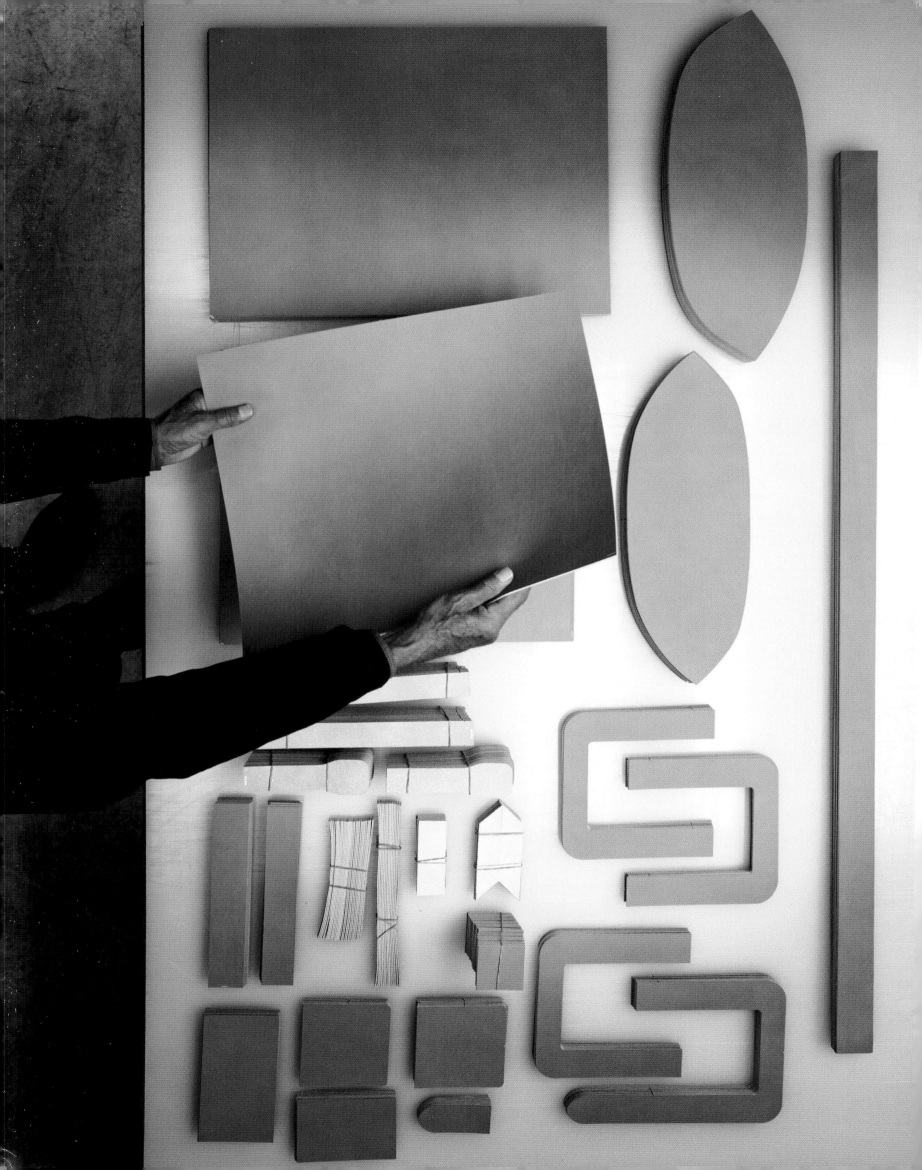

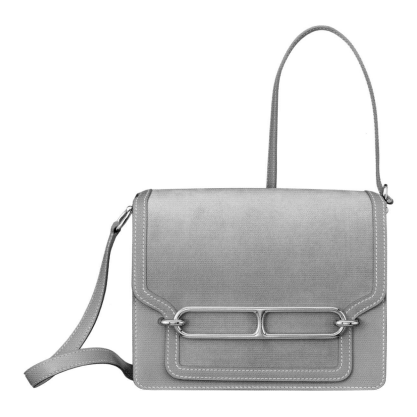

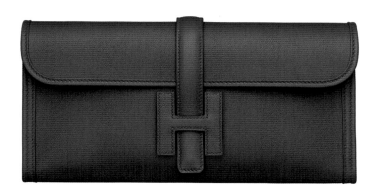

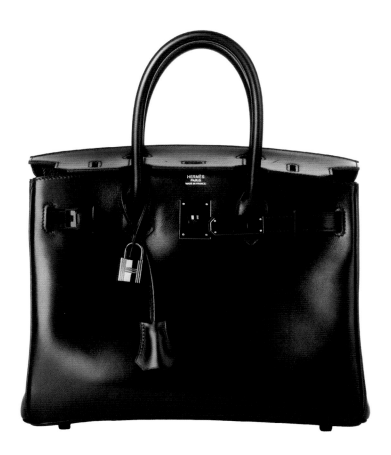

HERMÈS

Why does it really take so long to finally get your hands on a Birkin bag to call your own? Because total dedication to the creation of a bag requires a little more time and devotion. Training as a bag maker at Hermès takes many years, including 2 years as an apprentice, until each and every careful hand movement has been perfected. Each bag is made from start to finish by a single craftsman. It takes the experienced artisans many hours to make one bag (up to 25 for some models) depending on the form, size, and the material used. A lot of know-how is involved, from selecting a faultless piece of leather to cutting, preparing, assembling, saddle-stitching and polishing. This takes time and production hardly meets demand. Hermès bags are not just a brief romance; they are a great and life-long love. With a bit of luck, however, you might also be able to take your favorite bag home right away.

Warum dauert das eigentlich so lange, bis man endlich eine Birkin Bag sein eigen nennen darf? Weil es eben etwas länger braucht, wenn in einer Tasche absolute Hingabe steckt. Die Ausbildung eines Täschners bei Hermès dauert viele Jahre, einschließlich 2 Jahren als Handwerkslehrling – eben solange, bis jeder Handgriff sitzt. Jede Tasche wird von Anfang bis Ende von einem einzigen Täschner gefertigt. Ein erfahrener Handwerker benötigt viele Stunden, um eine Tasche herzustellen (bei einigen Modellen bis zu 25), je nach Form, Größe und Material. Entsprechendes Know-how ist erforderlich: Die Auswahl des makellosen Leders, das Schneiden, das Zusammensetzen der Einzelteile, der Sattlerstich, das Polieren…. Dies benötigt viel Zeit und die Produktion kann die Nachfrage kaum decken. Hermès-Taschen sind eben kein kurzer Flirt – sie sind eine lebenslange große Liebe. Doch mit ein bisschen Glück kann man seine Lieblingstasche manchmal auch sofort mit nach Hause nehmen.

Pourquoi, au juste, cela prend-il autant de temps avant que l'on puisse enfin devenir l'heureuse propriétaire d'un sac Birkin? Eh bien justement parce qu'il faut beaucoup de temps pour réaliser un sac en lui consacrant une affection absolue. Chez Hermès, il faut compter quelques années pour former un maroquinier – dont l'apprenti passe deux années à l'école professionnelle artisanale - jusqu'à ce que chaque geste attentif soit maîtrisé à la perfection. Tous les sacs sont faits par un seul et unique artisan. Et il faut beaucoup de temps aux mains plus expertes (jusqu' à 25 heures pour quelques modèles) dépendant de la forme, taille et matière. Une entière chaîne de savoir-faire est impliquée: la sélection du cuir impeccable, la coupe, l'assemblage, le point sellier, le polissage. Tout cela prend beaucoup de temps et avec les demandes dynamiques c'est n'est pas toujours possible pour la production de les accomplir. Les sacs Hermès ne constituent pas une amourette passagère – mais un réel amour passionnel, à vie. Mais avec un peu de chance, on peut quelquefois trouver son sac préféré et l'emporter immédiatement.

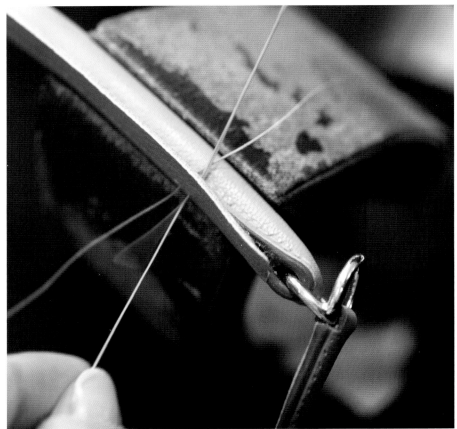
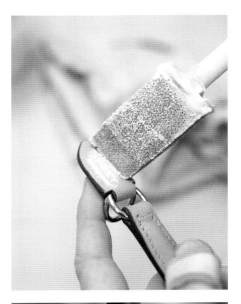
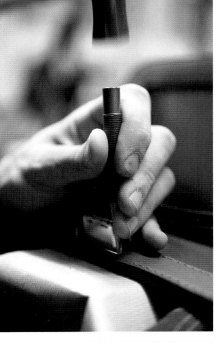
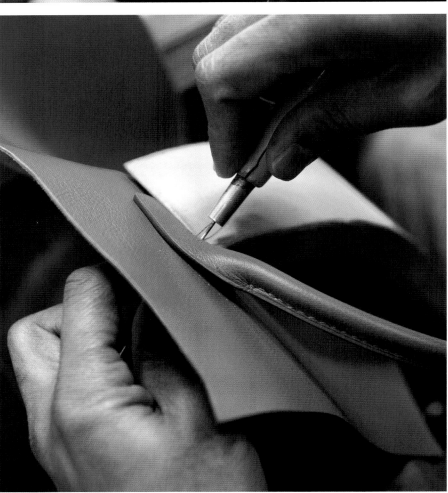

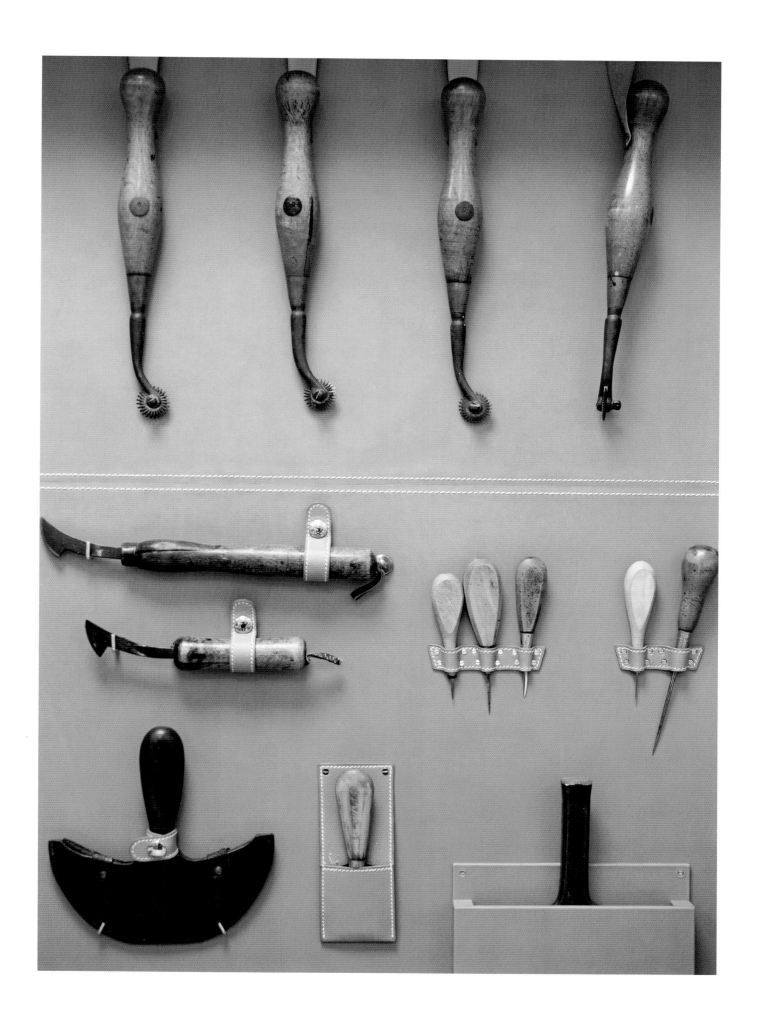

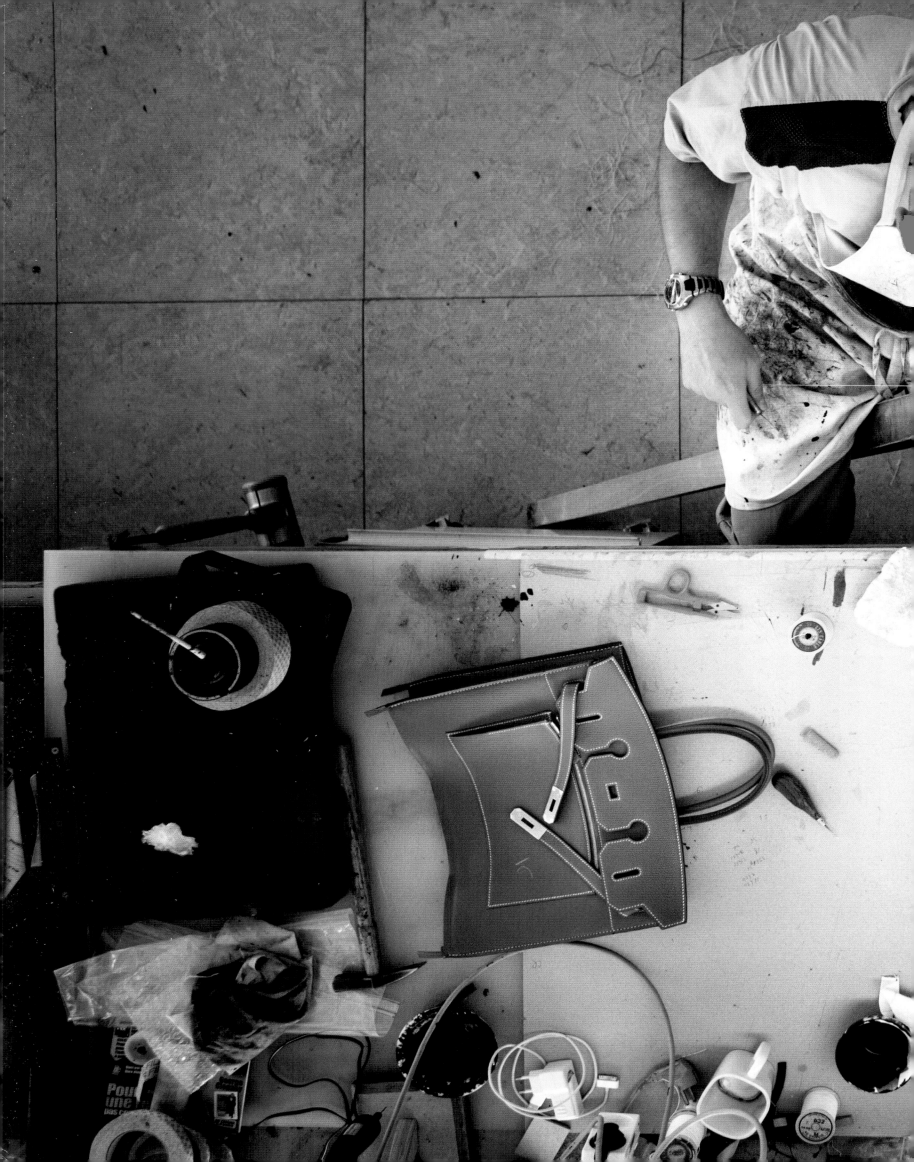

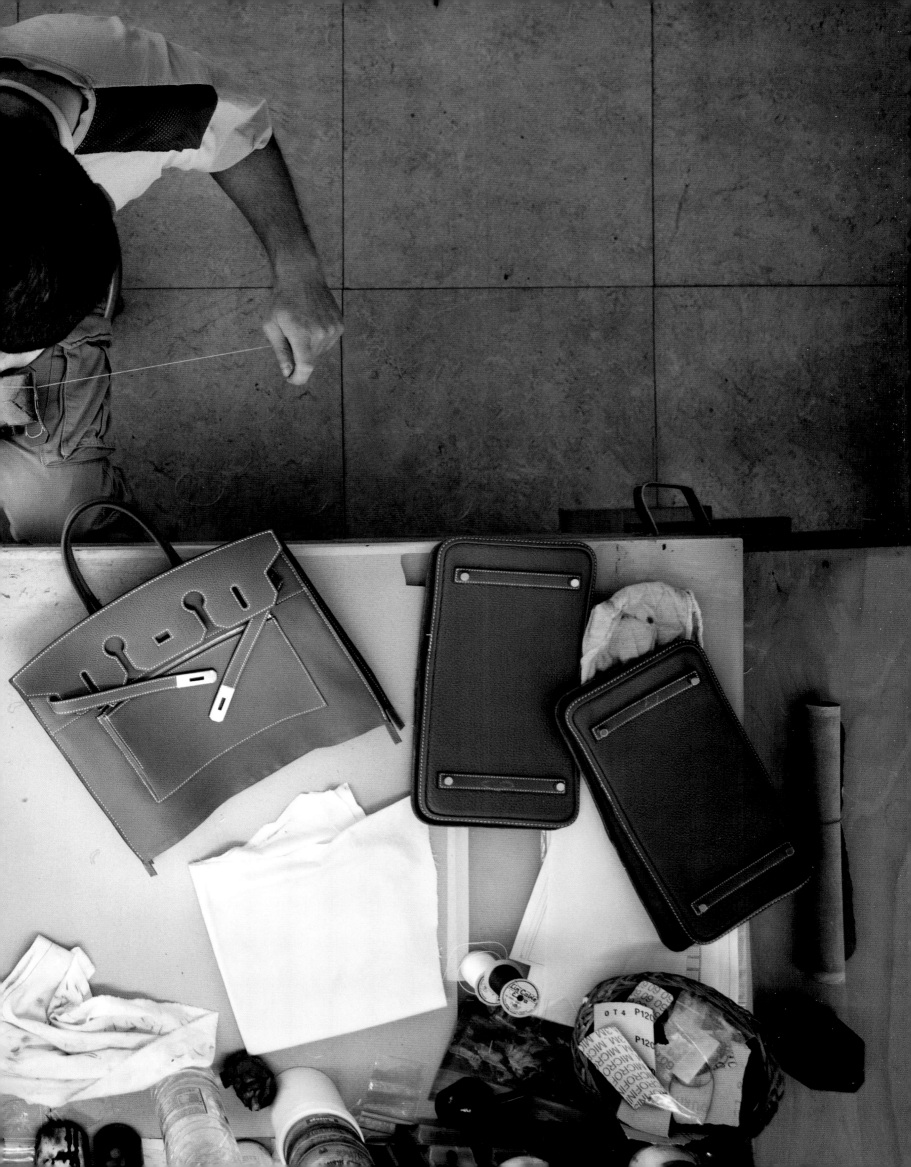

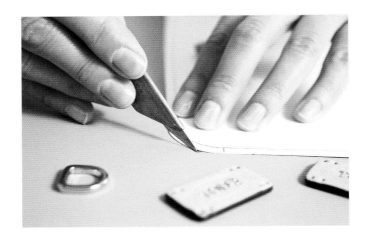

TOD'S

Made in Italy—in the world of accessories, this is nothing more than the translation of "must have." No other company embodies these three magic words the way Tod's does. Filippo Della Valle founded a small shoe manufacturer in the early 1900s in Le Marche, a region on the Adriatic coast of Italy known for its leather goods. Diego Della Valle joined the company in the '70s and turned it into a world-famous luxury label. His success was founded on the nub-soled moccasins that are now a symbol for Italian casual chic. Legend has it that Della Valle was inspired by a driving shoe that he came across at a flea market on the American East Coast. Soon after that, the first handbags appeared: the D bag, made of natural leather with the famous Tod's nubs on the sides, became the shoemaker's first It Bag. Even Lady Diana had one, and she carried it while wearing matching Tod's loafers. What is Tod's secret to success? On the one hand, it's the quality you can achieve only when leather crafting know-how is in your employees genes, as it is for the artisans living in Le Marche. And on the other, there's the revolutionary (at that time) linking of la dolce vita on a sailboat with chic Milan ladies. In the end, Diego Della Valle didn't just change street style, he changed the way the entire world looks at Italy, a country that inspires longing in so many.

Made in Italy – das ist in der Welt der Accessoires eigentlich nichts anderes als die Übersetzung für Sehnsucht. Kein anderes Unternehmen steht so für diese magischen drei Worte wie Tod's. Zu Beginn des 20. Jahrhunderts gründete Filippo Della Valle eine kleine Schuh-manufaktur in den Marken, der für ihr Lederhandwerk berühmten Region an der italienischen Adriaküste. In den 1970er-Jahren stieg Diego Della Valle ins Unternehmen ein – und machte aus ihm ein weltweit berühmtes Luxuslabel. Sein Erfolg beruht auf dem Mokassin mit den Noppen, der heute das Symbol für italienischen Casual Chic ist. Die Legende besagt, Della Valle habe sich dafür von einem *Driving Shoe* inspirieren lassen, den er auf einem Flohmarkt an der amerikanischen Ostküste entdeckte. Bald darauf folgten die ersten Taschen: die D Bag, aus Naturleder und mit den berühmten Tod's-Noppen an den Seiten, wurde zur ersten It-Bag des Schuhmachers. Selbst Lady Diana trug sie, und zwar gleich in Kombination mit den passenden Tod's Loafers. Das Erfolgsgeheimnis: einerseits die Qualität, die man nur erreichen kann, wenn das Know-how des Lederhandwerks den Mitarbeitern in den Genen liegt, so wie das bei den Handwerkern, die in den Marken leben, der Fall ist. Und, natürlich: die damals neue Verbindung von der leichten Dolce Vita auf dem Segelboot mit dem Chic der Mailänder Damen. So hat Diego Della Valle nicht nur das Straßenbild revolutioniert, sondern gleich den Blick der Welt auf das Sehnsuchtsland Italien.

Made in Italy – Ces trois mots, dans le monde des accessoires, ne sont rien d'autre, en réalité, que la traduction d'une aspiration ultime. Aucune autre entreprise n'incarne aussi bien ces trois mots magiques que Tod's. Au début du 20ᵉ siècle, Filippo Della Valle fonda une petite manufacture de chaussures dans la région des Marches, sur la côte adriatique, connue pour son artisanat du cuir. Dans les années 1970, Diego Della Valle fit son entrée dans l'entreprise et la transforma en l'une des marques de luxe les plus connues du monde. Son plus grand succès repose sur le mocassin à picots, qui évoque encore aujourd'hui le casual chic italien. La légende dit que Della Valle s'est inspiré d'une *driving shoe*, qu'il aurait découverte sur un marché aux puces de la côte Est américaine. Peu de temps après, suivirent les premiers sacs : le D-Bag, en cuir naturel et doté des célèbres picots de Tod's sur les côtés, devint le premier it-bag du cordonnier. Même Lady Diana le porta, et à savoir en combinaison avec les loefers Tod's assortis. Le secret de la réussite : d'une part, la qualité que l'on ne peut atteindre que si le savoir-faire de l'artisanat du cuir existe dans les gènes des employés. Et c'est le cas des artisans qui travaillent dans la région des Marches. Et, d'autre part naturellement, le lien autrefois nouveau, entre la Dolce Vita légère sur le voilier et le chic des dames de Milan. Diego Della Valle n'a pas seulement révolutionné l'image de la rue mais également le regard du monde sur le pays de l'aspiration ultime, l'Italie.

The cutting of exotic leathers such as python or crocodile is a special art, because the patterns and grains always run differently. When the individual pieces are put together, a harmonious whole must be created. At the company headquarters in Sant'Elpidio a Mare, bag makers master this art. Here in the Italian Marche region, this knowledge is traditionally passed from generation to generation.

Das Zuschneiden von exotischem Leder wie Python oder Krokodil ist eine besondere Kunst, weil Maserung und Narben immer anders verlaufen. Wenn die Einzelteile zusammengefügt werden, muss daraus ein harmonisches Ganzes entstehen. Im Firmensitz in Sant'Elpidio a Mare beherrschen Täschner diese Kunst. Sie wird hier in den italienischen Marken traditionell von Generation zu Generation weitergegeben.

Découper du cuir exotique comme le python ou le crocodile est un art très particulier car la texture et le grain ne se comportent pas toujours de la même manière. Lorsque les différents composants sont assemblés, il faut qu'ils forment un tout harmonieux. Au siège de l'entreprise à Sant'Elpidio a Mare, les maroquiniers maîtrisent parfaitement cet art. Dans la région des Marches, il est transmis traditionnellement de génération en génération.

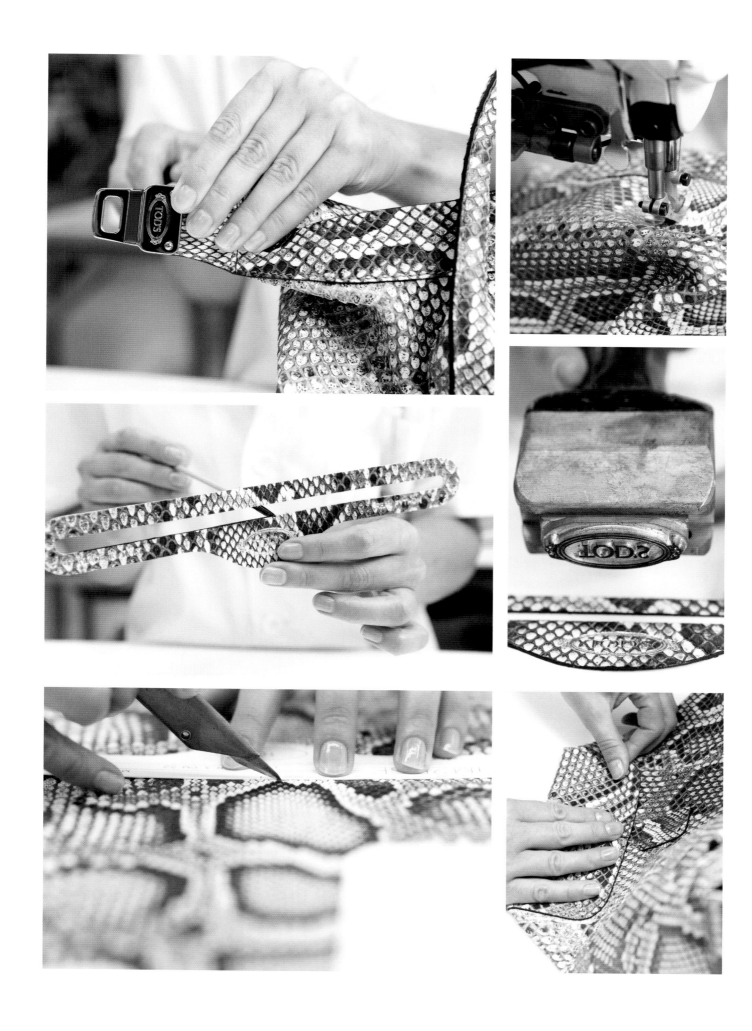

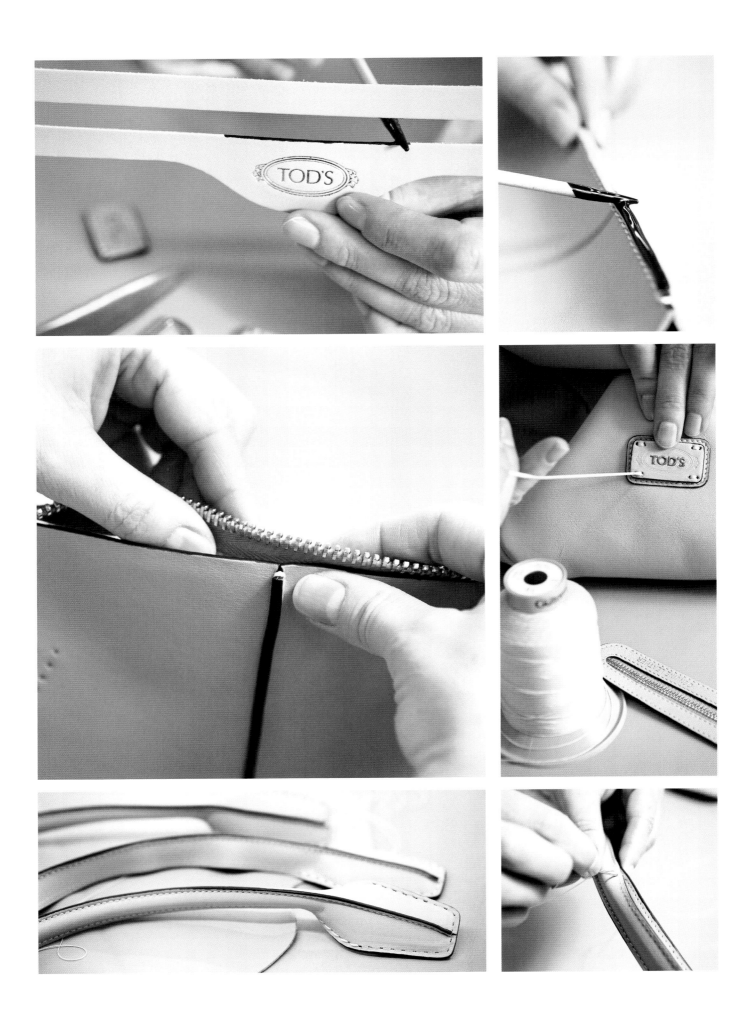

TOD'S LEATHER

You like a bag because of its look: the design. And you love it because of it's feel: the leather. Toni Ripani is the ruler of the leather warehouse at the headquarters of Tod's. He oversees the quality of every single piece of leather, which later become bags. The Italian label buys leather from the best tanneries in the world—but how do you distinguish excellent leather from merely good leather? "The sense of touch helps the eye in the analysis," says Toni. That's because leather at Tod's is inspected and checked manually, with the exception of some wear and tear tests that can only be simulated with machines; after all, a Tod's bag is not a bag for one season only, but rather, is made to last. "We only use leather that is as close to perfection as possible," Toni adds. Absolute perfection is rare; after all, leather is a natural product. And quality control, as Toni says, is "a bit like a DNA analysis" in that you can see in the leather exactly how an animal once lived—from stretch marks to virtually invisible scars. "Each type of leather has its specific peculiarities," says the company's quality tsar. The same is true for the wishes and visions of the designers: the creative designer at Tod's, Alessandra Facchinetti, works with leather like a fabric, devising new stampings, marquetry, and forms. With increasingly complex requests, Toni reacts like all people who practice their craft with passion, "With difficult tasks you grow. Nothing is impossible!"

Man mag eine Tasche wegen dem, was man sieht: dem Design. Und man liebt sie wegen dem was man fühlt: wegen des Leders. Toni Ripani ist der Herrscher des Lederlagers im Headquarter von Tod's. Er überwacht die Qualität jedes einzelnen Lederstücks, aus dem später einmal eine Tasche wird. Das italienische Label kauft Leder bei den besten Gerbereien der Welt – aber wie kann man hervorragendes Leder von gutem Leder unterscheiden? „Der Tastsinn hilft dem Auge bei der Analyse", erklärt Toni. Denn Leder bei Tod's wird manuell begutachtet und geprüft – mit Ausnahme von einigen Abnutzungstests, die man nur mit Maschinen simulieren kann, schließlich ist eine Tod's-Tasche keine Tasche nur für eine Saison und soll lange halten. „Wir verarbeiten nur Leder, das so nah wie möglich an der Perfektion ist", so Toni weiter. Denn die absolute Perfektion ist selten: schließlich ist Leder ein Naturprodukt – und die Qualitätskontrolle, so Toni, „ein bisschen wie eine DNA-Analyse": man kann im Leder genau sehen, wie ein Tier einmal gelebt hat – von Dehnungsstreifen bis hin zu so gut wie unsichtbaren Narben. „Jede Lederart hat ihre besonderen Eigenheiten", so der Qualitäts-Papst der Firma. Das gleiche gilt natürlich auch für die Wünsche und Visionen der Designer: Die Tod's-Kreativ-Designerin Alessandra Facchinetti arbeitet mit Leder wie mit Stoff, entwirft neue Stanzungen, Intarsien, Formen. Auf immer komplexere Anfragen reagiert Toni wie alle Menschen, die ihr Handwerk mit Leidenschaft ausüben: „An schwierigen Aufgaben wächst man. Nichts ist unmöglich!"

On aime un sac dans la façon qu'il a de se montrer : le design. Et on l'aime au moindre contact de son cuir. Toni Ripani est le leader incontesté dans le monde du cuir au sein de la direction de Tod's. Il contrôle la qualité de toutes les pièces de cuir à partir desquelles va naître un sac. La griffe italienne achète le cuir chez les meilleurs tanneurs du monde – mais comment distinguer un excellent cuir d'un cuir de qualité ? « Le toucher aide l'œil dans sa quête de l'excellence. », explique Toni. Car chez Tod's, le cuir est minutieusement examiné à la main – à l'exception des tests portant sur l'usure naturelle du cuir qui sont du strict ressort des machines. En vérité, un sac Tod's n'est pas le sac d'une seule saison, il est appelé à durer longtemps. « Nous travaillons seulement le cuir qui est proche de la perfection. », ajoute Toni. Car l'absolue perfection est rare : de toute évidence, le cuir est, selon Toni, un produit naturel et sa détection est comparable à la démarche de la recherche de l'ADN : à travers le cuir, on peut reconstruire l'histoire d'un animal en devinant les déformations de sa peau et ses cicatrices invisibles. « Chaque type de cuir présente des particularités qui lui sont propres. » selon le pape de l'entreprise. La même rigueur perfectionniste habite le designer dans ses aspirations et ses visions. Alessandra Facchinetti, la directrice artistique de Tod's travaille le cuir à la manière du tissu. Elle conçoit le poinçonnage, les incrustations, les formes. Lorsque les questions gagnent en complexité, Toni réagit comme tous les êtres humains passionnés par leur savoir-faire : « C'est dans l'accomplissement des tâches difficiles qu'on se sublime. Rien n'est impossible. »

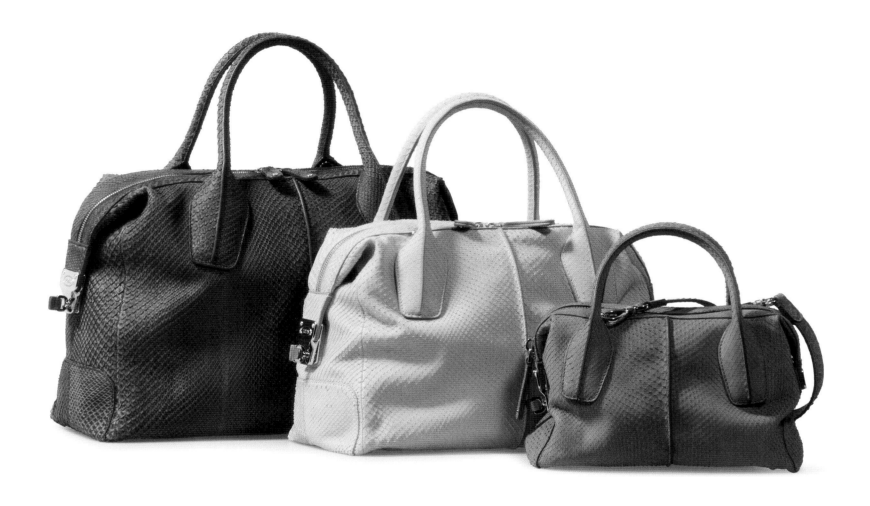

Finished snakeskin models—softer than a pillow! The D-Cube (right) is the ultimate street style star from Tod's.

Fertige Schlangenleder-Modelle – softer als ein Kissen! Die D-Cube (rechts) ist der ultimative Streetstyle-Star aus dem Hause Tod's.

Des modèles réalisés en peau de serpent, plus doux qu'un coussin ! Le D-Cube (à droite) est la star absolue du street style de la maison Tod's.

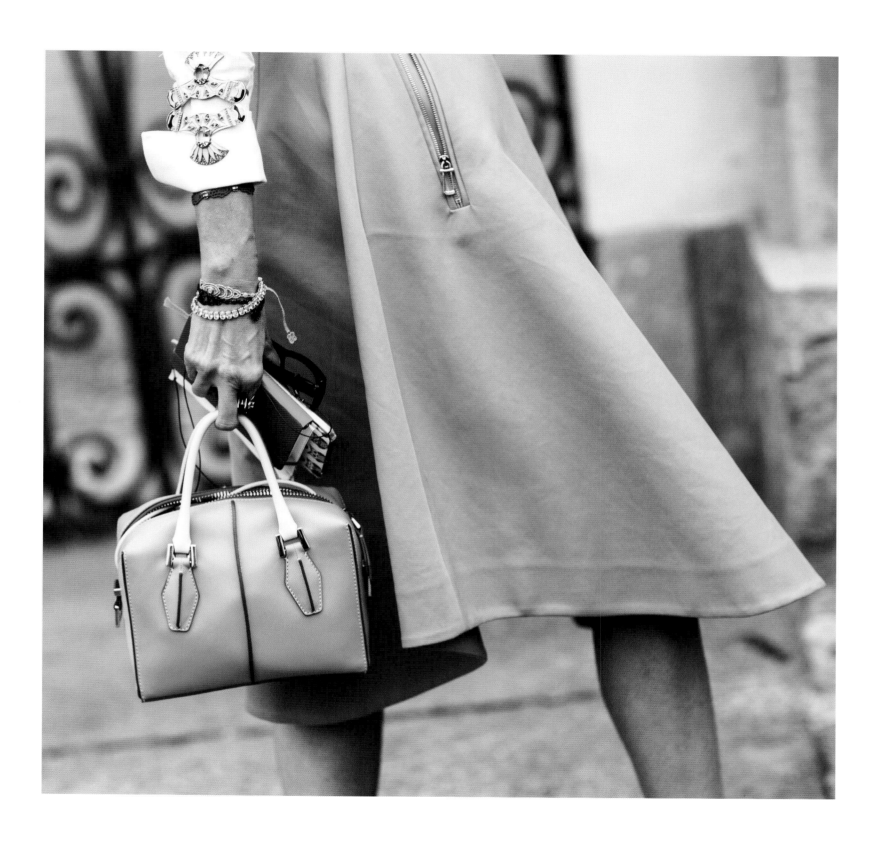

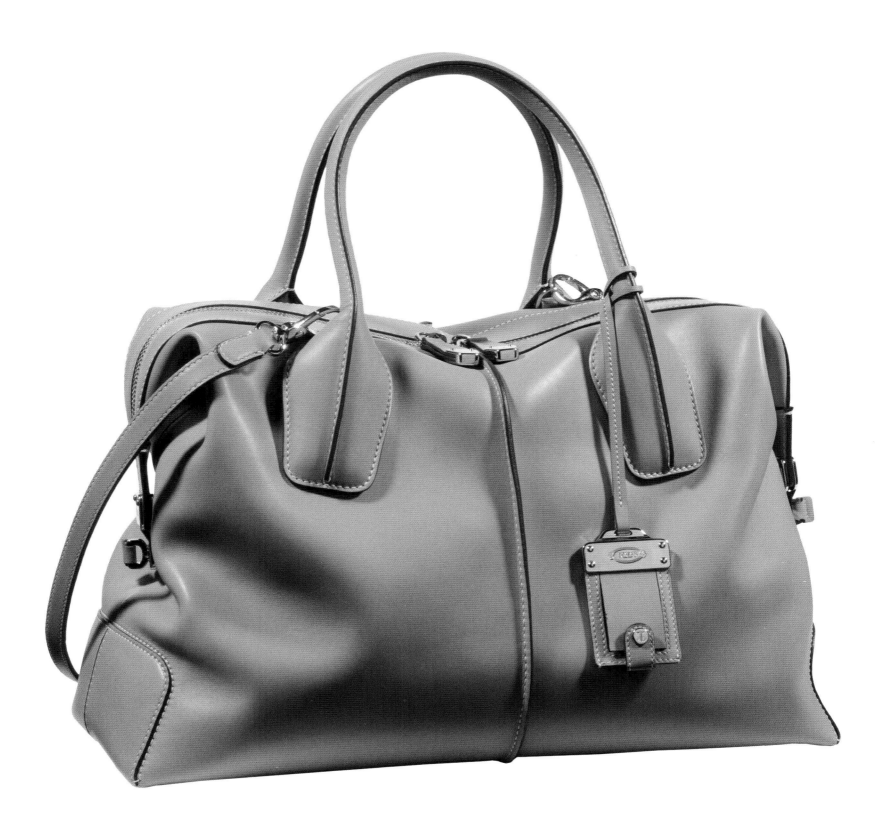

The D-Cube (right, 2nd row right) is the successor to the legendary D bag, which even Lady Diana wore and from which the shoemaker started an accessory label (top and right, 2nd and 3rd row).

Die D-Cube (rechts, 2. Reihe rechts) ist der Nachfolger der legendären D Bag, die sogar Lady Diana trug und aus der Schuhmanufaktur Tod's ein Accessoire-Label machte (oben und rechts, 2. und 3. Reihe).

Le D-Cube (à droite, 2^e rang à droite) est le successeur du légendaire D Bag que même Lady Diana portait et qui fit de la maison de chaussures Tod's une marque d'accessoires (en haut et à droite, 2^e et 3^e rang).

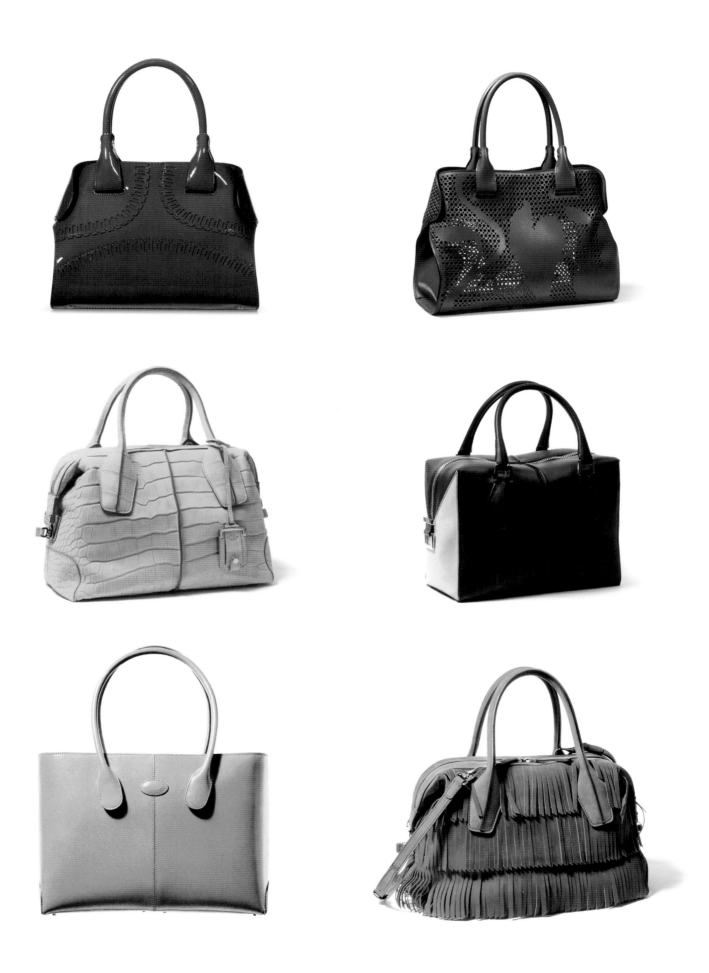

VALEXTRA

The Milanese leather manufacturer is all about craftsmanship, attention to detail, and special designs. But only real connoisseurs would recognize from afar a Valextra hanging on a woman's arm. Giovanni Fontana founded the factory in 1937, and to this day, the philosophy has not changed: True luxury is not what you see. True luxury is what you feel. For example, when you open a bag that appears rigid from the outside, and the fastener springs open like a magic box. And when the interior of the bag is so cleverly designed that it seems to arrange the life of its owner as they would themselves. Fontana's designs are timeless and seem as modern today as they did 70 years ago. Even today, Valextra bags are not designed to set trends. They are forever. The products have always come without logos and therefore tend to become real status symbols. Oprah Winfrey never travels without the famous Italian cream luggage and sends it back to the factory once a year for cleaning. You could say Valextra is the label for the private jet set.

In der Mailänder Ledermanufaktur dreht sich alles um Handwerkskunst, Liebe zum Detail und Sonderanfertigungen. Aber nur wirkliche Connaisseure würden ein Valextra-Modell am Arm einer Frau von weitem erkennen. 1937 wurde die Manufaktur von Giovanni Fontana gegründet – und bis heute hat sich an der Philosophie nichts geändert: wahrer Luxus ist der, den man nicht sieht. Wahren Luxus fühlt man. Zum Beispiel, wenn man eine von außen steif erscheinende Tasche öffnet und der Verschluss aufspringt wie ein Zauberkasten. Und wenn das Innenleben der Tasche so clever gestaltet ist, dass es der Trägerin wie von selbst das Leben ordnet. Fontanas Entwürfe sind zeitlos und wirken heute noch so modern wie vor 70 Jahren. Und auch jetzt werden Valextra-Taschen nicht designt, um Trends zu setzen. Sie sind für immer. Die Modelle kommen seit jeher ohne Logo aus und sind wahrscheinlich deshalb zu echten Statussymbolen geworden. Oprah Winfrey reist übrigens nur mit dem berühmten cremeweißen Gepäck der Italiener und lässt es einmal im Jahr in der Manufaktur reinigen. Man könnte auch sagen Valextra ist das Label der Privatjet-Flieger.

Dans la manufacture du cuir de Milan, tout tourne autour de l'artisanat, de l'amour du détail et des produits spécialisés. Cependant, seuls les experts reconnaîtraient de loin un modèle Valextra au bras d'une femme. La manufacture de Giovanni Fontana fut fondée en 1937 et jusqu'à maintenant, rien n'a changé dans la philosophie de Valextra : le luxe véritable est celui qui ne se voit pas mais il est aussi palpable. Par exemple, lorsqu'on ouvre un sac à l'apparence rigide et que le fermoir s'ouvre en sautant à la manière d'un coffret de magie. Et lorsque la vie intérieure du sac est conçue si intelligemment que l'existence de celle qui le porte s'organise d'elle-même. Les créations de Fontana sont intemporelles et sont aujourd'hui encore aussi modernes qu'il y a 70 ans. Et encore de nos jours, les sacs Valextra ne sont pas réalisés dans l'optique de lancer des modes. Ils s'inscrivent dans l'éternité. Les modèles n'ont, de tout temps, pas eu besoin de logos. C'est certainement la raison pour laquelle ils ont le statut d'icône. Oprah Winfrey voyage toujours avec le célèbre bagage couleur crème et le fait nettoyer une fois par an dans la manufacture de Valextra. On peut dire qu'un sac Valextra est le symbole de ceux qui voyagent à bord de jets privés.

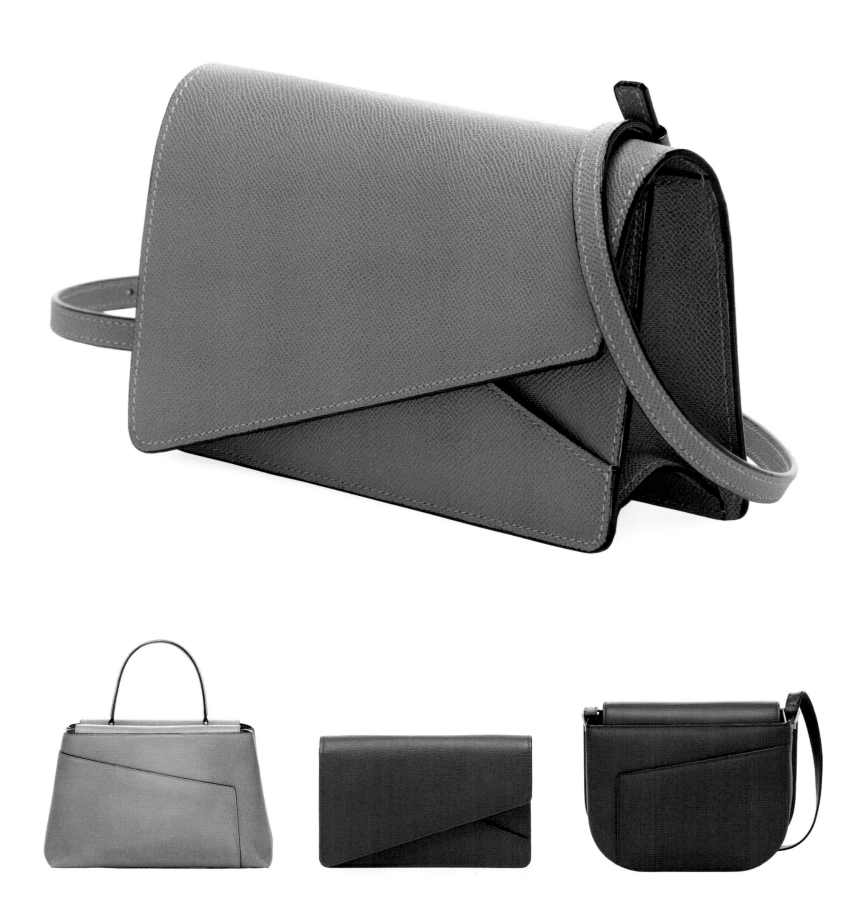

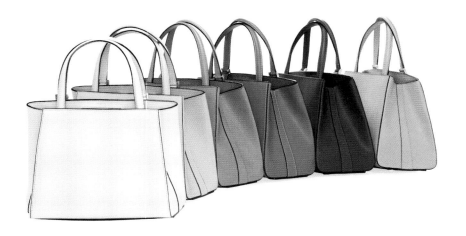

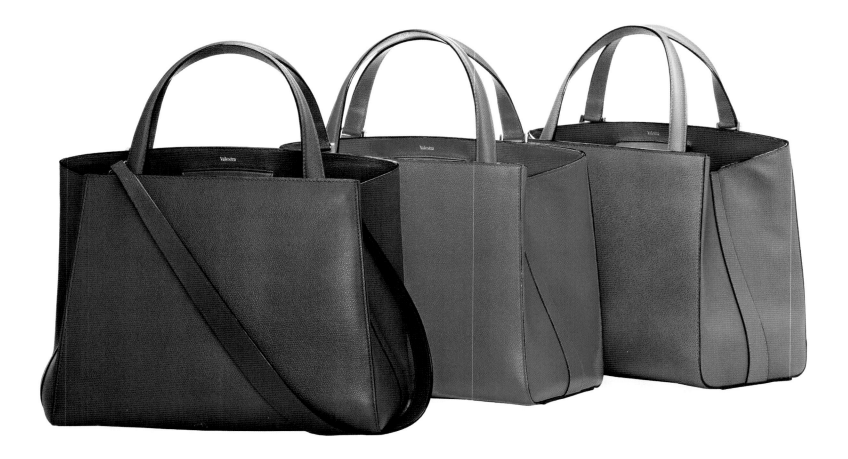

The Triennale and other models are available in various colors.

Die Triennale und andere Modelle gibt es in zahlreichen Farben.

Le sac Triennale et d'autres modèles existent dans divers coloris.

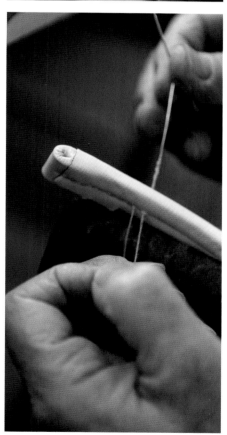

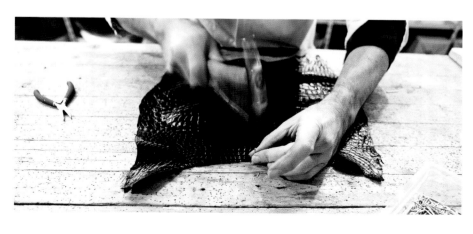

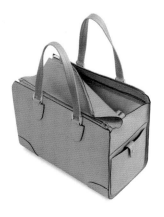

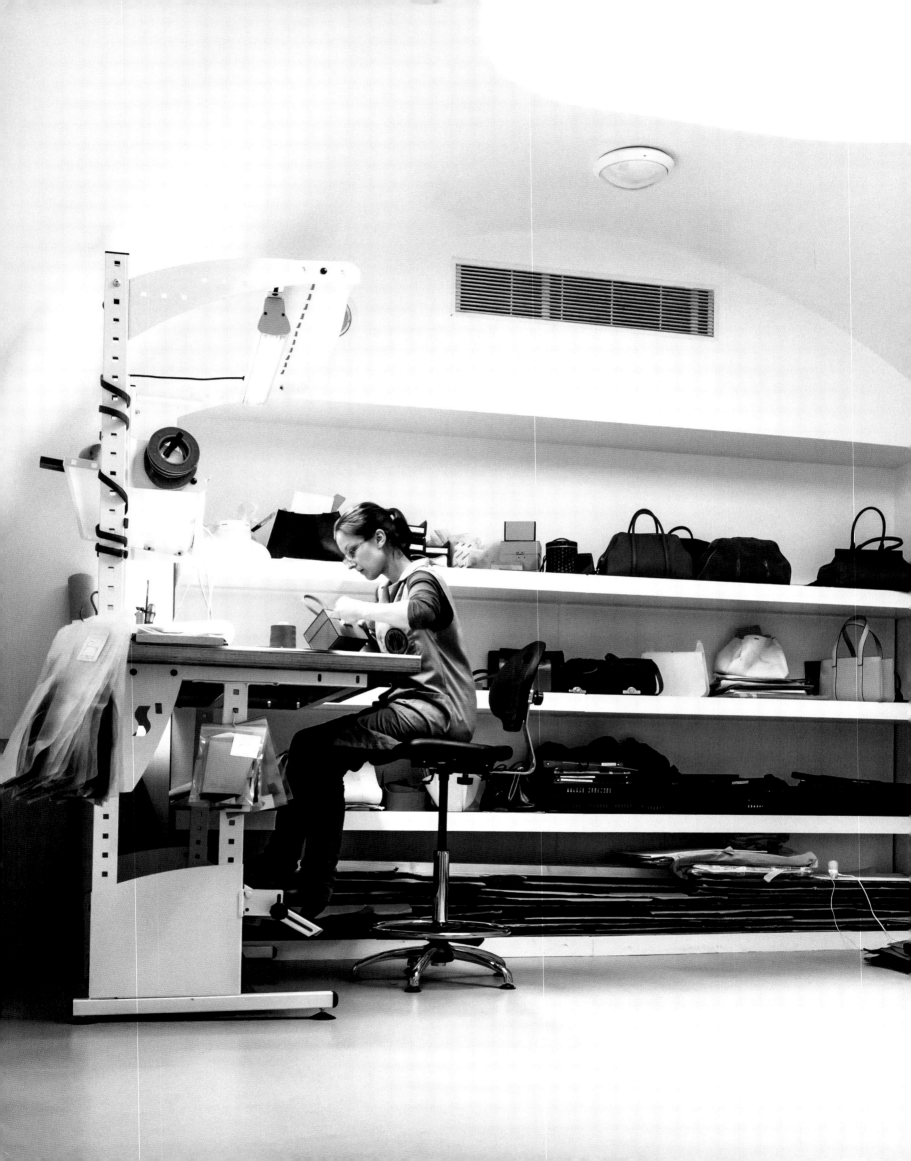

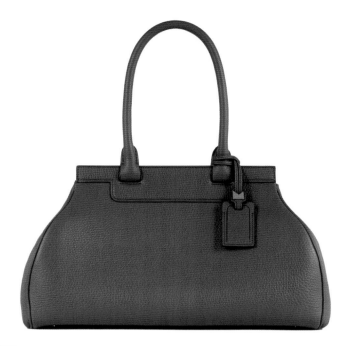

MOYNAT

Jeanne Lanvin may have been the fashion industry's first businesswoman, but Pauline Moynat started an atelier for handbags forty years earlier. The Frenchwoman had the idea to optimize the size of suitcases and picnic baskets for transport by train. Her big breakthrough, however, came with the popularization of the automobile, because the earliest cars did not have a trunk. Suddenly, all of Paris was ordering customized luggage from Moynat's 250 employees, something for the roof or the inside of the spare tire, color-coordinated to match the car, lightweight, and waterproof. The venerable business on the Avenue de l'Opéra closed in 1976, as every car came with a trunk. However, luxury goods company Groupe Arnault revived Moynat in 2010. The atelier now has seven leatherworkers, who spend up to two days making each finished Pauline bag, a modern take on the classic top handle handbag named for the company's founder. Humorous interpretations of Moynat's origins are available as well in the form of the Limousine bag and the Train bag, which was designed by Pharrell Williams.

Es mag sein, dass Jeanne Lanvin die erste Geschäftsfrau in der Mode war. Pauline Moynat gründete jedoch bereits 40 Jahre vor ihr ein Atelier für Taschen. Die Französin hatte die Idee, das Format von Koffern und Picknickkörben für den Transport mit der Eisenbahn zu optimieren. Ihr Durchbruch kam im Zuge der Verbreitung des Automobils, denn die ersten Wagen besaßen noch keinen Kofferraum. Plötzlich bestellte ganz Paris bei Moynats 250 Angestellten maßgeschneidertes Gepäck, zum Beispiel für das Dach oder den Innenraum des Ersatzreifens, im Farbton der Karosserie, leicht und wasserdicht. 1976 schloss das Geschäft an der Avenue de l'Opéra. Der Kofferraum war mittlerweile serienmäßig. 2010 wurde Moynat vom Luxuskonzern Groupe Arnault wiederbelebt. Sieben Täschner zählt das Atelier seitdem. Bis zu zwei Tage brauchen sie vom Prototypen bis zum fertigen Modell der Pauline, einer modernen, nach der Gründerin benannten klassischen Henkeltasche. Auch humorige Interpretationen der Ursprünge Moynats finden sich im Sortiment, in Form der Limousine oder der Train Bag, die übrigens von Pharrell Williams entworfen wurde.

S'il est vrai que Jeanne Lanvin fut la première femme d'affaires dans le domaine de la mode, Pauline Moynat fonda cependant, 40 ans plus tôt, un atelier pour sacs. La Française eut l'idée d'optimiser le format des valises et corbeilles de pique-nique pour les voyages en train. Sa percée survint lors de l'envol de l'automobile car les premières voitures ne possédaient pas encore de coffre. Soudain, tout Paris commanda aux 250 employés de Moynat des bagages faits sur mesure, par exemple pour le toit ou l'intérieur des pneus de rechange, assortis à la carrosserie, légers et imperméables. En 1976, la boutique située avenue de l'Opéra ferma, le coffre étant produit désormais en série. En 2010, Moynat fut réanimé par le groupe de luxe Groupe Arnault. L'atelier compte sept maroquiniers. Il leur faut deux jours pour fabriquer à partir du prototype le modèle Pauline, un sac classique et moderne portant le nom de sa créatrice. Des interprétations humoristiques, des modèles originaux de Moynat font partie de la gamme, sous les traits d'un sac en forme d'une limousine ou d'un train, réalisés, du reste, par Pharrell Williams.

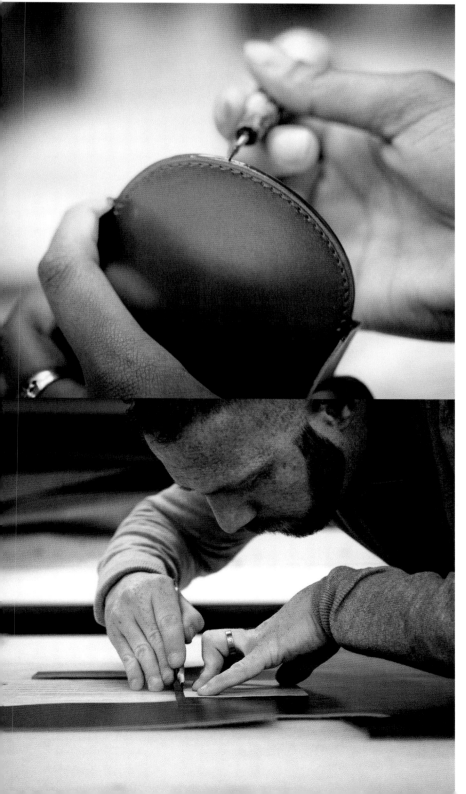

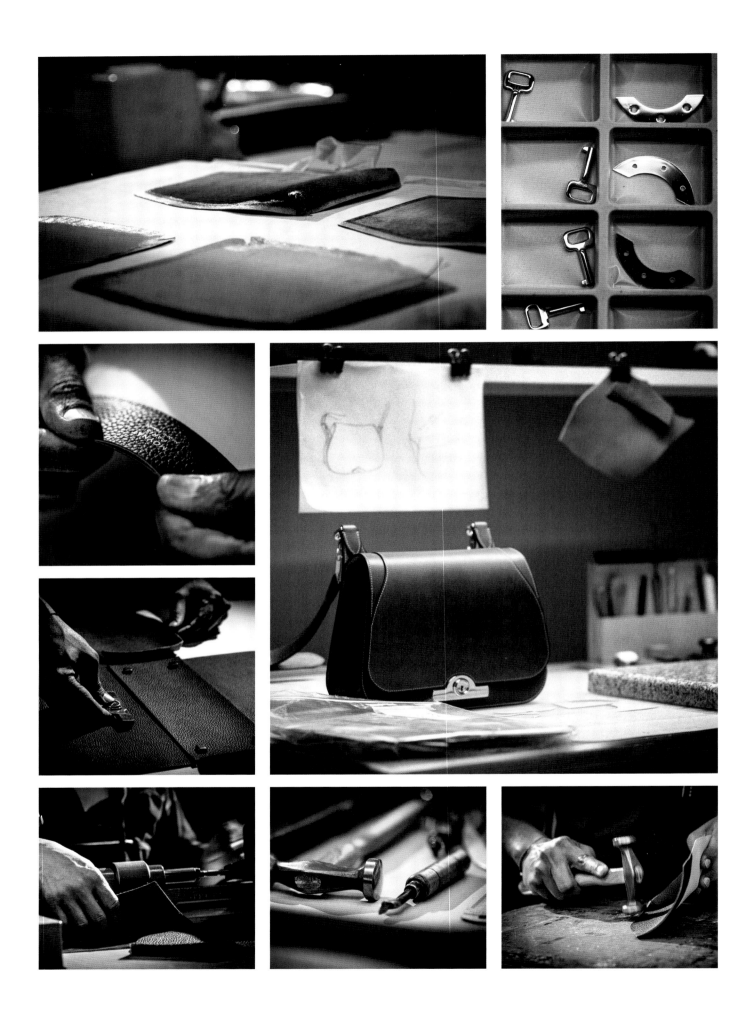

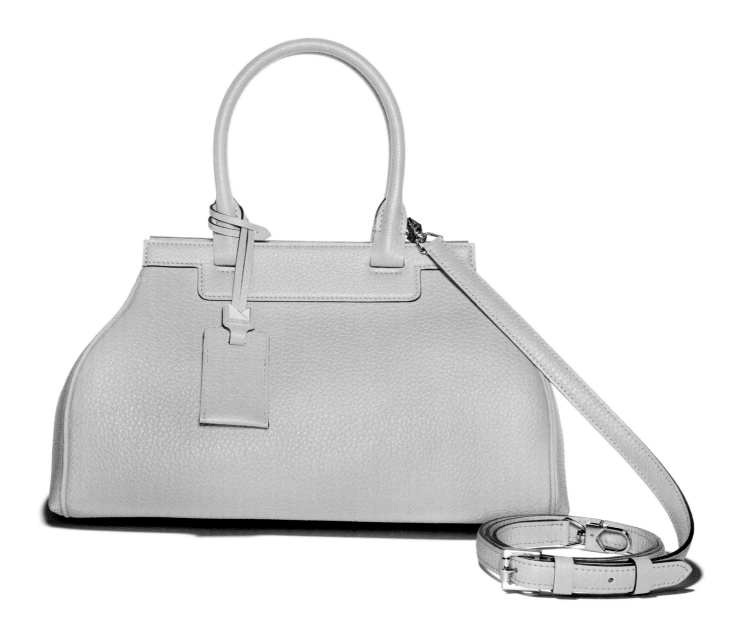

In the Saddle Bag (left), in the Pauline (top), and in any other Moynat bag, you will find loving dedication.
That's because each is made by a single artisan leatherworker.

In der Saddle Bag (links), in Pauline (oben) und in jeder anderen Tasche von Moynat steckt liebevolle Hingabe.
Weil jede von einem einzigen Täschner gemacht wird.

Moynat voue une passion ardente à chaque sac, comme par exemple au Saddle Bag (à gauche) ou au Pauline (en haut).
Chaque sac est réalisé par un seul et unique artisan maroquinier.

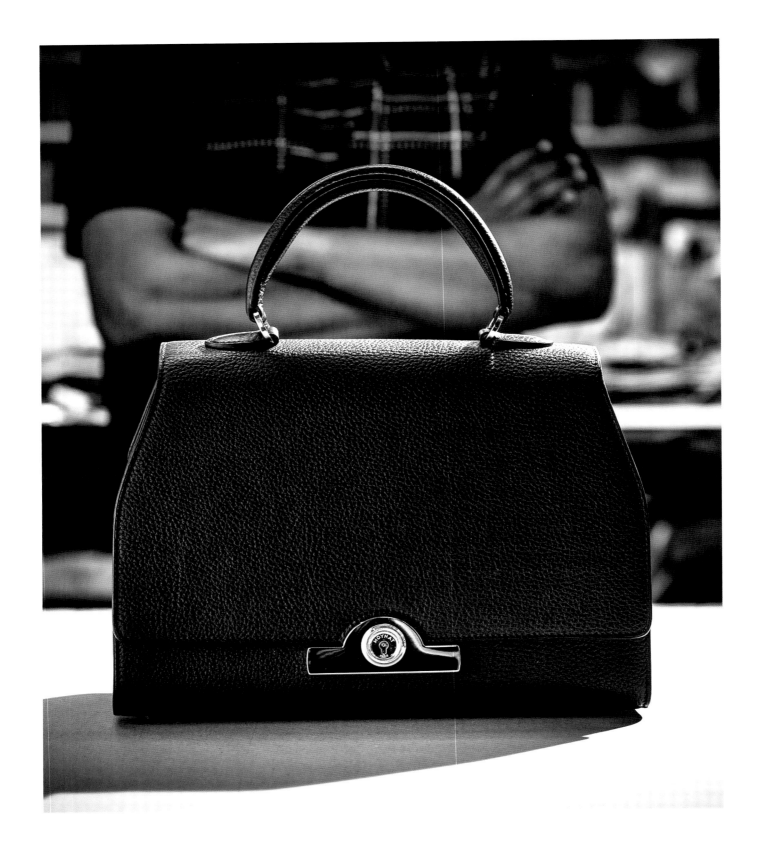

The Réjane (above and right) is one of the most sought-after Moynat models.
The French label's roots lie in the manufacture of luggage—like all iconic bag manufacturers.

Die Réjane (oben und rechts) gehört zu den gefragtesten Modellen von Moynat.
Die Wurzeln hat das französische Label in der Herstellung von Reisegepäck – wie alle legendären Taschenhersteller.

Le Réjane (en haut et à droite) compte parmi les modèles les plus convoités de Moynat.
La marque française puise ses racines dans la réalisation de bagages, comme tous les légendaires fabricants de sacs.

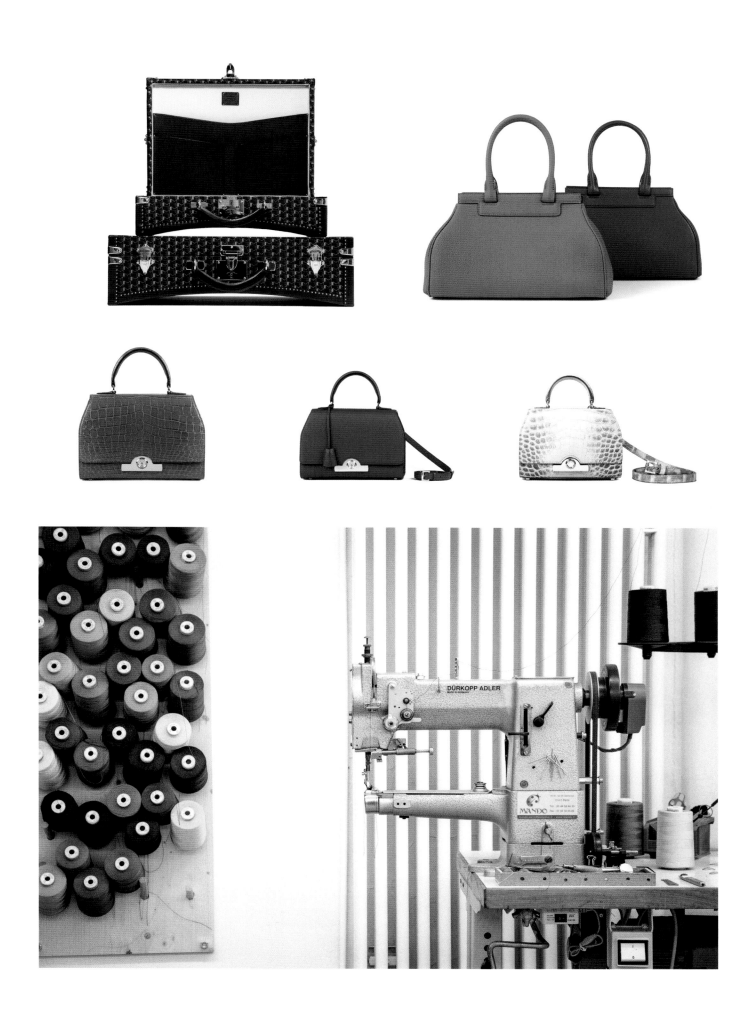

INSTA BAGS

—

Colorful, personalized, embroidered: Insta Bags are the new generation of It Bags. They are the darlings of street style photographers and have become famous thanks to social media and blogs. But of course it's not just about the what, but definitely about the how as well. From supersize clutches for day use to the crossbody trend, the codes of purse carrying are in constant flux. And the street style bloggers are documenting it all.

Bunt, personalisiert, bestickt: Insta Bags sind die neue Generation der It-Bags. Weil sie die Lieblinge der Streetstyle-Fotografen sind und durch Social Media-Kanäle und Blogs Berühmtheit erlangt haben. Aber natürlich geht es nicht nur um das Was. Sondern vor allem auch ums Wie. Von XL-Clutches am Tag bis zum Crossbody-Trend: die Codes des Taschentragens verändern sich ständig. Und Streetstyle-Blogger sind ihre Chronisten.

Bigarrés, personnalisés, brodés, les sacs Instagram sont les it-bags nouvelle génération. Ces chouchous des photographes du street style doivent leur célébrité aux médias sociaux, en particulier aux blogs. Mais il s'agit bien sûr moins du « quoi » que du « comment » : clutch XL pour la journée ou cross-body ? Les codes qui régissent le port d'un sac sont en constante évolution. Et les blogueurs du street style en font la chronique.

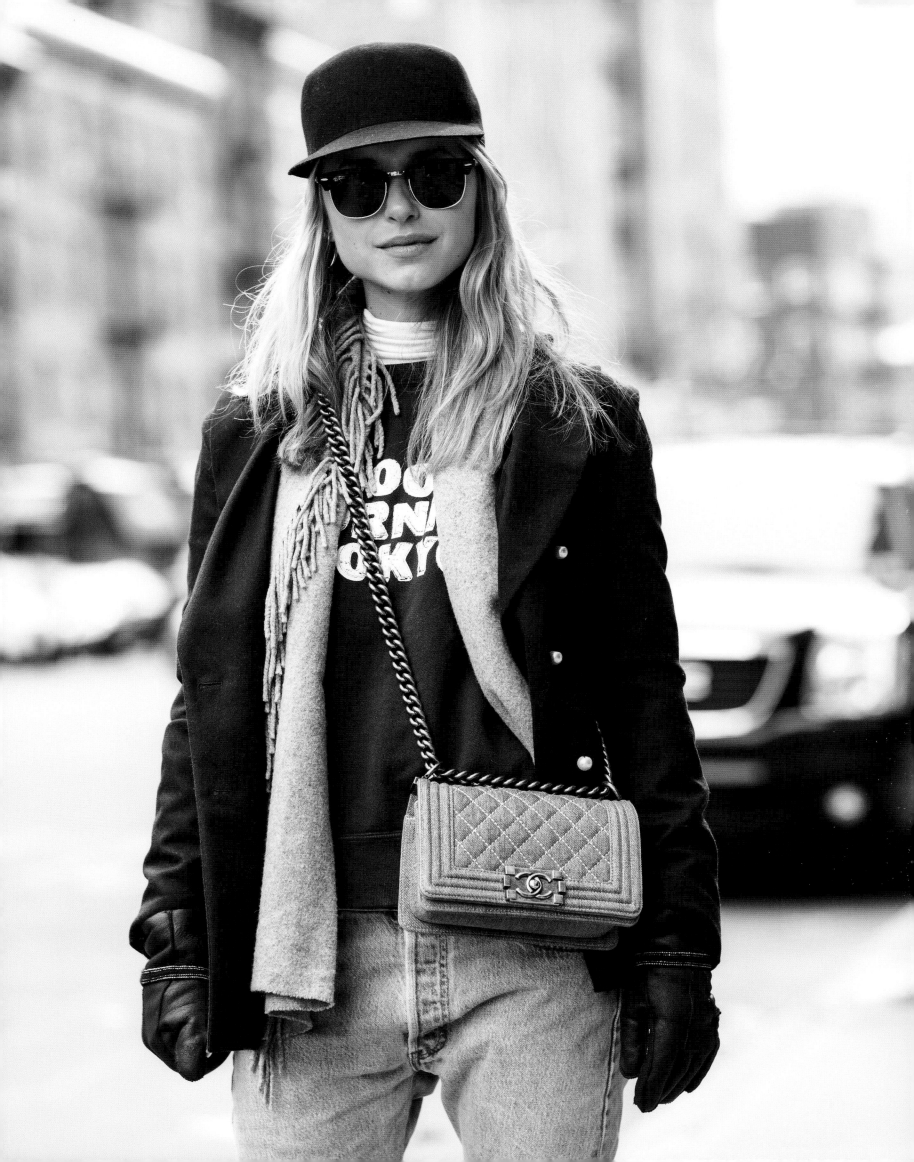

CHANEL
BOY

Coco Chanel took material intended for men's underwear and made jersey dresses out of it. As Karl Lagerfeld famously said, she had a "boyish attitude" she acquired from the love of her life, a man by the name of Boy Capel. Coco's love received an homage in 2011 in the form of a purse that became an instant classic. The Boy is actually quite the chameleon: it comes in velvet, tweed, leather, and has tons of embellishment options, which has made it a star on Instagram and in the closets of women around the world.

Coco Chanel machte aus Stoffen für Herrenunterwäsche Jerseykleider. Sie hatte, wie Karl Lagerfeld einmal sagte, eine „boyish attitude" – abgeschaut von ihrer großen Liebe, einem Mann namens Boy Capel. 2011 erhielt Cocos Liebe eine Hommage in Form einer Tasche, die sofort zum Klassiker wurde. Dabei ist die Boy ein Chamäleon: Samt, Tweed, Leder und unzählige Embellishment-Varianten haben sie zum Star gemacht – auf Instagram und in den Kleiderschränken von Frauen auf der ganzen Welt.

Coco Chanel créait des robes dans du jersey, une matière utilisée à l'époque pour les sous-vêtements masculins. Comme Karl Lagerfeld le remarquait un jour, elle avait une « attitude garçonne », imitant en cela son grand amour, « Boy » Capel. En 2011, un sac à main rapidement devenu un classique rend hommage à cet amour. Véritable caméléon se parant de velours, de tweed, de cuir et de détails déclinables à l'infini, le sac Boy est une star, sur Instagram et dans les garde-robes féminines aux quatre coins du monde.

BOY BAG IN BLACK, CHANEL

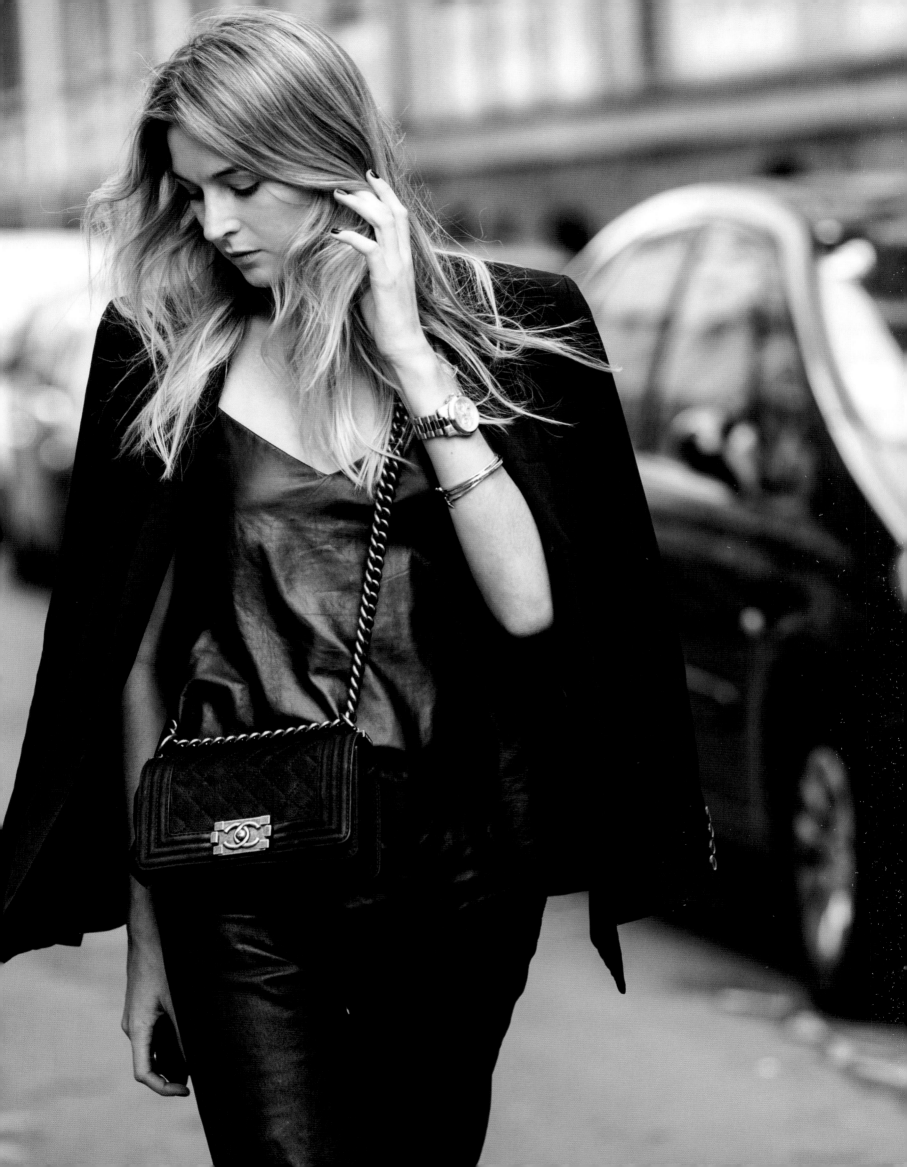

PAULA CADEMARTORI

—

The new generation of accessory designers has made it to the top without huge advertising budgets. The best example of this is Paula Cademartori. The Italian designer with Brazilian roots launched her label in 2010 and became a new superstar in just a few seasons. How? Not only because her bags are made in Italy, but because every detail of her playful designs, from leather insets to intricate appliqués, makes a street style photo that much more exciting—not to mention the woman carrying the bag.

Die neue Generation der Accessoire-Designer hat es ohne große Werbebudgets nach ganz oben geschafft. Bestes Beispiel: Paula Cademartori. Die italienische Designerin mit brasilianischen Wurzeln gründete ihr Label 2010 und wurde innerhalb weniger Saisons zum neuen Superstar. Warum? Nicht nur, weil ihre Taschen Made in Italy sind. Jedes Detail ihrer verspielten Entwürfe, von Leder-Intarsien bis zu aufwändigen Applikationen macht ein Streetstyle-Foto aufregender. Und den Look einer Frau sowieso.

La nouvelle génération de créateurs d'accessoires s'est hissée au firmament sans battage publicitaire. Le meilleur exemple en est Paula Cademartori, Italienne aux origines brésiliennes. Elle fonde sa marque en 2010 et devient la nouvelle superstar en l'espace de quelques saisons. Pourquoi ? Pas uniquement parce que ses sacs sont « made in Italy », mais parce que chaque détail de ses créations ultravitaminées, du patchwork en cuir aux applications sophistiquées, donne du piment à une photo de street style. Et, il va sans dire, au look d'une femme.

BRIGHT COLORS PLAY SUCH A GREAT ROLE IN MY CREATIONS

INTERVIEW
WITH PAULA CADEMARTORI

Ms. Cademartori, when you enter your name on Google, the search engine suggests adding the term Instagram.

Seriously? I had hoped it would be "handbags." But really, I love Instagram and social media. I share daily moments, inspirations, just about anything I have encountered that is important for my work. It's great that people can understand what is behind me and my bags.

Shortly before our interview, Instagram could count 50 different hashtags with your name, over 100,000 posts in total.

This makes me very happy, of course. But I have also worked hard for it.

Your success story began in the period when industry members began to give a fashion platform to streetstyle photographers in order to increase their visibility on the Internet. To whom do you owe the most?

Anna dello Russo, of course. She really has an iconic style and a strong personality. She stopped by my showroom by chance during a Fashion Week, asked if she could borrow a bag, and that was it. She was photographed so often, and her images shared so much on the Net, that my phone was ringing off the hook. I am honored that people like her understood and picked up my design language immediately.

Which, just like Anna dello Russo's outfits themselves, has been very colorful and expressive from the beginning, and not without reason.

Of course, it has matched well and perhaps provoked more than very plain designs. Bright colors play such a great role in my creations; I'm Brazilian, they are part of my culture. I love to use time and again not only surprising combinations, but also mixing the most different materials. It's about having fun and making such a serious world a little bit more colorful, it's my way to express my very personal point of view on everything that surrounds us.

Was it easy to turn your creative success into a commercial one?

I always wanted to build my own business, with a great team around me to make progress. That's why I not only studied for a master's degree in accessories in Milan at the Marangoni Institute, but also earned a Fashion Manager certificate at the SDA Bocconi. Every project needs a solid base, and I tackle everything with a certain business acumen. It doesn't work any other way these days.

To what extent does it really help to be successful in social media channels when it comes to gaining the attention of the major fashion magazines?

I must confess that I had my very first publication in a magazine in 2010, before I was ever on Instagram or Facebook. Of course, later on online platforms helped enormously to make my brand and products known in a hurry, which has also had an impact on collaboration with fashion magazines.

Will the Internet eventually displace printed fashion magazines?

Never. One side can not exist without the other. They are two different forms of communication that can only exist and be successful if they work together.

Frau Cademartori, wenn man Ihren Namen bei Google eingibt, liefert die Suchmaschine gleich den Zusatzbegriff: „Instagram"…

Ernsthaft? Ich hatte gehofft, es wären „Handtaschen". Aber ehrlich, ich liebe Instagram und Social Media. Ich teile täglich Momente, Inspirationen, einfach alles, was mir begegnet und wichtig für meine Arbeit ist. Es ist doch toll, dass Menschen so verstehen können, was hinter mir und meinen Taschen steckt.

Kurz vor unserem Gespräch zählte Instagram 50 verschiedene Hashtags mit Ihrem Namen, insgesamt über 100,000 posts…

Mich macht das natürlich sehr glücklich. Aber ich habe auch hart dafür gearbeitet.

Ihre Erfolgsgeschichte begann in der Zeit als sich Branchenmitglieder für Streetstyle-Fotografen modisch inszenierten, um ihren Bekanntheitsgrad im Internet zu steigern. Wem haben Sie am meisten zu verdanken?

Anna dello Russo, natürlich. Sie hat wirklich einen ikonischen Stil und eine starke Persönlichkeit. Sie kam während einer Modewoche durch Zufall an meinem Showroom vorbei, fragte, ob sie sich eine Tasche leihen könnte und das war's. Sie wurde so oft fotografiert und ihre Bilder im Netz geteilt, dass mein Telefon danach nicht mehr stillstand. Es ehrt mich, dass Leute wie sie meine Designsprache sofort verstanden und aufgegriffen haben.

Die war, wie ja auch die Outfits von Anna dello Russo selbst, nicht ohne Grund von Anfang an sehr bunt und expressiv…

Natürlich hat das zusammengepasst und vielleicht mehr bewirkt, als sehr schlichte Designs. Bunte Farben spielen bei mir eine so große Rolle, weil ich brasilianische

Wurzeln habe. Sie sind Teil meiner Kultur. Ich liebe es, immer wieder überraschende Kombinationen, aber auch verschiedenste Materialien einzusetzen. Es geht darum, Spaß zu haben und die sonst so ernste Welt ein bisschen bunter zu machen. Das ist meine Art meinen persönlichen Standpunkt zur Welt die uns umgibt auszudrücken.

War es leicht, aus dem kreativen auch einen wirtschaftlichen Erfolg zu machen?

Ich wollte immer ein eigenes Business aufbauen, ein großes Team um mich herum haben und vorankommen. Deshalb habe ich in Mailand am Institut Marangoni nicht nur den Master-Studiengang im Fach „Accessoires" belegt, sondern am SDA Bocconi auch das Zertifikat des „Fashion Manager" erworben. Jedes Projekt braucht eine solide Basis und ich gehe alles mit einem gewissen Geschäftssinn an. Anders funktioniert es heute nicht mehr.

Inwieweit hilft es wirklich in Social-Media-Kanälen erfolgreich zu sein, wenn es um die Aufmerksamkeit der ganz großen Modemagazine geht?

Ich muss gestehen, dass ich meine allererste Veröffentlichung in einem Magazin 2010 hatte, noch bevor ich überhaupt bei Instagram oder Facebook angemeldet war. Aber natürlich haben Online-Plattformen später extrem dabei geholfen meine Marke und Produkte in einer Schnelligkeit bekannt zu machen, die sich auch auf die Zusammenarbeit mit Modemagazinen ausgewirkt hat.

Wird das Internet irgendwann gedruckte Modemagazine verdrängen?

Niemals. Die eine Seite kommt nicht ohne die andere aus. Es sind zwei unterschiedliche Kommunikationswege, die nur bestehen und erfolgreich sein können, wenn sie miteinander arbeiten.

Madame Cademartori, lorsque nous entrons votre nom sur Google, le moteur de recherche nous livre immédiatement le terme « Instagram » ...

Sérieusement ? J'aurais espéré qu'il s'agirait de « sacs à main ». Mais, sincèrement, j'aime Instagram et les médias sociaux. Je partage quotidiennement des moments, des inspirations. Simplement, ceux avec lesquels se produit une confrontation, essentielle pour mon travail. N'est-il pas épatant que des êtres humains puissent comprendre ce qui se cache derrière moi et mes sacs ?

Peu avant notre conversation, Instagram comptait 50 hashtags avec votre nom, en tout plus de 100 000 posts ...

J'en suis naturellement très heureuse. Mais j'ai travaillé dur pour cela.

L'histoire de votre réussite débuta à l'époque où les membres de la branche se sont mis en scène sur le plan de la mode devant des photographes du street style, afin d'augmenter leur notoriété. Quelle est la personne à qui vous devez le plus ?

Anna dello Russo, naturellement. Elle a un style iconique et une personnalité forte. Elle passa par hasard à mon showroom pendant une « semaine de la mode » et demanda si elle pouvait emprunter un sac et voilà... Elle fut si souvent photographiée et ses photos si souvent partagées sur le réseau, que mon téléphone ne cessa de sonner par la suite. Cela m'honore que des gens comme elle comprennent mon langage de designer et aient recours à lui.

Il était, dès le début, et non sans raison, à l'image des tenues de Anna dello Russo elles-mêmes, très coloré et expressif

Bien sûr, cela est allé de pair et a, peut-être, eu plus d'effet que des designs très simples. Les couleurs vives jouent chez moi un rôle considérable parce que je possède des racines brésiliennes. Elles font partie de ma culture. J'aime particulièrement recourir à des combinaisons mais également à des matériaux étonnants. Il est important de s'amuser et de rendre le monde, si sérieux autrement, un peu plus coloré. Ceci est ma façon d'exprimer mon point de vue sur le monde qui nous entoure.

A-t-il été facile de transformer un succès créatif en une réussite économique ?

J'ai toujours voulu créer ma propre entreprise, avoir ma propre équipe autour de moi et progresser. C'est pourquoi j'ai suivi des cours dans le cadre du master en « accessoires » à l'Institut Marangoni à Milan ; j'ai également obtenu le certificat de « fashion manager » au SDA Bocconi. Chaque projet a besoin d'une base solide et j'aborde tout avec un certain sens des affaires. De nos jours, tout fonctionne comme cela.

Dans quelle mesure le succès dans les réseaux sociaux est-il vraiment utile lorsqu'il s'agit de capter l'attention des grands magazines de mode ?

Je dois avouer que j'ai obtenu ma première publication dans un magazine bien avant que je ne me sois enregistrée sur Instagram ou Facebook. Mais les plateformes en ligne ont plus tard largement contribué à faire connaître ma marque et mes produits à une vitesse qui a eu des répercussions sur ma collaboration avec des magazines de mode.

Est-ce que l'Internet évincera les magazines de mode ?

Jamais ! Ils ne peuvent pas vivre l'un sans l'autre. Ce sont deux différents moyens de communication qui ne peuvent exister et réussir l'un sans l'autre.

FAYE BAG, PAULA CADEMARTORI

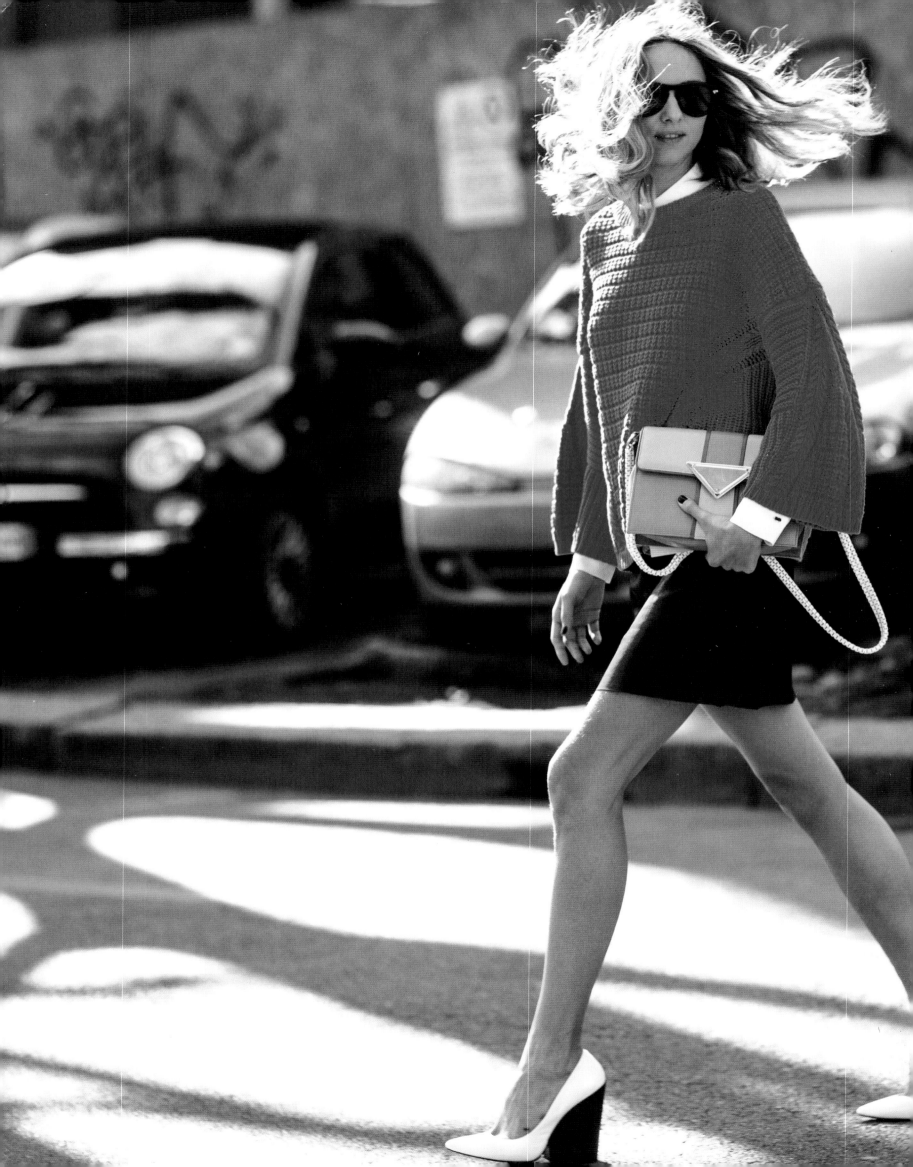

SARA
BATTAGLIA

Sara Battaglia is also part of the Insta Bags generation. She plays with fringe, embroidered details, new shapes—and she believes that a bag must enhance the female form as a vehicle for highlighting a woman's charm. The designer has long been a fashion industry darling. She got some great advertising from her sister Giovanna Battaglia, one of the most influential stylists and most-photographed women during the international fashion weeks.

Zur Insta-Bags-Generation gehört auch Sara Battaglia. Sie spielt mit Fransen, Stickereien, neuen Formen – und findet, eine Tasche müsse eine Akzentuierung der weiblichen Form sein, also etwas, das den Charme einer Frau unterstreicht. Die Designerin gehört längst zu den Darlings der Fashionbranche. Geholfen hat ihr dabei ein ziemlich guter Werbeträger: Ihre Schwester Giovanna Battaglia, eine der einflussreichsten Stylistinnen und meistfotografierten Frauen während der internationalen Fashion Weeks.

La génération des sacs Instagram compte aussi dans ses rangs Sara Battaglia. Cette créatrice qui joue sur les franges, broderies et nouvelles formes est d'avis qu'un sac doit mettre en valeur la féminité, c'est-à-dire souligner le charme d'une femme. Depuis longtemps enfant chérie de la mode, Sara Battaglia le doit à un support publicitaire plutôt efficace : sa sœur Giovanna Battaglia, qui est parmi les stylistes les plus en vue et les femmes les plus photographiées pendant les Fashion Weeks.

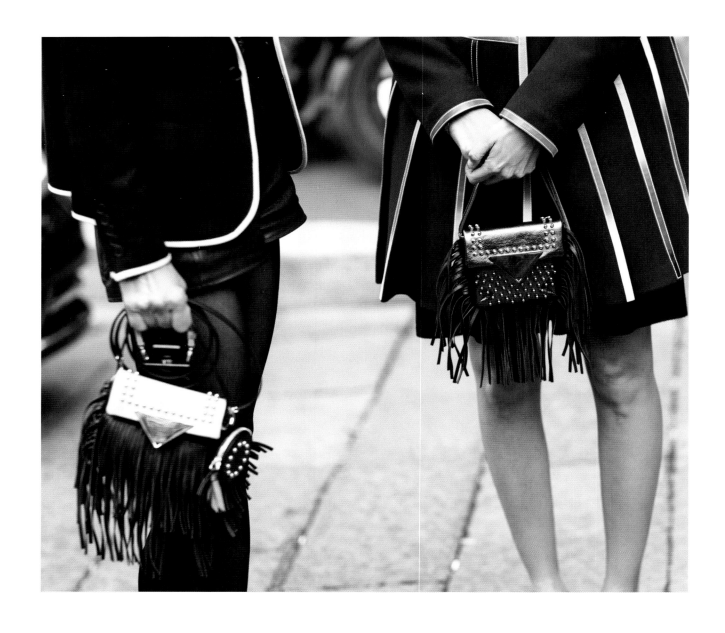

Fashion people love fringe—it's why they love bags by Sara Battaglia.

Fashion People lieben Fransen – und damit auch Taschen von Sara Battaglia.

Les fashion people affectionnent les franges et voilà pourquoi ils portent les sacs de Sara Battaglia.

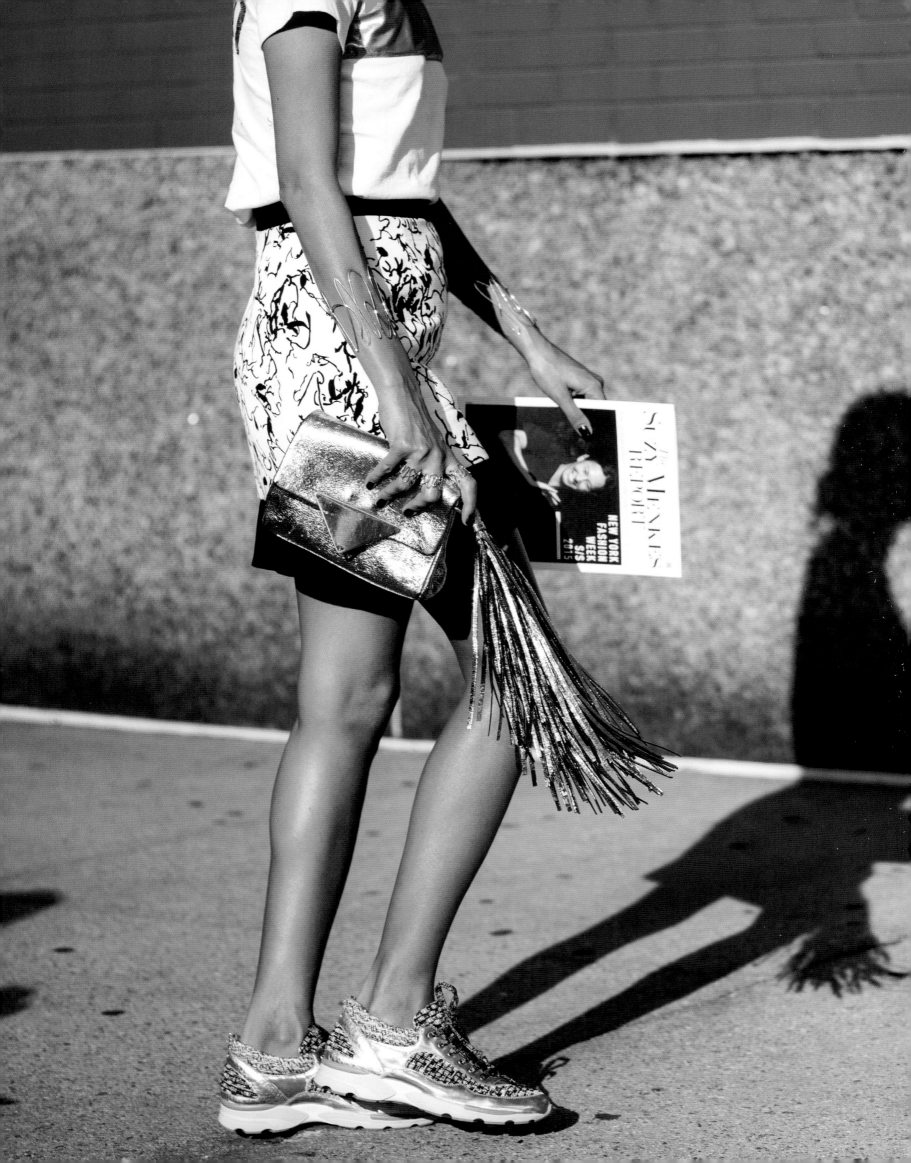

RISE OF THE
CLUTCH

Women used to carry clutches only after dark. After all, they needed to have their hands free during the day! But nothing exudes more chic than a clutch pressed under one's arm. This is why the day clutch, bigger and sleeker than its evening-wear cousin, marched to victory arm in arm with the street style photographers. Is it practical? Not even remotely. But it's the most elegant upgrade out there, even for simple denim looks.

Früher trugen Frauen die Clutch nur am Abend. Schließlich musste man tagsüber die Hände frei haben! Aber nichts versprüht mehr Chic als eine unter den Arm geklemmte Tasche. Weswegen die Day Clutch – größer und schlichter als die Abendvariante – ihren Siegeszug gemeinsam mit den Streetstyle-Fotografen antrat. Praktisch? Alles andere als das. Aber das eleganteste Upgrade, sogar für simple Denim-Looks.

Autrefois, les femmes se munissaient d'une pochette le soir uniquement. Parce qu'en journée, il fallait avoir les mains libres ! Mais rien n'apporte une telle touche d'élégance qu'une pochette calée sous le bras. Pourquoi l'avènement de la pochette de jour – plus grande et plus sobre que sa variante nocturne – coïncide-t-il avec celui des photographes du street style ? Parce qu'elle est pratique ? Loin s'en faut. Elle permet de rehausser avec une élégance extrême jusqu'aux sobres looks denim.

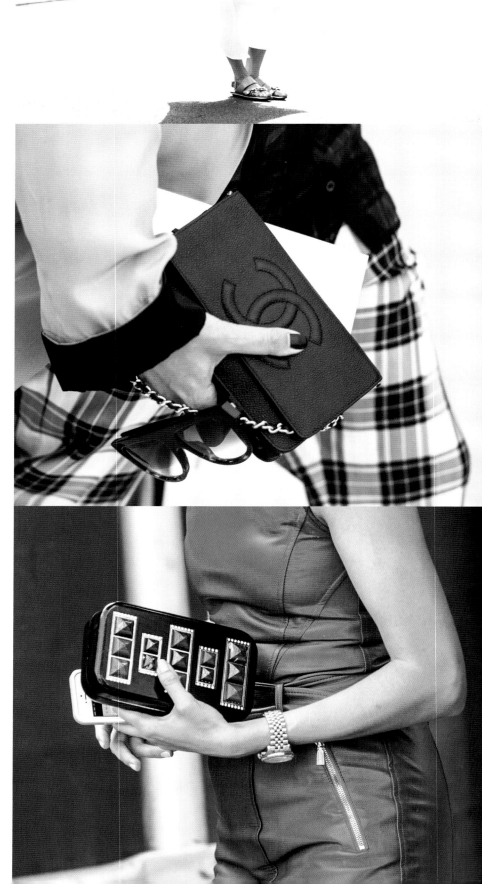

The experimenting began when clutches started getting bigger and were therefore suitable for everyday use—at least in fashion circles. It meant that eventually, you never had your hands free!

Das Spiel mit Taschen begann, als Clutches immer größer und damit alltagstauglich wurden. Zumindest in Fashionkreisen. Man hat damit schließlich niemals die Hände frei!

Le jeu avec les sacs débuta lorsque les pochettes commencèrent à être plus grandes et donc mieux adaptées à l'usage quotidien. Du moins dans le cercle de la mode. Somme toute, avec elles, on n'a jamais les mains libres !

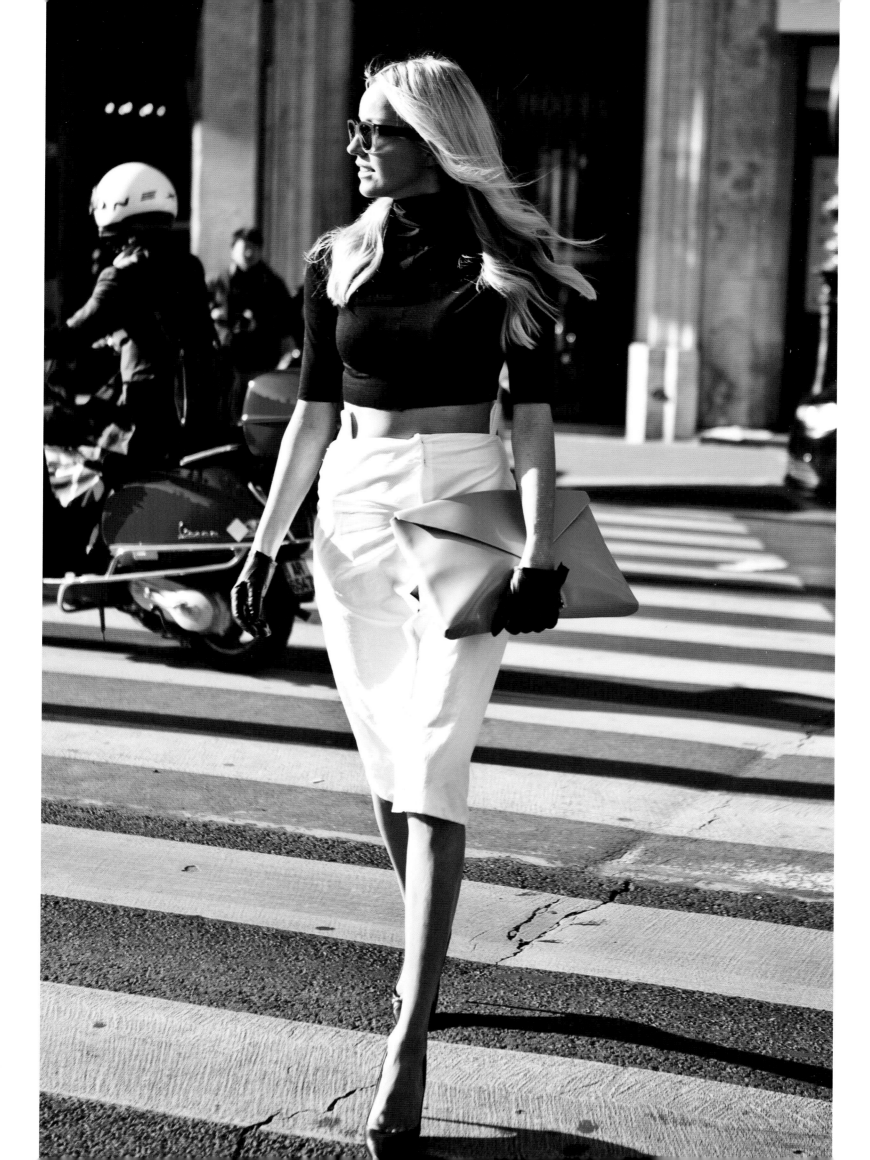

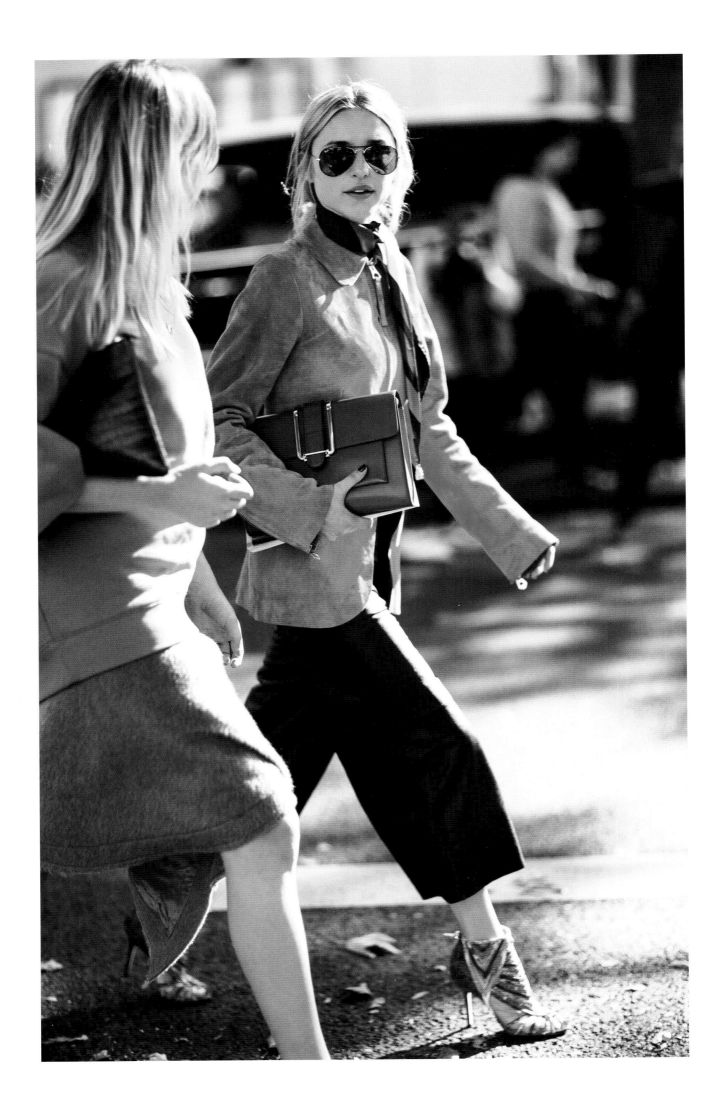

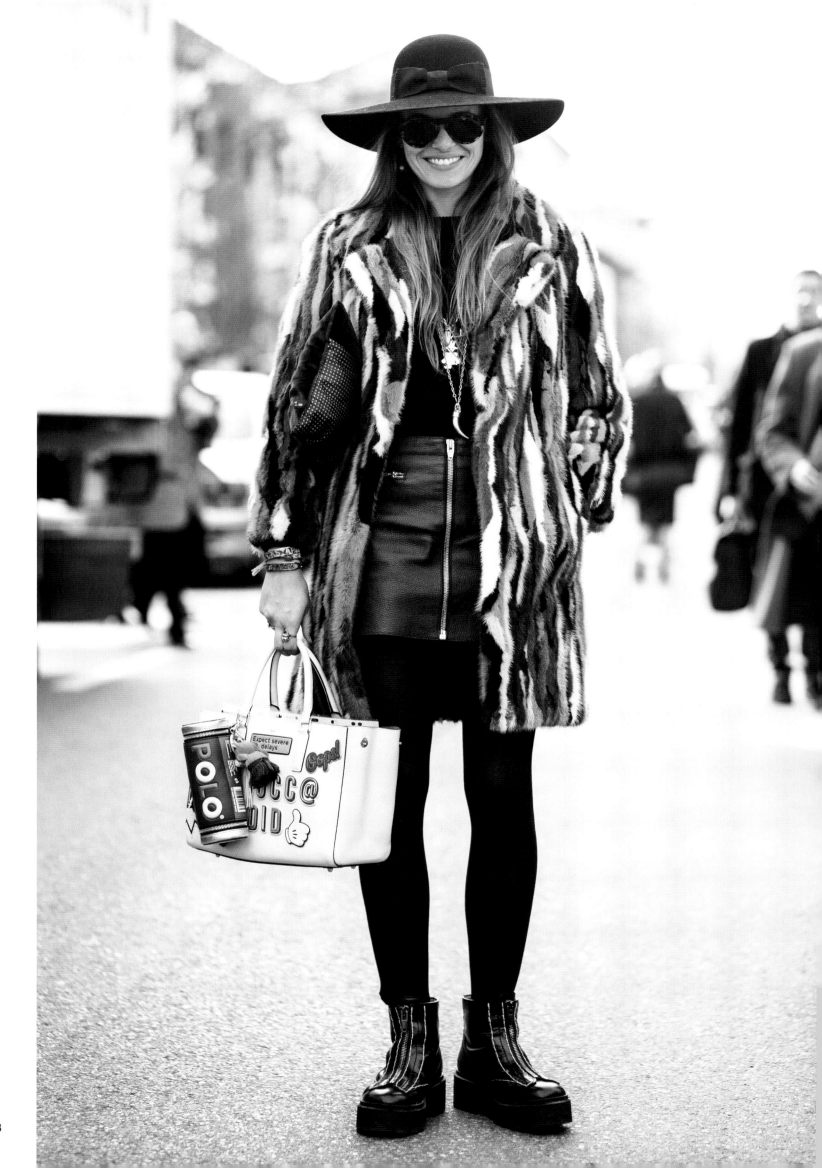

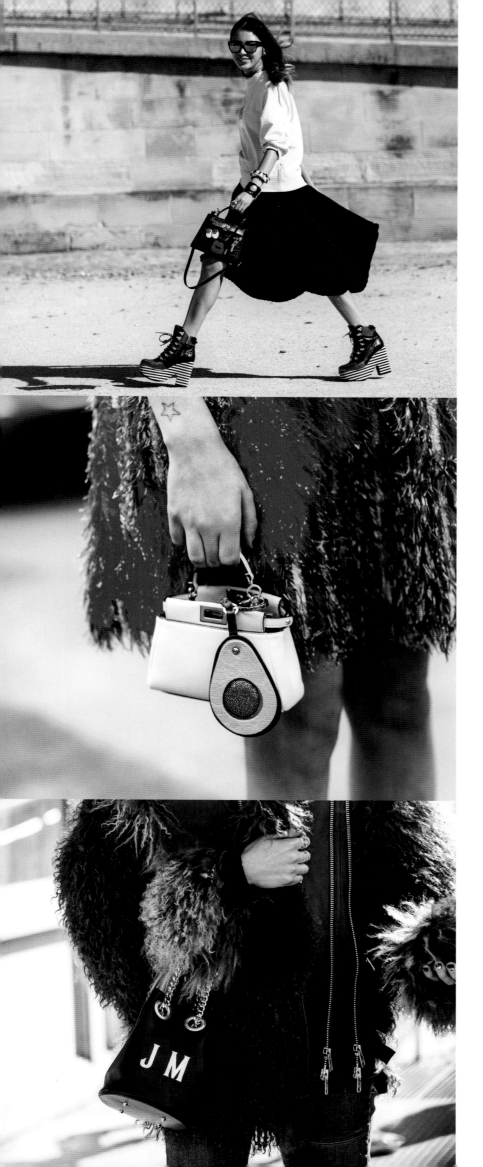

PERSONALIZED BAGS

The right bag? Anyone can buy one. But for true fashionistas, that's not special enough. So they decorate their bags with stickers from British designer Anya Hindmarch, handbag charms, or Fendi Fur Bag Bugs. However, this kind of customizing wasn't invented by any fashion house, but rather by Jane Birkin, the namesake of the famous Birkin bag. One of her own Birkins, personalized with stickers and charms, was auctioned off for charity in 2011.

Die richtige Tasche? Kann sich jede kaufen. Fashionistas ist das nicht individuell genug. Deshalb schmücken sie ihre Taschen: mit Bag-Stickers der englischen Designerin Anya Hindmarch. Oder mit Anhängern. Oder mit Bag-Bugs von Fendi aus Pelz. Erfunden hat diese Art des Customizings allerdings kein Modehaus, sondern Jane Birkin, Namensgeberin der berühmten Birkin Bag. Eine ihrer eigenen Birkins, personalisiert mit Aufklebern und Anhängern, wurde 2011 bei einer Charity-Auktion versteigert.

Acheter le bon sac ? Là n'est pas le problème. En mal d'individualisation, les fashionistas customisent leurs sacs avec des stickers de la styliste anglaise Anya Hindmarch, des pendentifs ou encore des bag-bugs en fourrure signés Fendi. Cette tendance n'a pas été lancée par un couturier, mais par Jane Birkin, qui a donné son nom à un sac iconique. En 2011, dans le cadre d'une vente aux enchères de bienfaisance, l'actrice et chanteuse vend son Birkin original, personnalisé par ses soins au moyen de stickers et pendentifs.

BAG: SAINT LAURENT
EMBELLISHMENT: PURE FANTASY!

Bag stickers by Anya Hindmarch, Fendi's fur Karlito, and what one is yet to find elsewhere—
when personalizing your own bag, you can do anything. The main thing is to do a lot and mainly with color!

Bag Sticker von Anya Hindmarch, Fendis Pelz-Karlito und was man sonst noch so findet –
beim Personalisieren der eigenen Tasche ist alles erlaubt. Hauptsache viel. Hauptsache bunt!

Les stickers pour sacs d'Anya Hindmarch, le Karlito en fourrure de Fendi et bien plus encore :
tout est permis pour personnaliser son sac. Le principal, la diversité des idées ! Des couleurs, aussi !

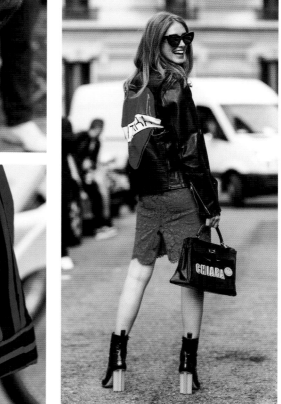

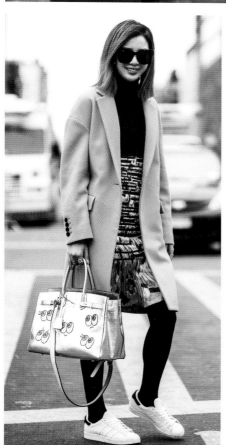

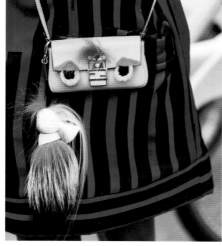

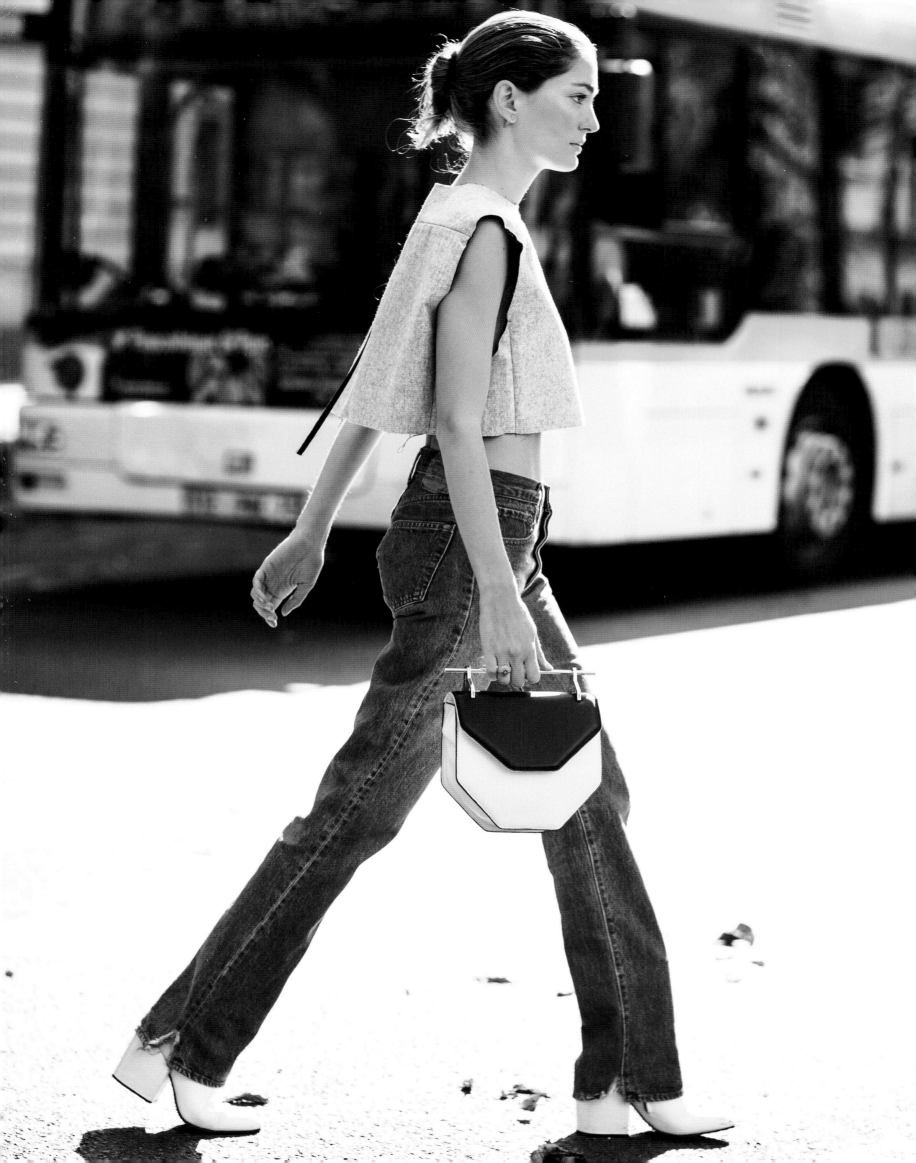

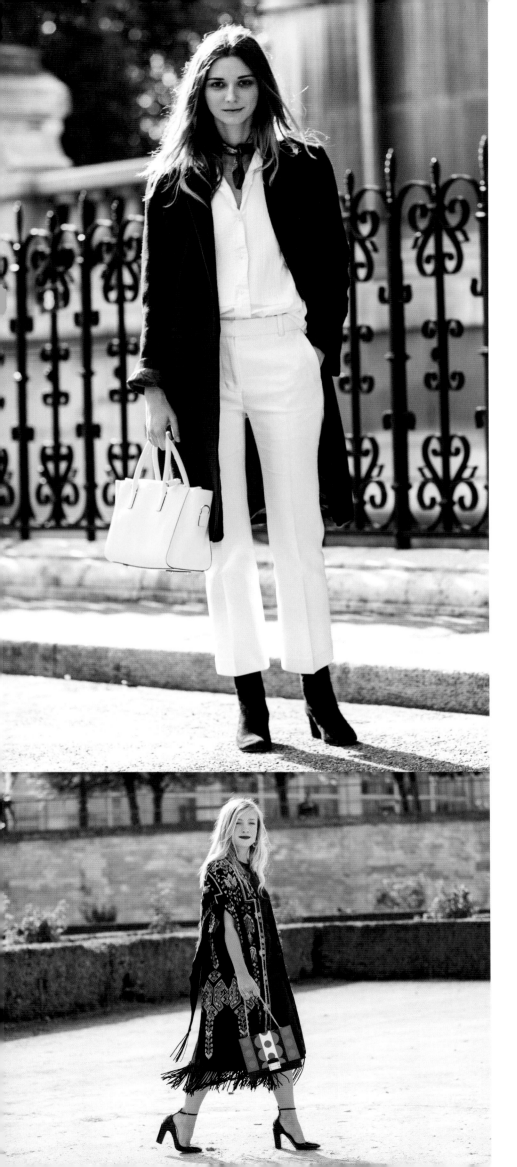

BAGS WITH TOP HANDLES

It's the bag every woman has: the kind with a top handle. After all, half a woman's life can fit inside. And she can wear the bag however she wants: carried in her hand or casually dangling from her wrist, as women used to do in the '50s. This is actually the preferred method among fashionistas, because it lets you smoke or type—even both at the same time—on your iPhone oh so elegantly.

Die Tasche, die jede Frau besitzt: das Modell mit Top Handle. Schließlich passt das halbe Leben einer Frau hinein. Und sie kann sie so tragen, wie es ihr gerade passt: Entweder in der Hand oder lässig am Unterarm baumelnd, wie bei den Damen in den 1950er-Jahren. Unter Fashionistas ist dies die bevorzugte Art sie zu tragen, weil man so elegant rauchen und ins iPhone tippen kann. Manchmal sogar gleichzeitig.

Toutes les femmes en ont un : le sac à anses. Elles y fourrent une multitude de choses, toutes nécessaires bien sûr ! Et libre à elles de le porter à bout de bras ou dans le creux du coude, comme les ladies des années 1950. Cette manière de le porter est d'ailleurs la plus en faveur auprès des fashionistas, car elle leur permet de fumer ou de pianoter sur son smartphone en toute élégance. Voire de faire les deux en même temps.

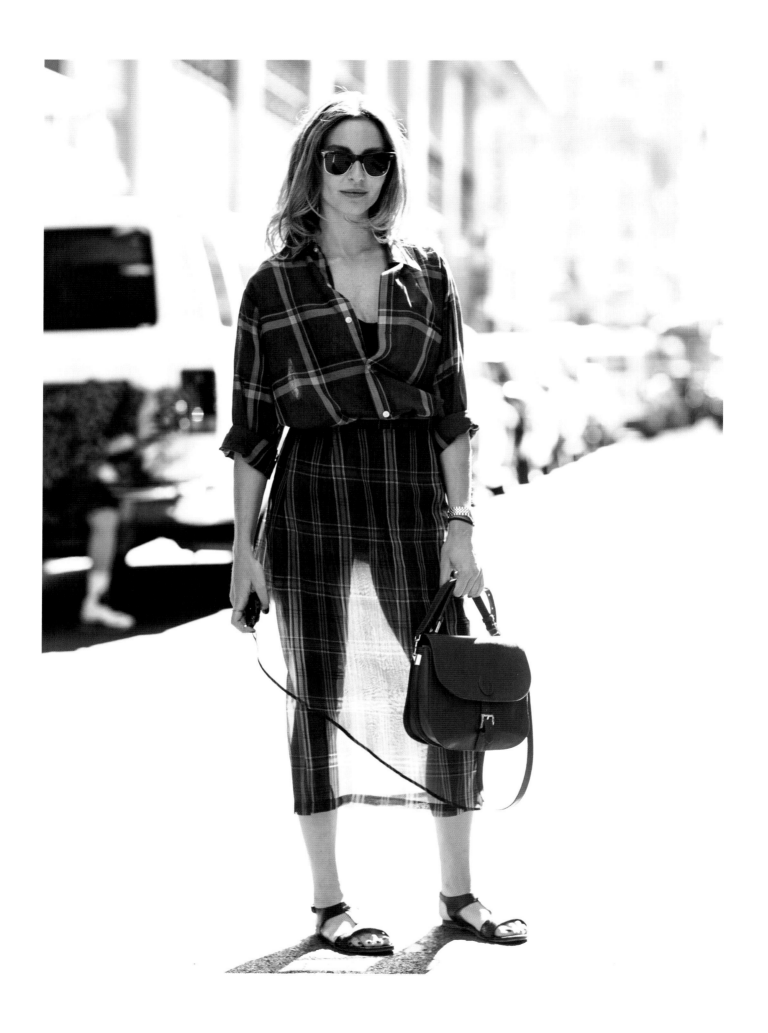

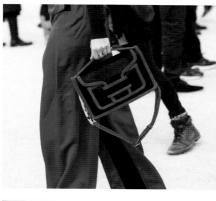
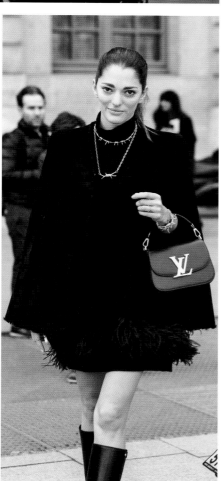

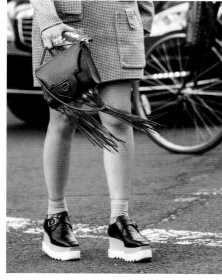

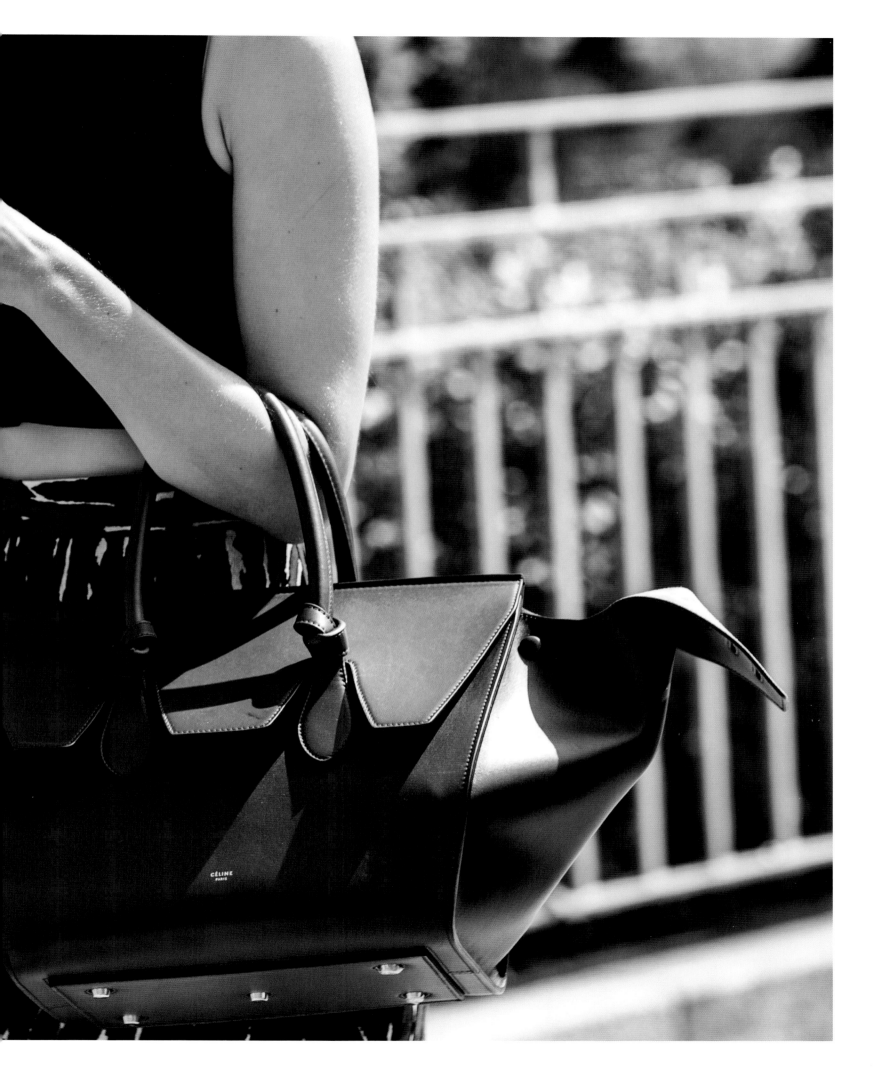

OVER THE
SHOULDER

Why is it that one season, we're carrying our bags in our hands, and in the next, they're slung over our shoulders? How you wear a purse is part of the Code of Chic, just as important as the right skirt length. And then, of course, there are also the official fashion trends. For bags that dangle down to at least the hip, it is a result of the big comeback of '70s styles; they go so well with a high-waisted look.

Woran liegt es, dass wir Taschen in einer Saison noch in der Hand und in der nächsten überlang an der Schulter tragen? Wie man eine Tasche trägt, ist ein Code of Chic, genauso wichtig wie die richtige Rocklänge. Und dann wären da natürlich noch die offiziellen Modetrends. So sind Bag-Styles, die mindestens auf Hüfthöhe baumeln, eigentlich nur eine logische Folge des großen Seventies-Comeback. Denn sie passen so schön zum High Waisted Look.

Comment se fait-il que des sacs que l'on tient à la main une saison se portent à l'épaule la saison suivante ? La manière de porter un sac est un code du chic, tout aussi important que la bonne longueur de jupe. Ajoutons bien sûr à cela les tendances des podiums. Ainsi les sacs qui pendent au moins jusqu'aux hanches ne sont en fait qu'une suite logique du grand retour des années 1970, eux qui vont si bien avec la mode taille haute.

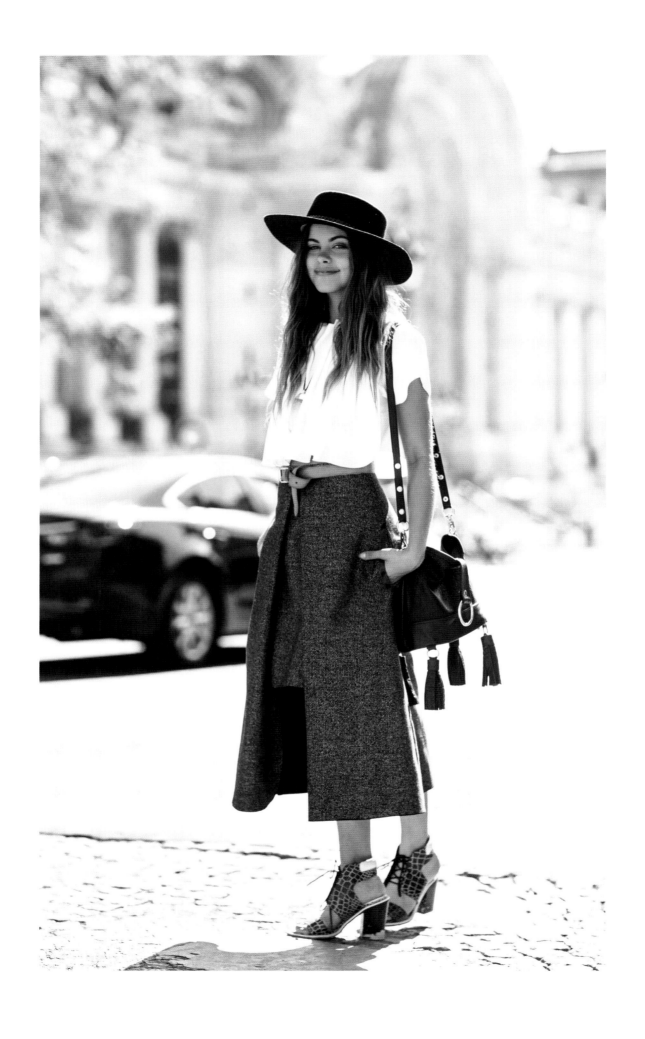

PETITE MALLE, LOUIS VUITTON

CROSSBODY
MANIA

It can happen in the blink of an eye: a few years ago, it would have been unthinkable to wear a purse across the body—only old ladies wore their purses the practical way! But then Phoebe Philo came to Céline, reworked the brand's Classic Bag, and voilà: suddenly everyone was wearing crossbody styles. Crossbody is still one of the most fashionable ways to wear a purse, especially with a coat thrown over your shoulders on top of it.

So schnell kann das gehen: vor ein paar Jahren wäre das schräg über den Körper getragene Modell noch undenkbar gewesen – nur Grannys trugen ihre Taschen auf die praktische Art! Aber dann kam Phoebe Philo zu Céline, überarbeitete einen Klassiker der Marke, die Classic Bag – und plötzlich hatten alle die Umhängevariante. Crossbody ist bis heute einer der schicksten Wege, Taschen zu tragen. Am besten mit über die Schultern geworfenem Mantel.

Les choses peuvent changer aussi vite que cela : Il y a quelques années, un modèle à porter en travers du corps aurait été encore impensable car seules les grands-mères sacrifiaient ainsi au pratique ! Il a suffi que Phoebe Philo entre chez Céline, revisite un classique de la marque, le Classic, pour que ces dames portent soudain leur sac en bandoulière. Il s'agit d'une manière parmi les plus élégantes de porter un sac. De préférence avec un manteau jeté sur les épaules.

IN LOVE WITH VALENTINO

Before Pierpaolo Piccioli and Maria Grazia Chiuri started making what are probably the world's most beautiful dresses at Valentino, they worked exclusively with accessories. As head designers, they introduced the Rockstud line. Not only does it provide just the right "tough contrast" to their ethereal dresses, it is also a good fit for real life.

Bevor Pierpaolo Piccioli und Maria Grazia Chiuri bei Valentino anfingen, die wahrscheinlich schönsten Kleider der Welt zu entwerfen, kümmerten sie sich ausschließlich um Accessoires. Als Chefdesigner führten sie die Rockstud-Linie ein, die einerseits der genau richtige "tough contrast" zu ihren feenhaften Kleidern ist. Und andererseits auch ziemlich gut ins echte Leben passt.

Avant de créer des robes probablement les plus belles au monde, Pierpaolo Piccioli et Maria Grazia Chiuri se consacraient exclusivement aux accessoires. Ces deux co-directeurs artistiques de Valentino ont lancé la ligne des sacs trapèze Rockstud, qui apporte juste ce qu'il faut de « contraste osé » à leurs robes de conte de fées, des sacs qui par ailleurs siéent si bien à la vraie vie.

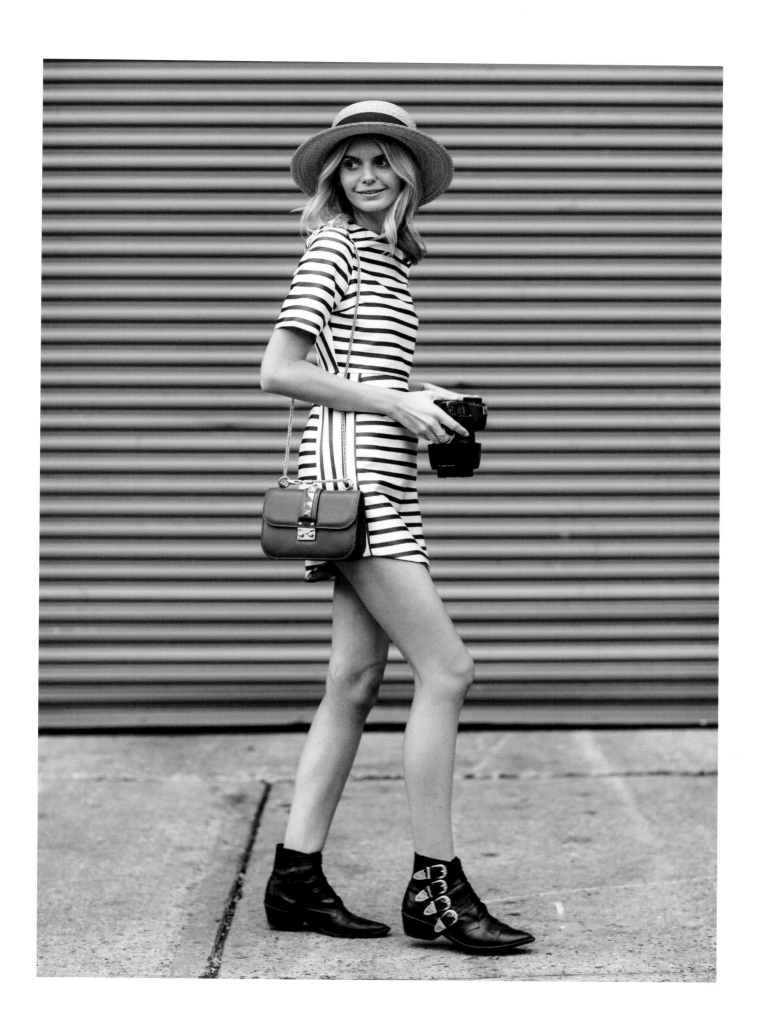

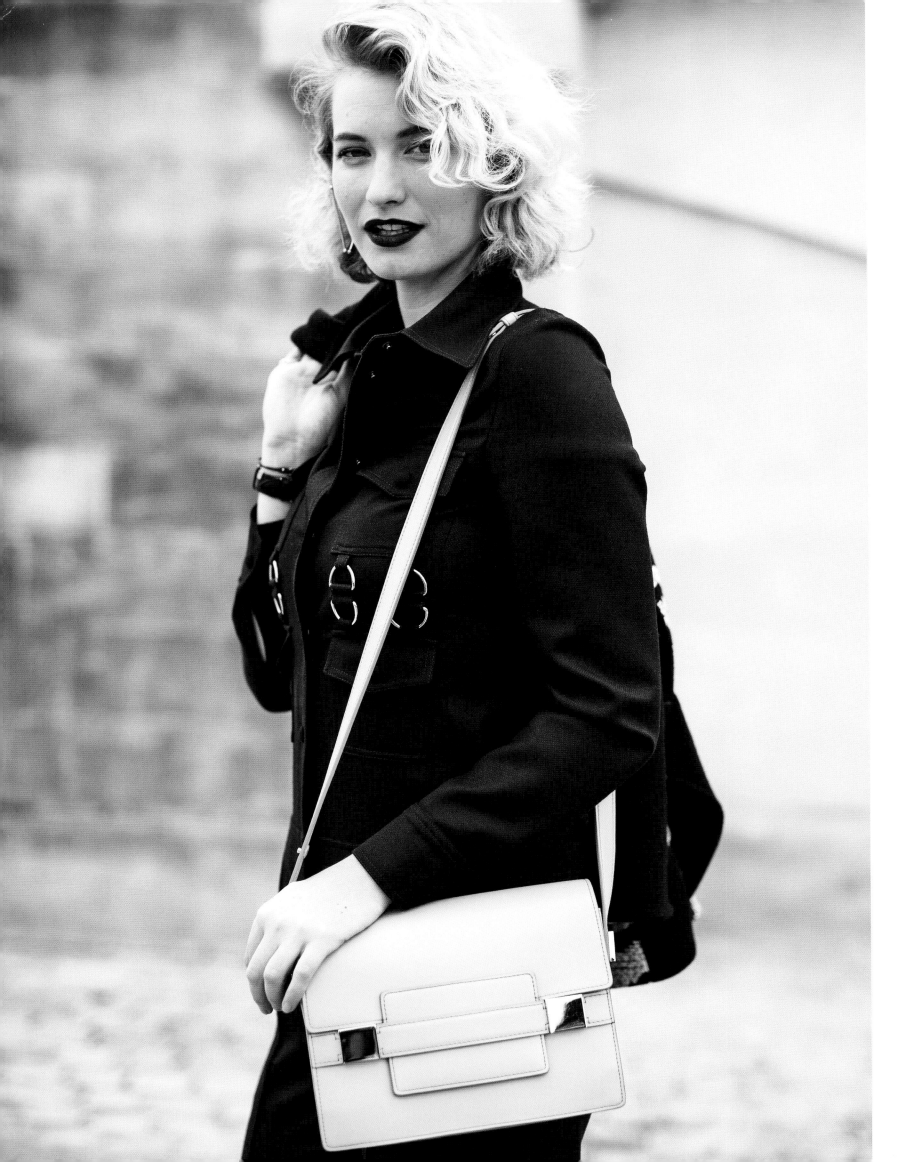

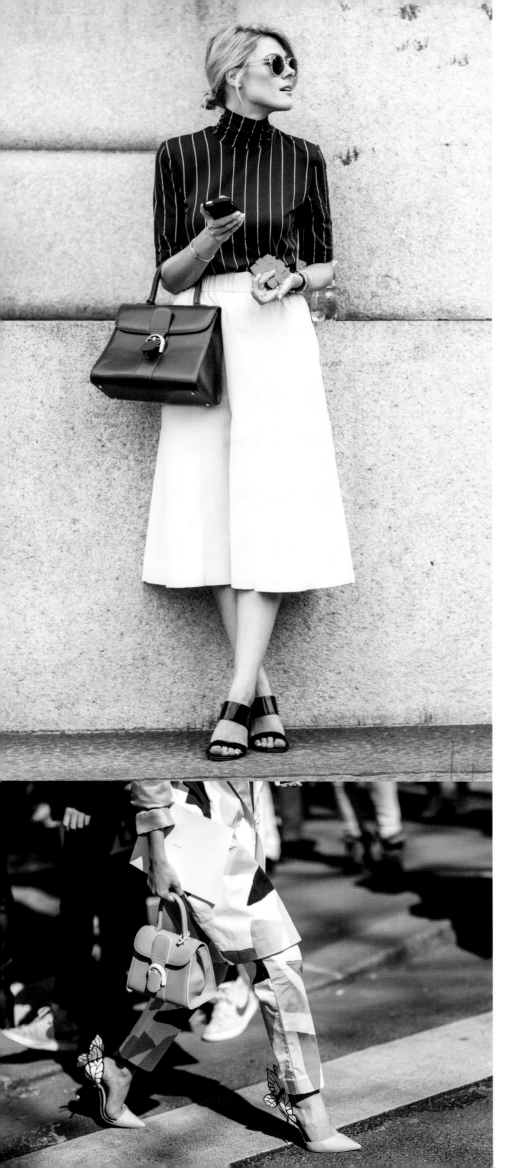

DELVAUX

One of the oldest fine luxury leather houses around is not based in France or Italy, but in Brussels, Belgium. Charles Delvaux founded it in 1829—only a few years before the inauguration of Europe's first passenger train services. The company founder knew early on what this meant for the women: they would need bags! Thus, from his luggage company emerged one of the first bag suppliers. In 1908, Delvaux registered a patent as the first ladies' handbag fashion house, which is why it's fully understandable how Delvaux reemerged a few years ago as an insider's tip—especially on blogs featuring street style. To this day, the manufacturer regards bags as sculptures. The house's most famous model, the Brillant, a design from 1966, consists of 64 individual leather panels. Today, almost fifty years later, it remains one of the most desirable It Bags among fashionistas.

Eines der ältesten „fine luxury leather houses" hat seinen Sitz nicht in Frankreich oder Italien, sondern in Brüssel, Belgien. Charles Delvaux gründete es 1829 – nur ein paar Jahre vor der Einweihung der ersten Zugverbindungen für Passagiere in Europa. Der Firmengründer verstand schon früh, was das für die Frauen bedeutete: Sie brauchten Taschen! Er meldete als erstes Haus 1908 Damenhandtaschen zum Patent an, weshalb völlig gerechtfertigt ist, dass Delvaux vor ein paar Jahren als Geheimtipp wieder auftauchte – vor allem in den Streetstyle-Blogs. Bis heute betrachtet die Manufaktur Taschen als Skulpturen. Das berühmteste Modell des Hauses, die Brillant, ein Entwurf aus dem Jahr 1966, besteht aus 64 einzelnen Lederelementen – und ist heute, fast fünfzig Jahre später, eine der begehrtesten It-Bags unter Fashionistas.

L'une des plus anciennes maisons de maroquinerie de luxe n'a son siège ni en France, ni en Italie mais en Belgique. Charles Delvaux la fonda en 1829, peu d'années avant l'inauguration des premiers réseaux ferroviaires destinés aux passagers d'Europe. Le fondateur de l'entreprise comprit très tôt ce qui revêtait de l'importance aux yeux des femmes : elles avaient besoin de sacs ! C'est ainsi que son entreprise de bagages devint l'un des premiers fournisseurs de sacs. En 1908, Delvaux fut la première maison de couture à déposer un brevet pour des sacs à main destinés aux femmes, ce qui justifie pleinement le fait que Delvaux réapparût il y a quelques années comme le designer à suivre, tout particulièrement dans les blogs de street style. Depuis toujours, la manufacture considère les sacs comme de véritables œuvres d'art. Le modèle le plus célèbre, le Brillant, une création datant de 1966, est constitué de 64 éléments individuels en cuir, et est aujourd'hui, presque plus de 50 ans plus tard, l'un des it-bags les plus convoités auprès des fashionistas.

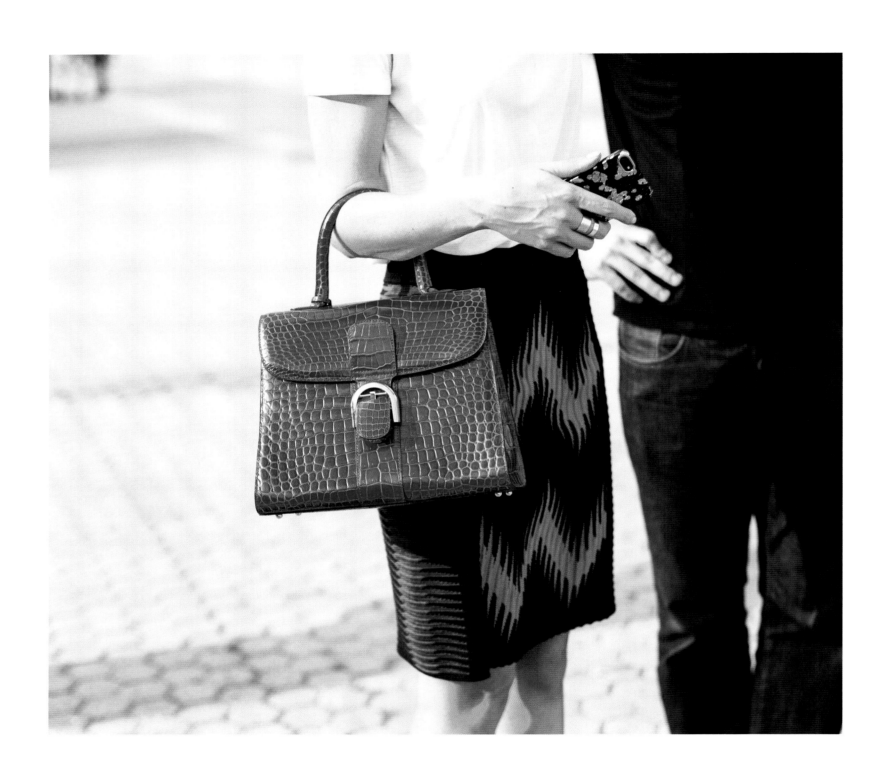

Alexa Chung and Sarah Jessica Parker are proud owners of the Madame (right), which is based on a design from 1977.

Alexa Chung und Sarah Jessica Parker sind stolze Besitzerinnen der Madame (rechts), sie beruht auf einem Entwurf von 1977.

Alexa Chung et Sarah Jessica Parker comptent parmi les fières propriétaires du sac Madame (à droite). Ce modèle se réclame d'une esquisse de 1977.

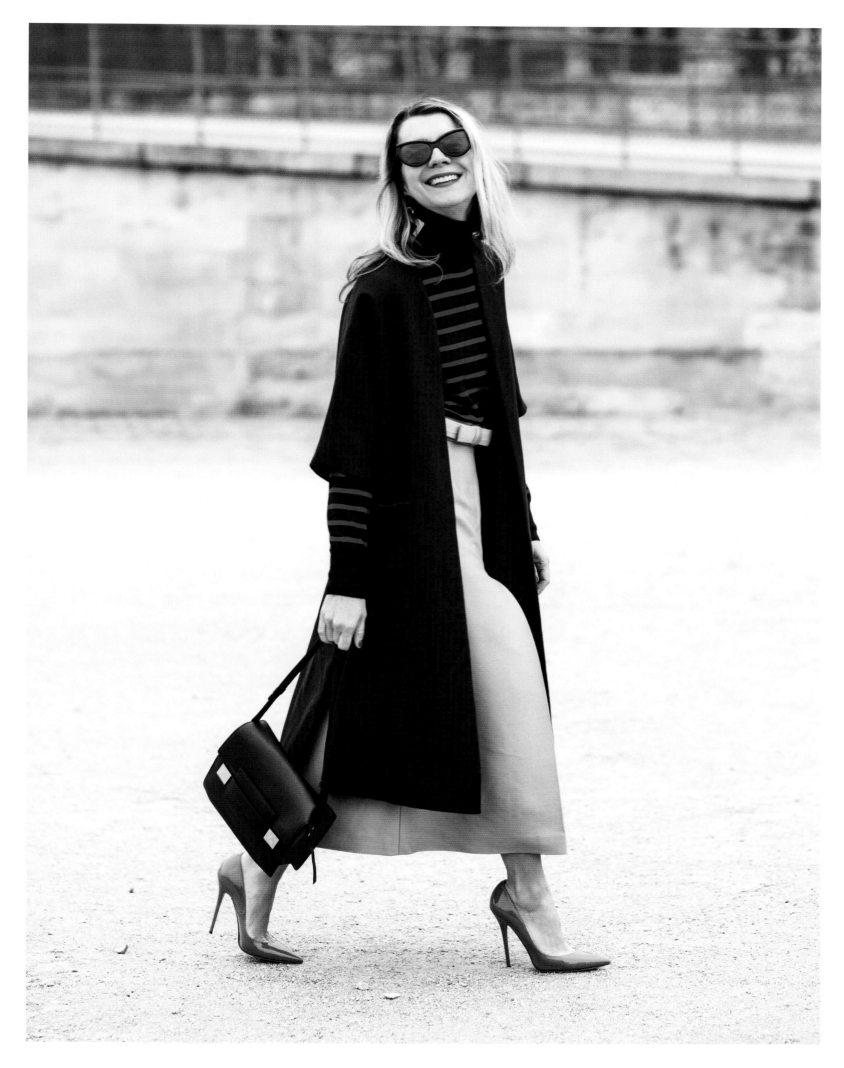

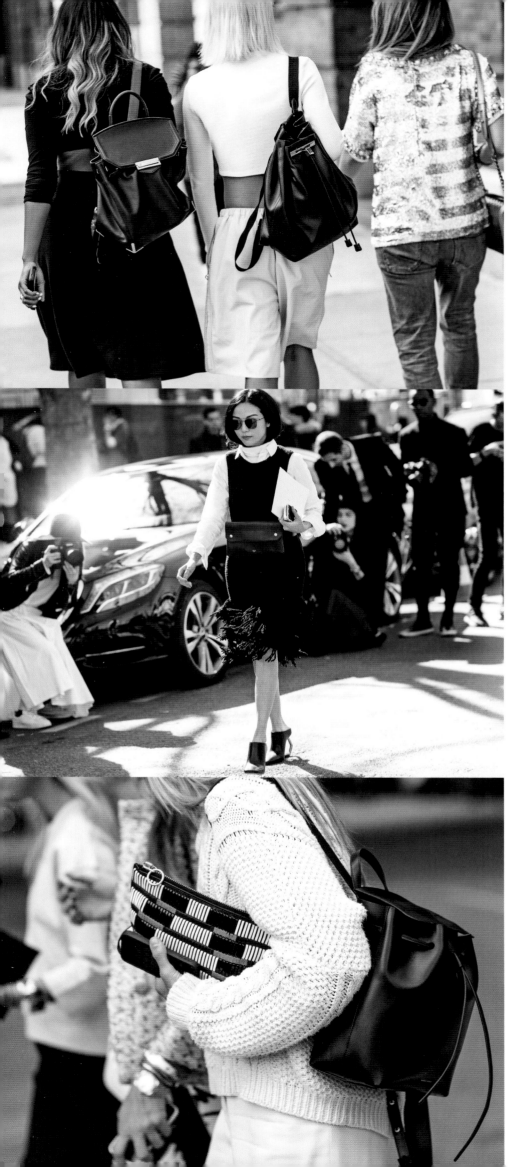

BACKPACK

The backpack as a status symbol—this is all thanks to Miuccia Prada, who launched a simple nylon version as part of a luggage collection in the mid-'80s. Everyone wanted one in the '90s. Since then, the backpack has had many successful comebacks, even at Chanel.

Der Rucksack als Statussymbol – das ist eine Erfindung von Miuccia Prada, die ihn schon Mitte der 1980er-Jahre aus schlichtem Nylon als Teil einer Reisegepäck-Kollektion lancierte. In den 1990er-Jahren wollten ihn dann alle. Seitdem feiert der Rucksack immer wieder sein Comeback. Sogar bei Chanel.

Le sac à dos comme signe extérieur de richesse, voilà une invention de Miuccia Prada, qui le lance dès le milieu des années 1980. Alors en simple nylon, il fait partie d'une collection de bagages. Dans les années 1990, on se l'arrache. Le sac à dos fait régulièrement son retour, même chez Chanel.

MICRO BAGS

Miniature bags are a real relic of the '90s, a time when women's fashion was all about mignon. Now they are back under the name micro bags—the smaller, the better, but only if they are petite versions of normal-size originals. Micro bags can be worn alone or with their larger cousin as a decorative accessory. Because let's face it: sometimes you need more than your keys and credit card.

Taschen in Miniaturform sind eigentlich ein Relikt aus den 1990er-Jahren. Damals trug man alles im Mignon-Look. Heute sind sie wieder da und heißen Micro Bags. Je kleiner, desto besser. Aber nur, wenn ein Original-Modell in normaler Größe Vorbild ist. Micro Bags werden solo getragen – oder sie verschönern die große Schwester als schmückendes Beiwerk. Weil Schlüssel und Kreditkarte ja nicht immer ausreichen.

Les sacs lilliputiens sont en fait une réminiscence des années 1990, une décennie qui affectionne les petits formats. Revenus au goût du jour, ils s'appellent micro sacs. Et plus ils sont petits, mieux c'est, mais à condition qu'il s'agisse de répliques en miniature de modèles originaux. Les micro sacs se portent seuls ou, parce que trousseau de clés et carte de crédit ne suffisent pas toujours, ils accompagnent leur grand frère, dont ils subliment l'esthétique.

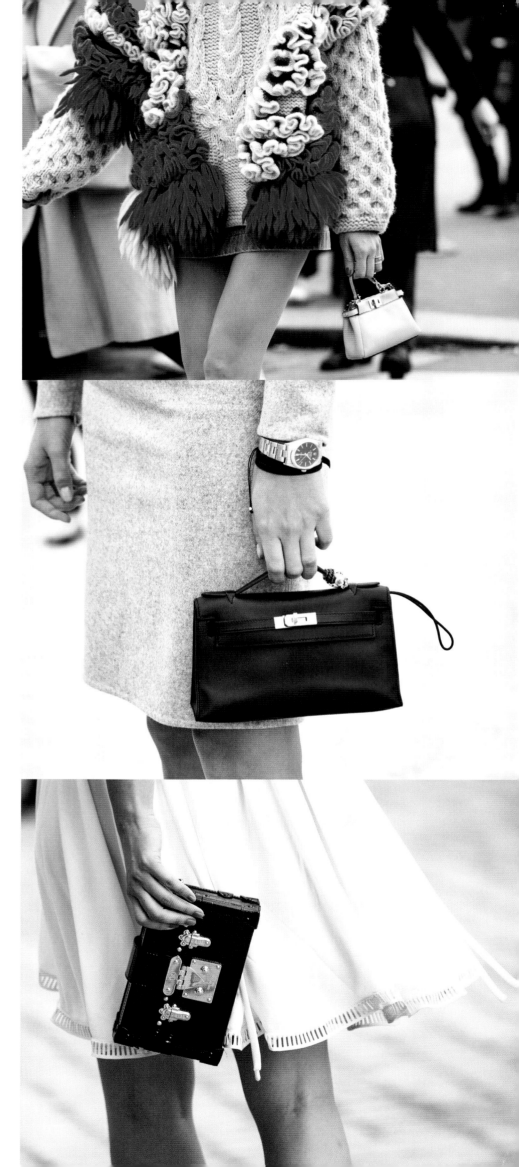

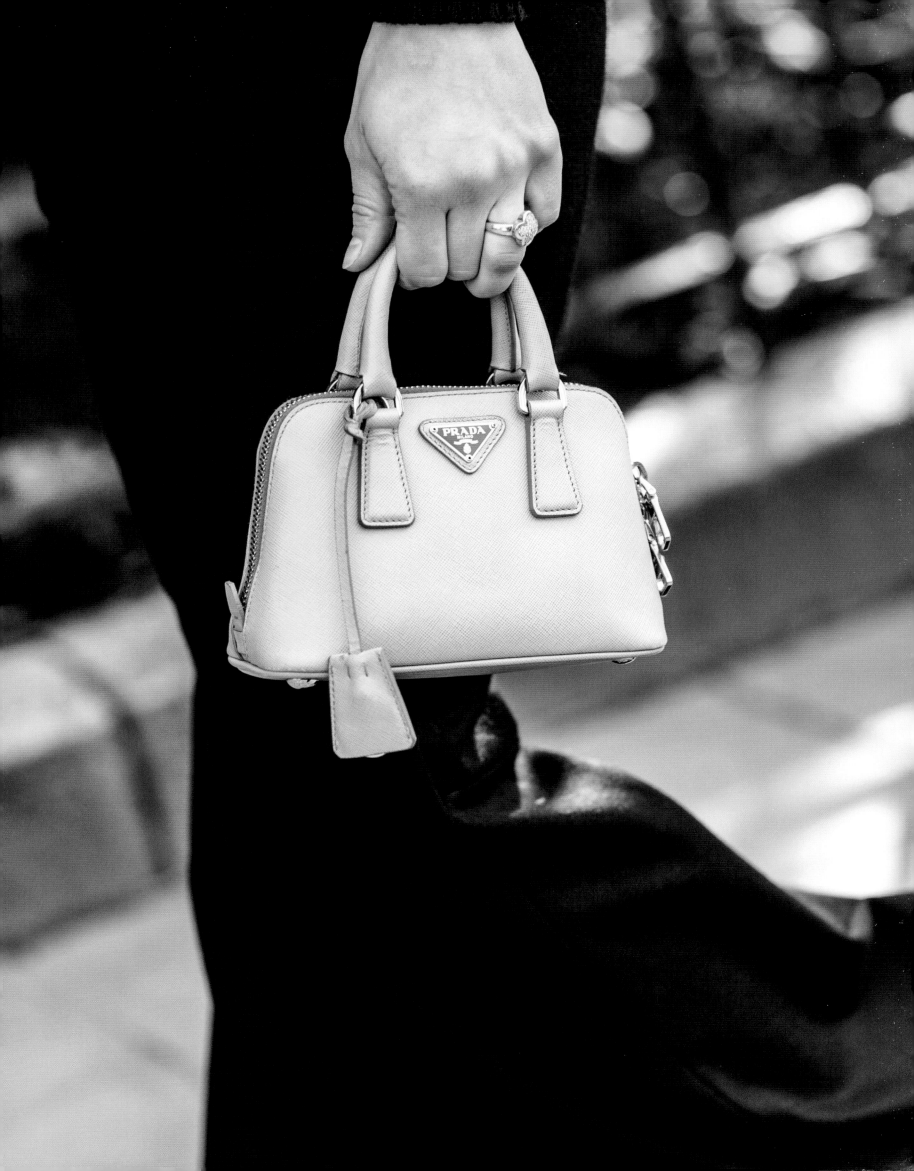

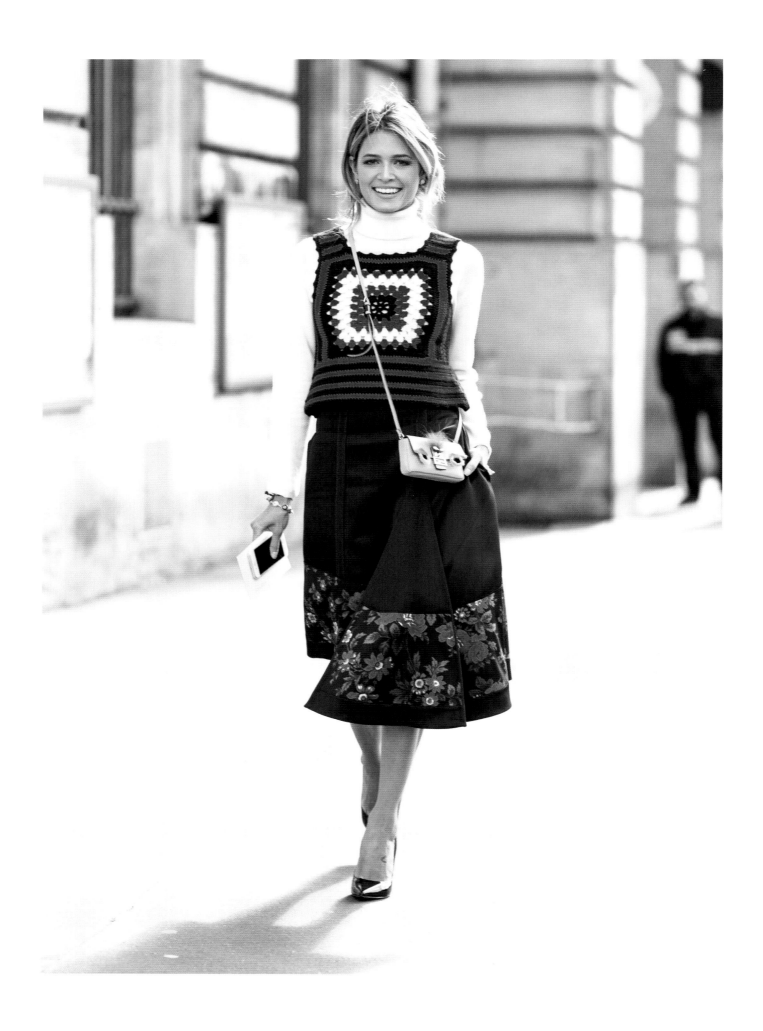

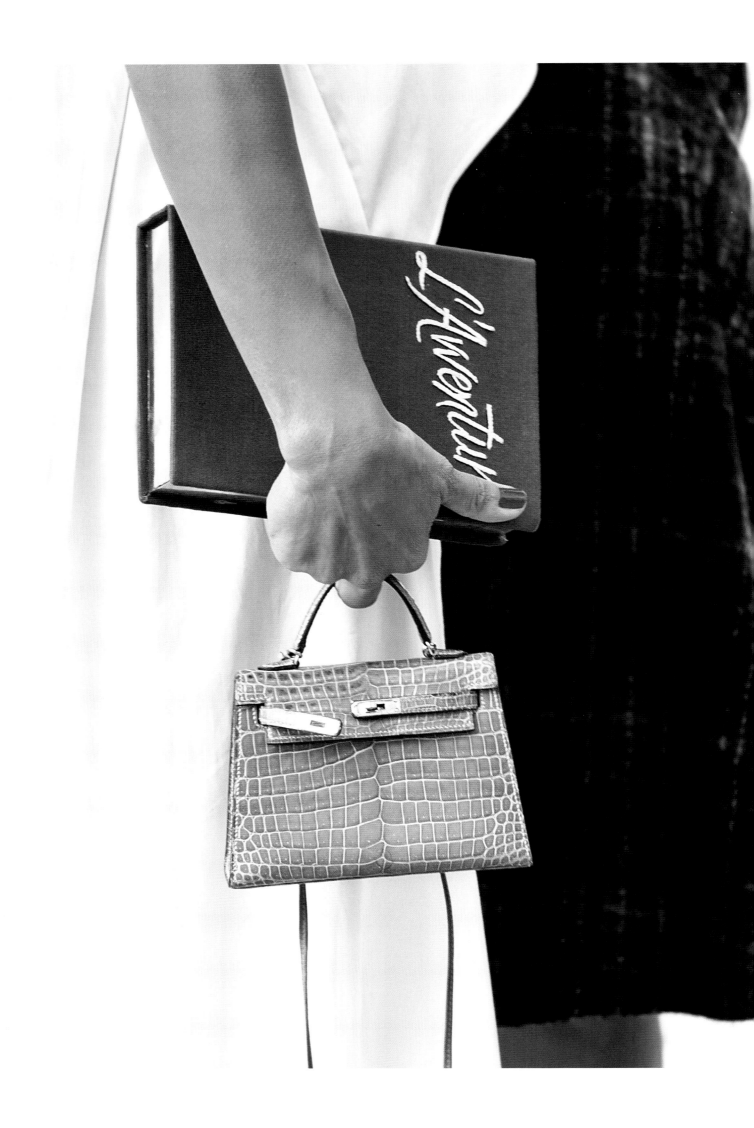

CHAPTER 5

EVENING JEWELS & CONVERSATION PIECES

—

They sparkle, they shine, and are sometimes so richly decorated with real gems that they would have to better be left in the safe rather than be taken to the dinner table. In actual fact, minaudières (the technical term for evening clutches) were invented in the 1930s by the French jeweler Van Cleef & Arpels. Soon other jewelry companies such as Cartier got into the business as well, of course, as the designers of haute couture. In the 1950s, the trend disappeared because evening bags with small chain handles were more functional for going out. Since around four years ago when women began to carry simple clutches—such as a leather envelope-style bag—during the day, the minaudière has once again been booming. Evening wear must now be even more glamorous than daywear. What good is the most expensive jewelry when it is not being worn?

Sie glitzern, glänzen und sind manchmal so reich mit echten Edelsteinen verziert, dass man sie eigentlich im Safe lassen müsste, statt sie mit an den Dinnertisch zu nehmen. Tatsächlich wurden Minaudières (so der Fachbegriff der Abend-Clutches) in den 1930er-Jahren vom französischen Juwelier Van Cleef & Arpels erfunden. Schon kurz darauf stiegen auch andere Schmuckfirmen wie Cartier ins Geschäft ein und natürlich die Designer der Haute Couture. In den 1950er-Jahren verschwand der Trend, weil Abendtäschchen mit kleinen Kettenhenkeln beim Ausgehen funktionaler waren. Seit Frauen vor ungefähr vier Jahren damit begannen, simple Clutches, also zum Beispiel aus Leder in Kuvert-Form, auch tagsüber zu tragen, boomt die Minaudière wieder. Eveningwear muss nun mal glamouröser sein als Daywear. Denn was nützt der teuerste Schmuck, wenn er nicht getragen wird.

Elles scintillent, brillent et sont parfois si richement ornées de pierres précieuses qu'il serait préférable de les laisser au coffre-fort plutôt que de les apporter à la table du dîner. En effet, les minaudières (terme spécifique désignant la pochette de soirée) ont été inventées par le joaillier français Van Cleef & Arpels dans les années 1930. Peu de temps après, des entreprises de joaillerie comme Cartier ainsi que des designers de haute couture suivirent cet exemple. Dans les années 1950, cette tendance disparut car les petits sacs de soirée munis de petites anses en chaîne rendirent les sorties plus fonctionnelles. Depuis que les femmes se sont mises, il y a environ quatre ans, à porter de simples pochettes, par exemple en cuir et en forme d'enveloppe, également pendant la journée, les minaudières connaissent à nouveau un véritable boom. Les tenues de soirée doivent être désormais plus glamoureuses que les tenues de jour. À quoi sert le bijou le plus onéreux s'il n'est pas porté ?

ALEXANDER MCQUEEN KNUCKLE CLUTCH

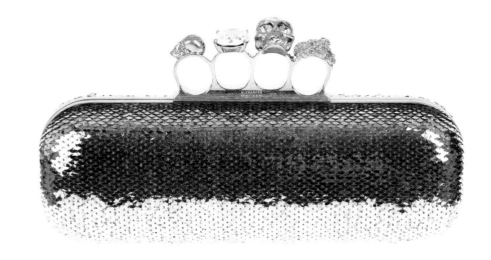

This bag is a weapon! At least, that was the initial impression of many customs officers when first seeing the clutch bag on their screens at airport security, where they mistook it for a set of brass knuckles. In fact in Germany, the bags were confiscated for a period until a district court in Bavaria once and for all decided it was all just decoration. A blow with such a model would lack the impact necessary to do damage, because to be effective, brass knuckles really need support from the palm. Alexander McQueen certainly did not have this much violence in mind when designing the bag. On the bag's fastening, the finger rings (even though they sometimes come with skulls and gemstones) are only meant to act as decoration and make it easier to carry. After the scandal, by the way, the rings increasingly came with flowers and little bees instead.

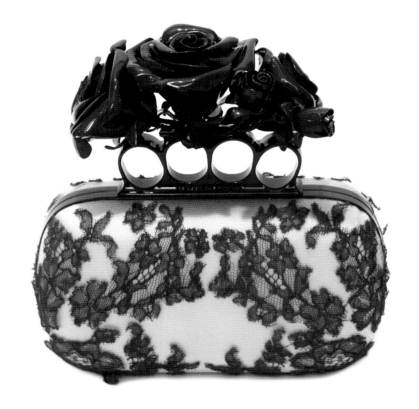

Diese Tasche ist eine Waffe! Zumindest sahen das bislang viele Zollbeamte so, die die Clutch bei der Sicherheitskontrolle am Flughafen auf ihren Bildschirmen für einen Schlagring hielten. Tatsächlich wurden die Modelle in Deutschland eine Zeit lang konfisziert, bis ein Amtsgericht in Bayern ein für allemal entschied: Alles nur Zierrat. Einem Hieb mit solch einem Modell fehle die nötige Kraft, weil ein wirkungsvoller Schlagring unbedingt eine Abstützung in der Handinnenfläche brauche. So viel Gewalt hatte Alexander McQueen beim Entwerfen auch gar nicht im Sinn. Auf dem Verschluss der Clutch sollten nur Fingerringe (manchmal sogar mit Totenköpfen und Schmucksteinen) als Deko und verbesserte Tragemöglichkeit sitzen. Nach dem Skandal wurden die Ringe übrigens vermehrt mit Blumen und kleinen Bienen versehen.

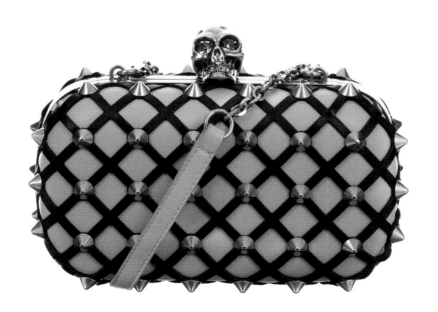

Ce sac est une arme ! Du moins, c'est ce que croyaient voir jusqu'à présent de nombreux agents des douanes qui prenaient la pochette pour un poing américain lorsque celle-ci apparaissait sur leur écran de contrôle de sécurité à l'aéroport. En effet, les modèles furent confisqués un certain temps en Allemagne, jusqu'à ce qu'un tribunal administratif en Bavière tranchât la question une bonne fois pour toutes. À ses yeux, tout n'était que gadget décoratif. Un coup porté avec un tel modèle ne pourrait d'aucune façon avoir la puissance du poing américain, lequel a besoin d'être solidement fixé dans la paume de la main pour être efficace. Alexander McQueen n'a pas été inspiré par une telle violence lors de la conception de ce modèle. Sur le fermoir de la pochette, des bagues, parfois même ornées de têtes de mort et de pierres précieuses, devaient seulement servir de décoration et faciliter le port de la pochette. Du fait de ce scandale, les bagues furent accompagnées à plusieurs reprises de fleurs ou de petites abeilles.

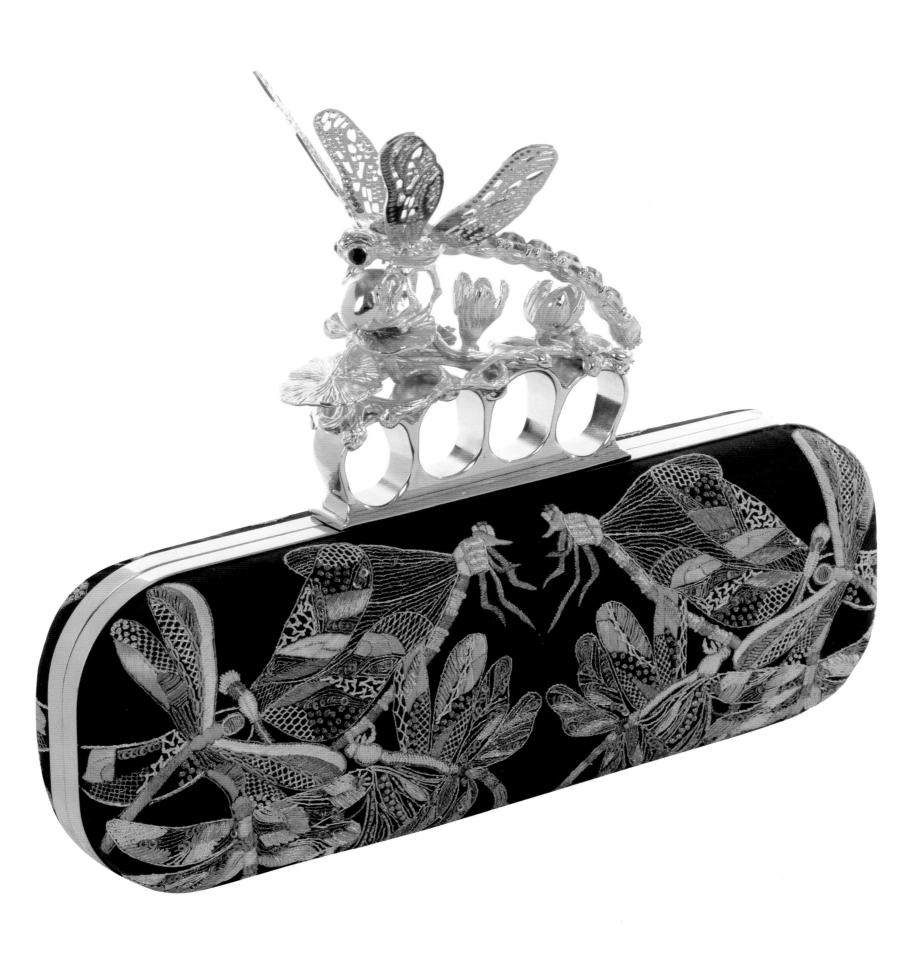

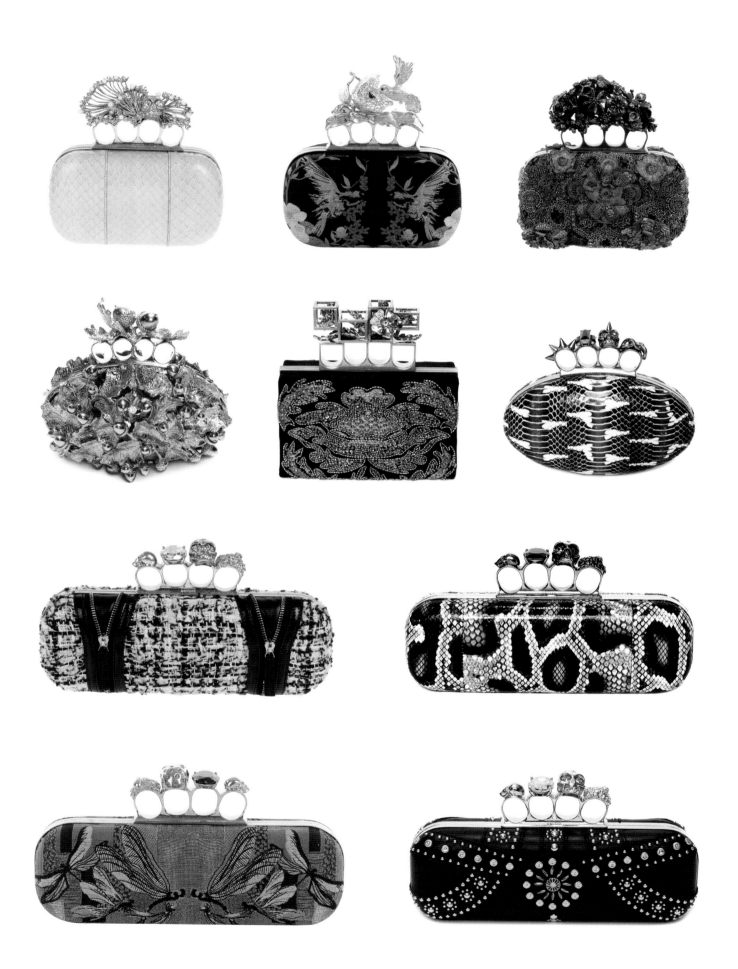

Besides the Knuckle and Skull clutch, the Padlock and Folk clutch (right) are also suitable for a night out.

Neben Knuckle und Skull Clutch eignen sich auch die Padlock und die Folk Clutch (rechts) für den abendlichen Auftritt.

À côté des pochettes Knuckle et Skull, les pochettes Padlock et Folk (à droite) sont opportunément adaptées aux sorties du soir.

BOTTEGA VENETA
KNOT CLUTCH
—

In the middle of the It Bag boom, so at the beginning of the 2000s, a man entered the fashion scene who had no real interest in all the hype: Tomas Maier. Originally from Pforzheim in southwest Germany, he had just taken over the creative direction of the financially hard-hit Bottega Veneta brand—and first up created a shopper bag from braided leather straps, the logo-less Cabat, based on the motto: "When your initial is enough." Shortly thereafter came the Knot, a clutch for the evening, whose form was already in the archives. Maier simply added a new knot lock and in doing so triggered a new round of hype. There are now hundreds of variations of the Knot; each, however, in limited edition. Sometimes there are only 100 or even 25 of a model—depending on the availability of rare materials (there were even some woven of pure gold).

Mitten im Boom der It-Bags, also Anfang der Nullerjahre, betrat ein Mann die Mode-Bühne, der sich für all den Rummel eigentlich nicht interessierte: Tomas Maier. Der gebürtige Pforzheimer hatte gerade die kreative Leitung der wirtschaftlich stark angeschlagenen Marke Bottega Veneta übernommen – und kreierte zu allererst einen Shopper aus geflochtenen Lederriemen, die Logo-lose Cabat, frei nach dem Motto: „When your initial is enough". Kurz danach kam die Knot, eine Clutch für den Abend, deren Form schon in den Archiven bestand. Maier setzte nur einen neuen Knotenverschluss darauf und löste so einen Hype aus. Mittlerweile gibt es die Knot in Hunderten Varianten, jede allerdings immer in limitierter Auflage. Manchmal sind es nur 100 oder 25 Stück – je nach Verfügbarkeit der seltenen Materialien (es wurden sogar schon Modelle aus reinem Gold geflochten).

En pleine période de boom des it-bags, au début des années 2000, un homme, Tomas Maier qui, en réalité, ne s'intéressait pas à tout cela, fit son entrée sur le devant de la scène de la mode. Né à Pforzheim, il prit la direction artistique de la marque Bottega Veneta, qui avait subi des revers économiques et créa en priorité un shopper doté de lanières en cuir tressées, le cabas sans logo, libre selon la devise : « When your initial is enough ». Peu de temps après suivit le modèle Knot, une pochette de soirée, dont la forme existait déjà dans les archives. Maier y ajouta un fermoir en forme de nœud et provoqua, avec ce détail, un engouement frénétique. Le modèle Knot existe désormais en une centaine de variantes, toutefois chacune dans une édition limitée. Parfois, il ne s'agit que de 100 ou 25 pièces, cela dépend de la disponibilité des matériaux rares (certains ont même été tressés à partir d'or).

The Knot bag by Bottega Veneta is the ultimate minaudière—professionals no longer
carry it only in the evenings, but also throughout the whole day.

Die Knot Bag von Bottega Veneta ist die ultimative Minaudière – Profis tragen sie längst
nicht mehr nur am Abend. Sondern den ganzen Tag.

Le sac Knot de Bottega Veneta est la minauderie ultime. Depuis longtemps, les expertes ne la portent
plus uniquement le soir. Mais bien toute la journée.

CONVERSATION PIECES

During the 2013 Paris summer shows, something happened which no one had expected so soon: the street style craze had nothing more to ask of its icons. After soda cans on their heads, tops made from real sunflowers, and lampshades as skirts, there was nothing more that could attract the attention of photographers—until the Surrealist bags struck. Pioneers of this movement include Olympia Le-Tan, whose clutches look like old books, and Charlotte Olympia, whose creation of a matryoshka doll on a chain handle sold out in record time. This became a successful icebreaker to the best accessory small talk at cocktail parties that even Karl Lagerfeld suddenly started designing leather milk cartons and jerry can bags for Chanel. His creations in particular have already attained a collector's value worth twice the original price.

Während der Pariser Sommerschauen 2013 passierte etwas, mit dem eigentlich niemand so schnell rechnete: Der Streetstyle-Wahnsinn hatte seinen Ikonen alles abverlangt. Nach Cola-Dosen auf dem Kopf, Tops aus echten Sonnenblumen und Lampenschirmen als Röcken gab es nichts mehr, das die Aufmerksamkeit der Fotografen auf sich lenken konnte – bis kurz danach die Stunde der surrealistischen Taschen schlug. Pionierinnen dieser Bewegung sind Olympia Le-Tan, deren Clutches wie alte Bücher aussehen und Charlotte Olympia, die es mit einer Matroschka am Kettenhenkel zu einem Blitz-Ausverkauf schaffte. Diese sich auch auf jedem Cocktailevent als bestes Entrée zum Smalltalk eignenden Accessoires wurden so erfolgreich, dass selbst Karl Lagerfeld für Chanel plötzlich lederne Milchtüten oder Benzinkanister entwarf. Vor allem seine Modelle haben heute bereits einen Sammlerwert, der das Doppelte vom ursprünglichen Preis erzielt.

Pendant les défilés de mode de l'été 2013, il se produisit quelque chose que personne n'avait à vrai dire escompté si rapidement : la folie du street style avait tout exigé de ses icônes. Après les canettes de Coca-Cola sur la tête, les tops composés de véritables tournesols et les jupes en forme d'abat-jour, plus rien ne pouvait attirer l'attention des photographes, jusqu'à ce que l'heure des sacs surréalistes retentit. Les pionnières de ce mouvement sont Olympia Le-Tan dont les pochettes ressemblent à de vieux livres et Charlotte Olympia qui réussit une vente éclair jusqu'à l'épuisement de la série, avec sa poupée russe dotée d'anses en chaîne. Ces accessoires qui se révèlent comme le meilleur moyen d'engager une conversation lors d'un cocktail obtinrent un tel succès, que même Karl Lagerfeld se mit à créer pour Chanel des sacs en cuir, en forme de briques de lait ou de jerricanes d'essence. Mais surtout ses modèles ont déjà aujourd'hui une valeur de collection, qui atteint le double du prix de départ.

CHARLOTTE OLYMPIA
CONVERSATION PIECES

A horse's head made from suede as a handbag, a cat's face on a shopper, plus to-the-point names like
Daddy, I Want a Pony, and Lucky Clutch (for the horseshoe bag)—with Charlotte Olympia, anything is possible.

Ein Pferdekopf aus Wildleder als Handtasche, ein Katzengesicht auf einem Shopper und dazu so treffende Namen wie
Daddy, I want a Pony und Lucky Clutch (für die Hufeisentasche) – bei Charlotte Olympia ist alles möglich.

Une tête de cheval en cuir sauvage, un visage de chat sur un shopper et des noms tellement appropriés comme
Daddy, I want a Pony et Lucky Clutch (pour les sacs en forme de fer à cheval). Chez Charlotte Olympia, tout est possible.

OLYMPIA LE-TAN
CONVERSATION PIECES

The milk carton is one of Olympia Le-Tan's trademarks.

Die Milchtüte ist eines der Markenzeichen Olympia Le-Tans.

La brique de lait est le modèle emblématique de Olympia Le-Tan.

CHANEL
MINAUDIÈRES

Chanel's ironic/iconic minaudières are extremely popular on red carpets around the world.

Chanels ironisch-ikonische Minaudières erfreuen sich enormer Beliebtheit auf roten Teppichen rund um die Welt.

Les minaudières en de Chanel, à la fois ironiques et iconiques, sont très populaires sur les tapis rouges du monde entier.

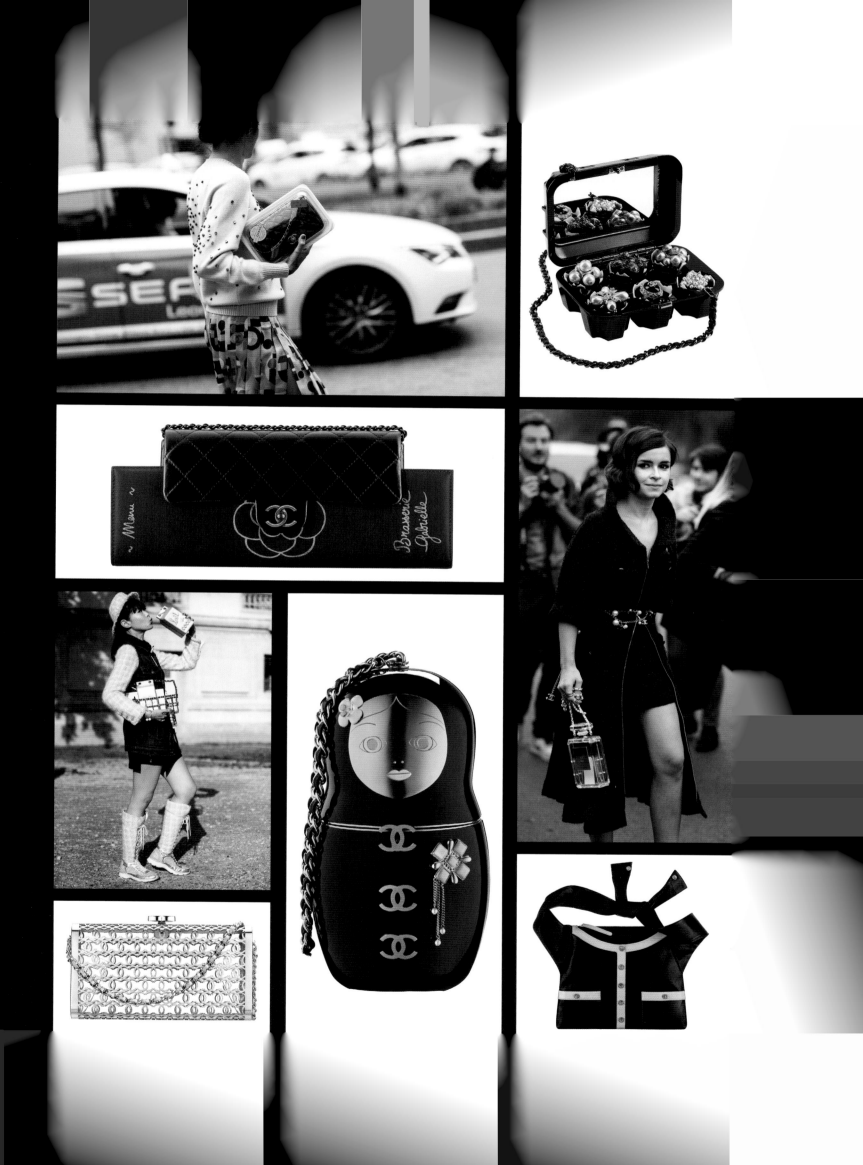

INDEX BAGS & BRANDS

Acne
143, 145 (bottom left)

Alexander McQueen
74-77, 194-199
De Manta 74-76
Heroine 75-76
Knuckle 194-197

Alexander Wang
160

Amicuore
207

Anya Hindmarch
148, 152, 155 (top),
205 (top & bottom), 206

Balenciaga
66-67, 145 (upper middle left)
Lariat 66-67

Bottega Veneta
41, 200-203
Knot 41, 200-203

Céline
8, 80-87, 145 (top left),
158-159, 185 (middle)
Classic 83, 85
Luggage 85
Phantom 82
Trapèze 8, 80-81, 85

Chanel
14-21, 123-127, 140, 184, 214-215
2.55 14-19
Chanel Boy 21, 123-127
Minaudières 6, 214-215

Charlotte Olympia
208-211

Chloè
62-65, 144, 165
Bronte 144, 169 (middle)
Drew 65, 165
Faye 62-63, 65
Marcie 65
Paddington 64
Paraty 65

Delphine Delafon
149 (bottom)

Delvaux
4, 157 (bottom left), 180-183
Brillant 181, 182
Madame 4, 156, 180, 183

Devi Kroell
140

Dior
24-31,
Lady Dior 24-31

Dolce & Gabbana
10-11

Fendi
46-55, 149 (middle),
153 (upper middle left &
bottom middle), 186 (top), 188
Baguette 46-52, 54, 153
(lower middle), 188

Ferragamo
145 (bottom middle)

Furla
168, 172 (top right)

Gianlisa
169 (bottom)

Givenchy
161 (top), 206
(upper middle left)

Gucci
22-23, 161 (bottom),
163 (bottom middle & right)
Jackie Bag 22-23

Hermès
8, 12-13, 32-43, 90-95,
186 (middle), 190
Birkin 92 (bottom)
Constance 40-43
Kelly 8, 12-13, 32-39,
186 (middle), 190

Jimmy Choo
142, 145 (top right)

Lanvin
193

Les Petits Joueurs
206 (top left)

Loewe
6, 153 (top left)
Puzzle Bag 6

Louis Vuitton
44-45, 68-73, 157 (bottom right),
166-167, 186 (bottom)
Alma 70, 71
Capucines 71
Lockit 71
Noe 71
Petite Malle 69, 70, 72, 166-167
Speedy 68, 71

M2Malletier
154

Mansur Gavriel
163 (top left), 185

Mark Cross
163 (middle left)

Marni
157 (top left)

Miu Miu
157 (top right),
163 (top right)

Moynat
114-121
Limousine 119
Pauline 115, 117, 119
Rejane 116, 118-119
Train 120-121

Olympia Le-Tan
140, 212-213

Paula Cademartori
128-135, 173

Pierre Hardy
145 (bottom right),
157 (lower middle)

INDEX PEOPLE

Phillip Lim
157 (upper middle left)

Play No More
149 (top),
153 (bottom left & right)

Prada
56-61, 145 (middle right), 187
Bowling Bag 57

Proenza Schouler
145 (lower middle left),
163 (bottom left), 169 (top)

Reece Hudson
157 (bottom middle)

Saint Laurent
78-79, 150-151, 162,
170-171, 172 (top left)
Muse 78-79

Sara Battaglia
136-139, 153 (top right)

Sarah's Bag
147

Stella McCartney
163 (middle right)

Tod's
96-105, 189 (top)
D 102, 104-105
D-Cube 103, 105

Trussardi
156

Valentino
153 (bottom right),
155 (bottom), 163, 174-179

Valextra
106-113
Isis 107
Milano 113
Triennale 112-113
Twist 110

Yazbukey
204, 205 (middle)

Andrea Dellal 208

Anna dello Russo
11, 61, 153

Anne-Catherine Frey 160

Brie Welch 155

Camille Charrière 127

Candela Novembre
52, 54, 136

Carlotta Oddi
130, 148

Charlotte Dellal 208

Chiara Ferragni
59, 153

Chiara Totire 168

Ece Sukan 156

Eleanor Pendleton 172

Elin Kling 141

Erika Boldrin 53

Gilda Ambrosio
6, 52, 85

Giorgia Tordini 161

Giulia Baggini 129

Hege Aurelie Badendyck
66, 143

Helena Bordon 188

Irene Kim
149, 153

Irina Lakicevic 84

Jessica Stein 177

Kate Foley 155

Katie Mossman 145

Lauren Remington Platt 203

Leaf Greener
204, 215

Leandra Medine 48

Lily Montana 140

Lolita Jacobs 83

Lucy Chadwick 85

Margherita Rovelli 129

Maria Duenas Jacobs 163

Marianne Theodorsen 206

Mimi Elashiry 164

Miroslava Duma
36, 38, 39, 40, 209, 215

Natalie Joos 183

Patricia Manfield
201, 203

Pernille Teisbaek
20, 44, 65, 123, 144, 206

Rajni Jacques 31

Shiona Turini 24

Sofia Sanchez de Betak
154, 157, 176

Sofie Valkiers 181

Tamu McPherson 173

Veronika Heilbrunner
56, 70

Virginia Cuscito 129

Yoyo Cao
18, 145, 185

Zanita Whittington
4, 157, 180

Zina Charkoplia 129

BIOGRAPHIES

Julia Werner

Julia Werner is an experienced journalist and book author. A graduate of the German School of Journalism in Munich, Werner is the style columnist for the *Süddeutsche Zeitung* and the new Assistant Editor-in-Chief of *Glamour* (Germany) as of July 2015. Julia Werner has a wide range of journalism experience in fashion and lifestyle segments, and lived and worked in Florence, Italy for five years—the center of the international purse and bag-making scene. Her first style guide, *Who is Who im Kleiderschrank* (A Closet Who's Who), a collaboration with Kera Till, was published in 2014.

Julia Werner ist eine erfahrene Journalistin und Buchautorin. Die Absolventin der Deutschen Journalistenschule in München ist Stilkolumnistin der *Süddeutschen Zeitung* und seit Juli 2015 stellvertretende Chefredakteurin der deutschen *Glamour*. Julia Werner hat vielseitige journalistische Erfahrungen im Bereich Mode und Lifestyle und lebte und arbeitete fünf Jahre in Florenz – dem Zentrum der internationalen Täschnerkunst. Ihr erster Stilratgeber *Who is Who im Kleiderschrank* in Zusammenarbeit mit Kera Till erschien 2014.

Julia Werner est une journaliste et auteure expérimentée. Diplômée de l'école de journalisme de Munich, elle tient une rubrique Style dans le quotidien *Süddeutsche Zeitung* et depuis juillet 2015, elle est rédactrice en chef adjointe de *Glamour*. Julia Werner dispose d'une grande expérience journalistique dans les domaines de la mode et du lifestyle. Elle a vécu et travaillé pendant cinq ans à Florence, haut lieu de la maroquinerie. Son premier guide de style, coécrit avec Kera Till, est paru en 2014.

Sandra Semburg

Photographer Sandra Semburg studied film and acting in New York and has worked as a photographer for numerous magazines and labels. Her photos have appeared in outlets including *Vogue* (US), *Harper's Bazaar* (Germany), and garancedoré.fr. She began traveling to the most important fashion shows as a street style photographer in 2010 and shares the latest trends on her blog aloveisblind.com.

Sandra Semburg hat in New York Film und Schauspiel studiert und als Fotografin für zahlreiche Magazine und Label gearbeitet. Ihre Fotos sind u.a. in der amerikanischen *Vogue*, der deutschen *Harper's Bazaar* sowie auf garancedoré.fr erschienen. Seit 2010 reist sie als Streetstyle-Fotografin zu den wichtigsten Modenschauen und zeigt die neuesten Trends auf ihrem Blog aloveisblind.com.

Sandra Semburg a étudié les arts dramatiques à New York et travaillé pour de nombreux magazines et marques de prêt-à-porter. Ses photos ont paru dans *Vogue* US, *Harper's Bazaar* Allemagne et sur garancedoré.fr. Depuis 2010, elle assiste aux défilés de mode les plus importants en tant que photographe de street style et nous fait découvrir les nouvelles tendances sur son blog aloveisblind.com.

Dennis Braatz

Dennis Braatz studied fashion journalism and media communication at the Akademie Mode & Design in Munich. He was deputy head of fashion at *Cover* and part of the design editorial team at the Burda publishing house in Munich. He is currently responsible for the style pages of the *Süddeutsche Zeitung* and writes freelance for different fashion magazines.

Dennis Braatz studierte an der Akademie Mode & Design in München Modejournalismus und Medienkommunikation. Er war stellvertretender Modechef bei *Cover* und Teil der Entwicklungsredaktion des Burda-Verlags in München. Zurzeit ist er verantwortlich für die Stil-Seiten der *Süddeutschen Zeitung* und schreibt freiberuflich für verschiedene Modemagazine.

Dennis Braatz a étudié à l'académie Mode & Design de Munich le journalisme de mode et les moyens de communication. Il était rédacteur en chef à titre supplétif de la rubrique mode de *Cover* et faisait partie de la rédaction des éditions Burda à Munich. Aujourd'hui, il est responsable des pages de style du journal *Süddeutsche Zeitung* et écrit en freelance pour différents magazines de mode.

PHOTO CREDITS

Cover & back cover photos by © 2015 Sandra Semburg. All rights reserved.

All street style images by © 2015 Sandra Semburg. All rights reserved.

p. 06 (top) © Chanel | p. 08 (top) © Studio des Fleurs | pp. 15-16 © Chanel | p. 23 © David McGough/The LIFE Picture Collection/Getty Images | p. 25 (top) © Dior | p. 26 © Bertrand Rindoff Petroff/French Select/Getty Images | p. 27 © Tim Graham Photo Library/Getty Images | p. 30 © Dior | p. 31 (mid) © Dior | p. 32 © Studio des Fleurs | p. 33 © Howard Sochurek/The LIFE Picture Collection/Getty Images | p. 34 (top left) © Kilian Bishop, (top right) © Vicente Sahuc, (mid left) © Studio des Fleurs, (mid right & bottom) © Quentin Bertoux | p. 35 © Popperfoto/Getty Images | pp. 41-43 © Vicente Sahuc, except p. 42 (bottom right) © Kilian Bishop | p. 46 © action press/Everett Collection | p. 47-50 © Fendi | pp. 57-60 © Prada | p. 64 © firstVIEW | p. 71 © Louis Vuitton | pp. 74-77 © Alexander McQueen | p. 78 action press/Everett Collection | pp. 88-89 © Moynat | pp. 90 & 94-95 © Lucie & Simon | p. 91 (top & mid) Studio des Fleurs, (bottom) Kilian Bishop | pp. 92-93 Alfredo Piola | pp. 96-105 © Tod's SpA | pp. 106-113 © Valextra | pp. 114-121 © Moynat | p. 193 © firstVIEW | pp. 194-199 © Alexander McQueen | pp. 209-211 © Charlotte Olympia | pp. 214-215 © Chanel | p. 218 (top) © Andreas Ortner, (mid) © Vanni Bassetti, (bottom) © Marcus Schäfer

Every effort has been made by the publisher to contact holders of copyright to obtain permission to reproduce copyright material. However, if any permissions have been inadvertently overlooked, teNeues Publishing Group will be pleased to make necessary and reasonable arrangements at the first opportunity.

IMPRINT

Edited by Julia Werner

Texts: Julia Werner, Dennis Braatz

Translations: Amanda Ennis, Shearwater Language Service & David Knight (English), Christèle Jany & Lucile Frank & Schmellenkamp Communications (French)

Copyediting: Maria Regina Madarang (English), Nadine Weinhold, Stephanie Rebel, Inga Wortmann (German) Mireille Onon & Schmellenkamp Communications (French)

Editorial Coordination: Nadine Weinhold

Design, Layout & Prepress: Christin Steirat, Anika Lethen, Michelle Kliem, Nadine Weinhold

Imaging: David Burghardt

Production: Alwine Krebber

Published by teNeues Publishing Group

teNeues Media GmbH + Co. KG
Am Selder 37, 47906 Kempen, Germany
Phone: +49 (0)2152 916 0,
Fax: +49 (0)2152 916 111
e-mail: books@teneues.com

Press Department: Andrea Rehn
Phone: +49 (0)2152 916 202
e-mail: arehn@teneues.com

teNeues Publishing Company
7 West 18th Street,
New York, NY 10011, USA
Phone: +1 212 627 9090,
Fax: +1 212 627 9511

teNeues Publishing UK Ltd.
12 Ferndene Road, London SE24 0AQ, UK
Phone: +44 (0)20 3542 8997

teNeues France S.A.R.L.
39, rue des Billets,
18250 Henrichemont, France
Phone: +33 (0)2 4826 9348,
Fax: +33 (0)1 7072 3482

© 2015 teNeues Media GmbH + Co. KG, Kempen

ISBN: 978-3-8327-3273-8
Library of Congress Control Number: 2015940185

Printed in the Czech Republic.

Picture and text rights reserved for all countries. No part of this publication may be reproduced in any manner whatsoever. All rights reserved.

While we strive for utmost precision in every detail, we cannot be held responsible for any inaccuracies, neither for any subsequent loss or damage arising.

Bibliographic information published by the Deutsche Nationalbibliothek. The Deutsche Nationalbibliothek lists this publication in the Deutsche Nationalbibliografie; detailed bibliographic data are available in the Internet at http://dnb.d-nb.de

www.teneues.com